PUBLIC & PRIVATE

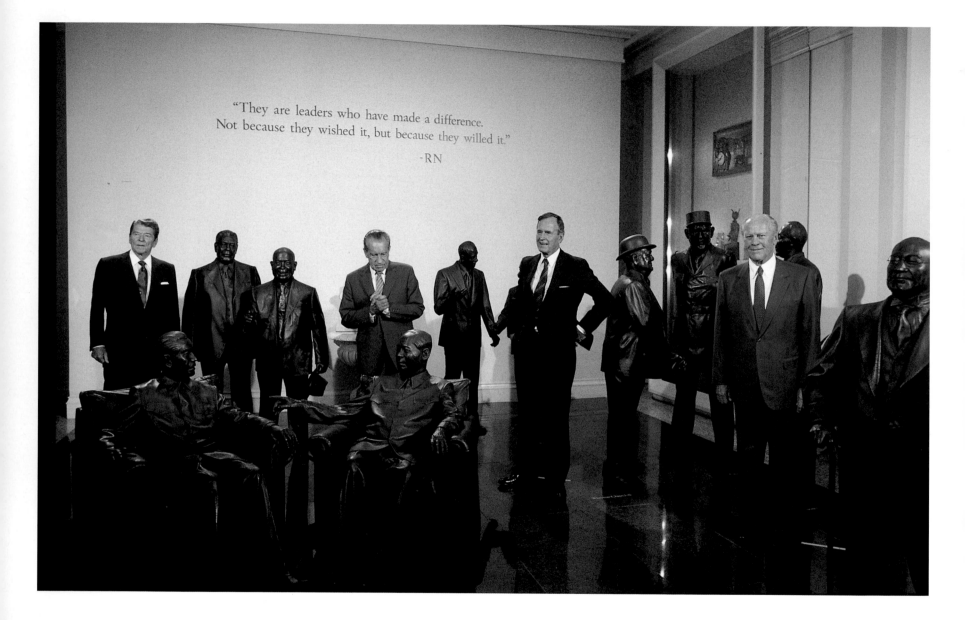

PUBLIC & PRIVATE

TWENTY YEARS PHOTOGRAPHING THE PRESIDENCY

DIANA WALKER

FOREWORD BY MICHAEL BESCHLOSS

COMMENTARIES BY THE PRESIDENTS AND FIRST LADIES

NATIONAL GEOGRAPHIC INSIGHT

NATIONAL GEOGRAPHIC
WASHINGTON, D.C.

THIS BOOK IS FOR MY FAMILY, WHO MEAN EVERYTHING TO ME—
MALLORY, OUR SONS, TAYLOR AND WILLY, AND OUR DAUGHTERS-IN-LAW,
JANE TIMBERLAKE AND SHEILA OHLSSON WALKER.

THIS BOOK IS DEDICATED TO OUR BELOVED NEPHEW AND COUSIN
CHRISTOPHER LAURISTON HARDIN (1981–2001).

Title Page: Presidents Reagan, Nixon, Bush, and Ford amid statues of the foreign leaders Nixon
met with during his Presidency, Nixon Library, Yorba Linda, California, July 19, 1990

6 *Foreword*

18 *Introduction*

26 **THE GERALD FORD YEARS**

42 **THE JIMMY CARTER YEARS**

60 **THE RONALD REAGAN YEARS**

94 **THE GEORGE BUSH YEARS**

132 **THE BILL CLINTON YEARS**

200 *Acknowledgments*

Foreword

DIANA WALKER STANDS IN A PROUD TRADITION OF PHOTOGRAPHERS who have shaped our understanding of American Presidents. Without Mathew Brady, we would have a very different idea of who Abraham Lincoln was. Without Lyndon Johnson's house photographer Yoichi Okamoto—"Okie"—whom the President prodded to follow him into even his bedroom and bathroom, we would have missed much of the private LBJ.

As a White House photographer for *TIME* and other publications, the author of this absorbing and elegant volume has had a distinctive influence on the way we have viewed the six Presidents who served during the last quarter of the 20th century. During this time, with the advent of 24-hour news on cable television and the Internet, Presidents have been covered more intensively than ever before. It is a tribute to Diana Walker's original eye, superb technical skill, and unexcelled personal diplomacy that she has so often won exclusive, behind-the-scenes access to these leaders and used it—despite the intensive coverage—to show us hidden, heretofore-unseen facets of their personalities, character, and, sometimes, senses of humor. If you had no idea who each of these Presidents was before poring through this book, you would by the time you finished. Walker combines the sensitivity of an 18th-century portrait artist with the shrewd news judgment of a world-class journalist. She shows us the majesty of the Presidency along with the eccentricities and foibles of those who have held that office. Looking through her body of work, it is startling to recognize how many of Walker's photographs have become iconic images in our national memory. For a historian of the late 20th century, they show how, despite war, scandal, and public skepticism about their job, these five Presidents managed to a remarkable degree to remain human beings.

Start with Gerald Ford. Walker captures the small boy's hurt on the President's face the morning after losing a razor-close election he had expected to win. You realize that a politician less comfortable in his own skin might not have allowed himself to let the public see that pain.

Walker lets us see Jimmy Carter among politicians but, in his vivid body language, not of them—and conspicuously averse to the playacting with which most Presidents conceal their dislikes. Look at Walker's image of Carter and Vernon Jordan, another public man who wears no poker face, and you will suspect that these two men do not care for each other.

Walker's Ronald Reagan shows a capacity for expressing public sorrow unrivaled by any other President. But in Walker's version, he is also a vaudevillian. What other President could sport such a rakishly tilted hat and devilish smile without looking ridiculous?

Walker's March 1981 photograph of Reagan guffawing, seemingly without a care in the world, along with Vice President Bush, White House aides, and the just-retired CBS newsman Walter

Cronkite, assumes a special poignancy when you realize it was taken just weeks before the new President was nearly murdered at the Washington Hilton. After that almost-tragedy, Reagan's Presidency never seemed so carefree again. Nevertheless, in a later image, the President in open Western-style shirt bounds into the White House with a youthful exuberance that is probably not very different from the way the young Reagan looked as a lifeguard on the Rock River in Illinois.

In an iconic image at the zenith of his Presidency, with athlete's grace, George H. W. Bush flings an arm in salute to thousands of American soldiers he is about to send off to fight Saddam Hussein in Iraq and Kuwait. Look at the picture of Bush being kissed by his adoring daughter, Doro, and you will know that what is most important to him is family.

Walker demonstrates her versatility by capturing just as deftly the many-faceted Bill Clinton. In Paris, as a new President learning diplomacy, Clinton is an uneasy waxworks figure in a tableau of other statues in the form of his secretary of state, his envoy to France, his aides, and the French president. Climbing out of his limousine in Red Square, grieving over the death of his beloved mother, he is far more animated. Only a self-confident President like the Clinton of the second term would let Walker snap him in that extraordinary "speak no evil—see no evil—hear no evil" photograph with his secretaries of state and defense and national security adviser that you will find in this book. Even the cheerfully rule-shattering FDR would never have dreamed of cutting up in such a way with Cordell Hull, Henry Stimson, and Harry Hopkins.

Walker's rendition of Clinton with Nelson Mandela conveys the President's intense admiration and sense of connection with that legendary South African. Joining his close aides for an airborne card game, he is the jolly Arkansan, the large, mobile face almost unguarded in the presence of partners he trusts. And for anyone who doubts how much Bill Clinton loved his White House job, note Walker's image of him at the airport on the day he gave it up, walking stone-faced into the cold, uncertain future of his ex-Presidency.

Walker's five Presidents are the armature of this book, but there is more. We see Nancy Reagan at her most regal, struggling without success to conceal her distaste for Raisa Gorbachev. Wearing tennis shoes, the unpretentious Barbara Bush tends her dogs. In the backseat of a White House limousine, Hillary Clinton jokes with her chief of staff, showing her high-school-chum sense of camaraderie that her staff always talked about but the public rarely saw. The author's photographs of other key Washington figures over a quarter century take you evocatively back into past historical moments.

Thanks to Diana Walker's intelligence and superb craftsmanship, these images are now enshrined in our remembered past. As you examine image after compelling image, you will realize that had Walker not been photographing all of those Presidents for all of those years, we would have lost a part of our history..

<div align="right">—MICHAEL BESCHLOSS</div>

Sometimes, if one has the opportunity to shoot from outside the confines of the press pen, it's interesting to try for the back shot, though in the news business this can be a risky thing to do. But here, to me, it just seems beautiful.

— *D.W.*

"This is when I went to Africa in '98. This was Ghana. They were robing me for my speaking ceremony, and they were wrapping me in *kente* cloth. Hillary and I went to speak in the square. It was the largest crowd I addressed. It was nearly 100 degrees, and I was in this cloth, and people were swarming against the barricades. It was unbelievable."

— *Bill Clinton*

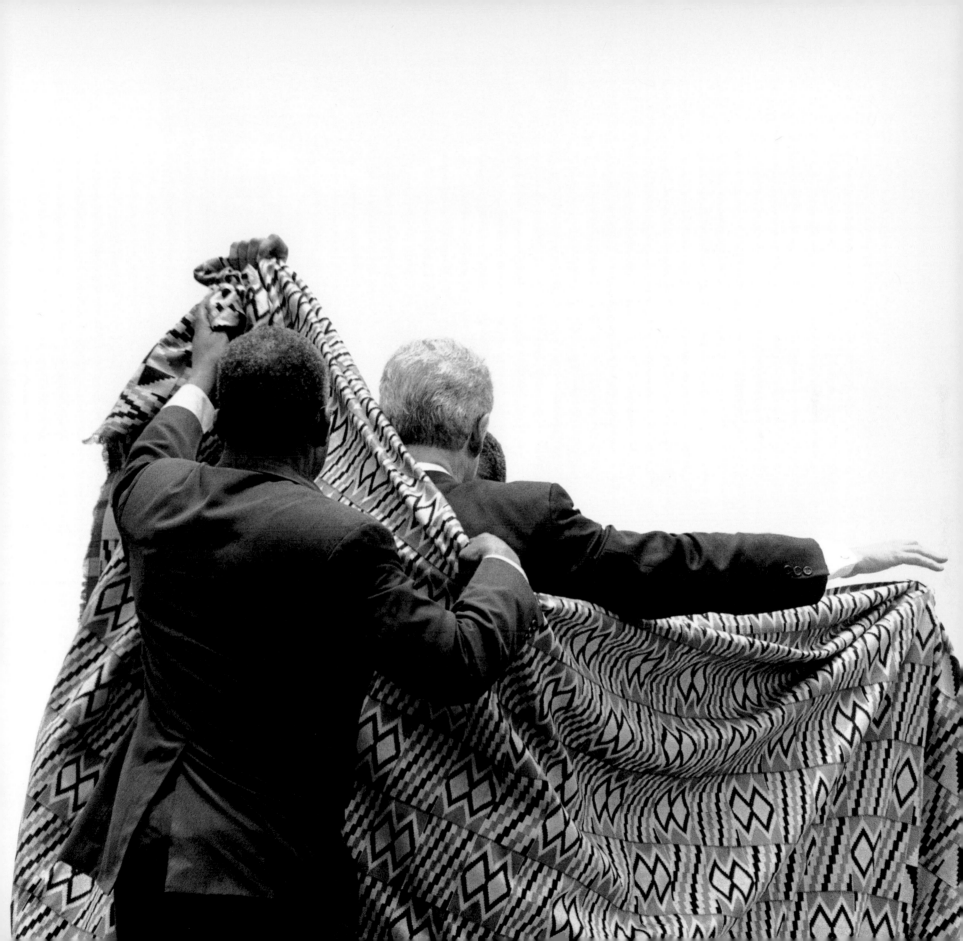

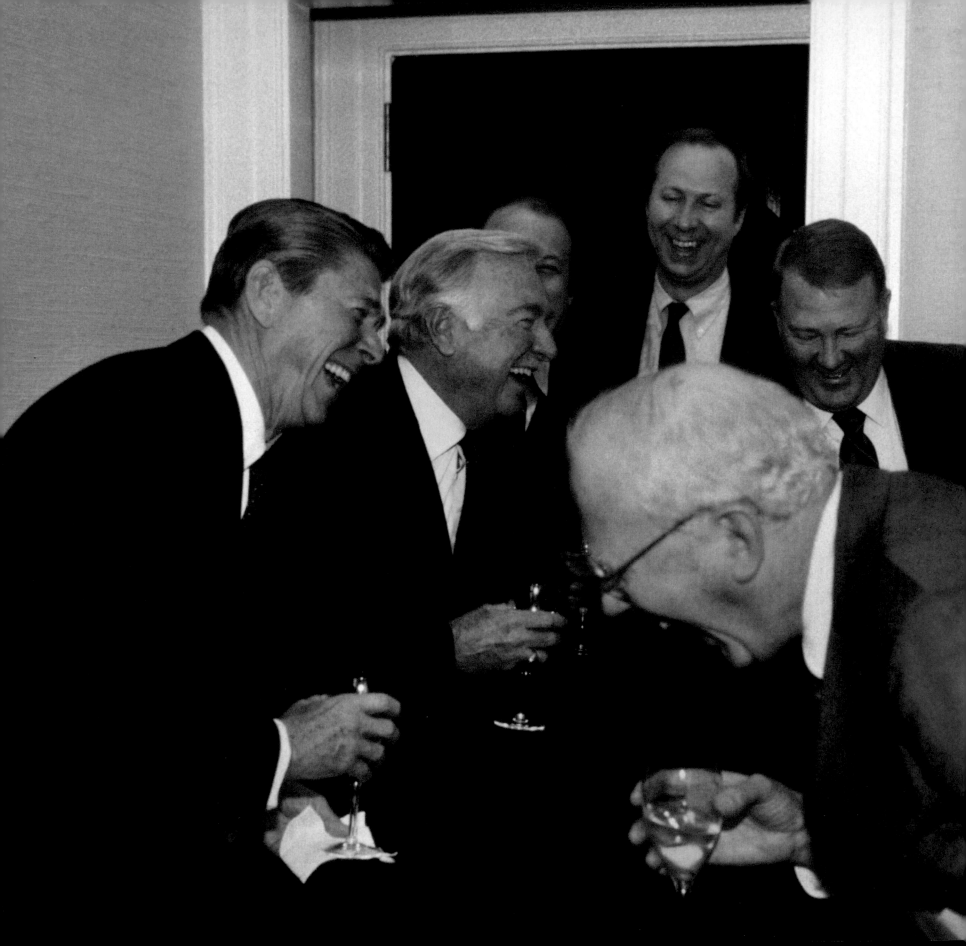

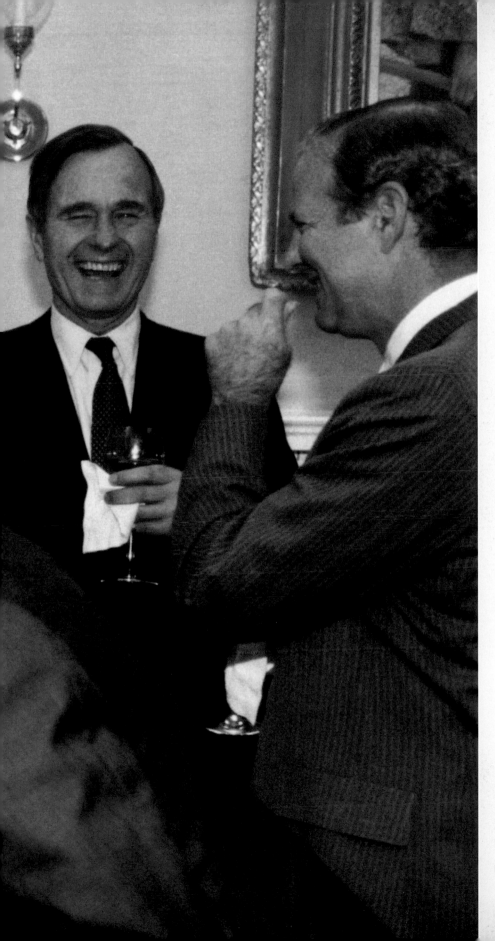

After Walter Cronkite's last interview with the President as the anchor of the CBS Evening News, there was a little celebration in the room off the Oval Office. I wish I had heard the President's joke.
— *D.W.*

"Reagan was the best storyteller of all kinds of jokes I've ever heard, ever met, with the possible exception of Al Simpson. I remember many luncheons just alone with Reagan, where he'd tell stories. I can't remember which one this was. One of the miracles of being a good storyteller is that you laugh yourself. And this is a good picture of that."
— *George Bush*

"Diana, I can't remember why we were so happy, but I'm glad you captured the moment in time— it will help as a reminder. Just as a hint, can you remember who said what?"
— *Ronald Reagan (1990)*

President Reagan, Walter Cronkite, Jim Brady, David Gergen, Ed Meese, Vice President Bush, Jim Baker, and CBS's Bud Benjamin, the White House, March 3, 1981

"This was at the dedication of the Reagan Library, with Jimmy Carter and George and Nixon. When we get together we don't spend time talking about issues. It's sort of a warm, friendly gathering. As you know, there are people who think we ought to have a formal organization of former Presidents. I'm vigorously opposed to that. Any one of these people can call the sitting President and talk to him or go see him. You don't have to have an organization. That would be another bureaucracy, and the Lord knows we don't need another bureaucracy in Washington. So these informal meetings are very enjoyable, constructive in a non-official way, and the net result is for whatever reason we get together, it's interesting."

— *Gerald Ford*

"When we all get together we relax and enjoy each other's company as much as possible. It's a matter of going out of our way to be very polite to each other; not raising any sort of controversial issues of the past; respecting the office that we've held; trying to be as compatible as possible. Of course, I didn't know Presidents Reagan and Bush very well, but President Ford and I probably have the closest friendship of any two Presidents, according to the historians. When I was President, I stayed in constant touch with both Ford and Nixon and got to know them well."

— *Jimmy Carter*

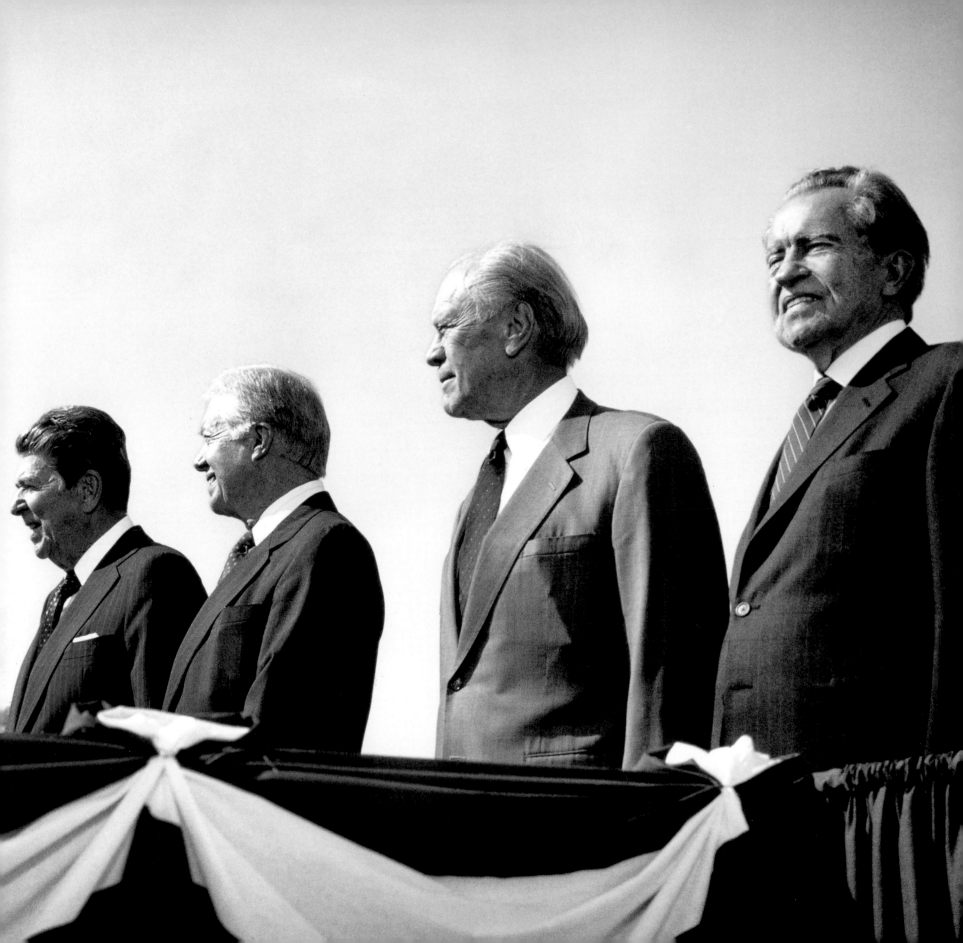

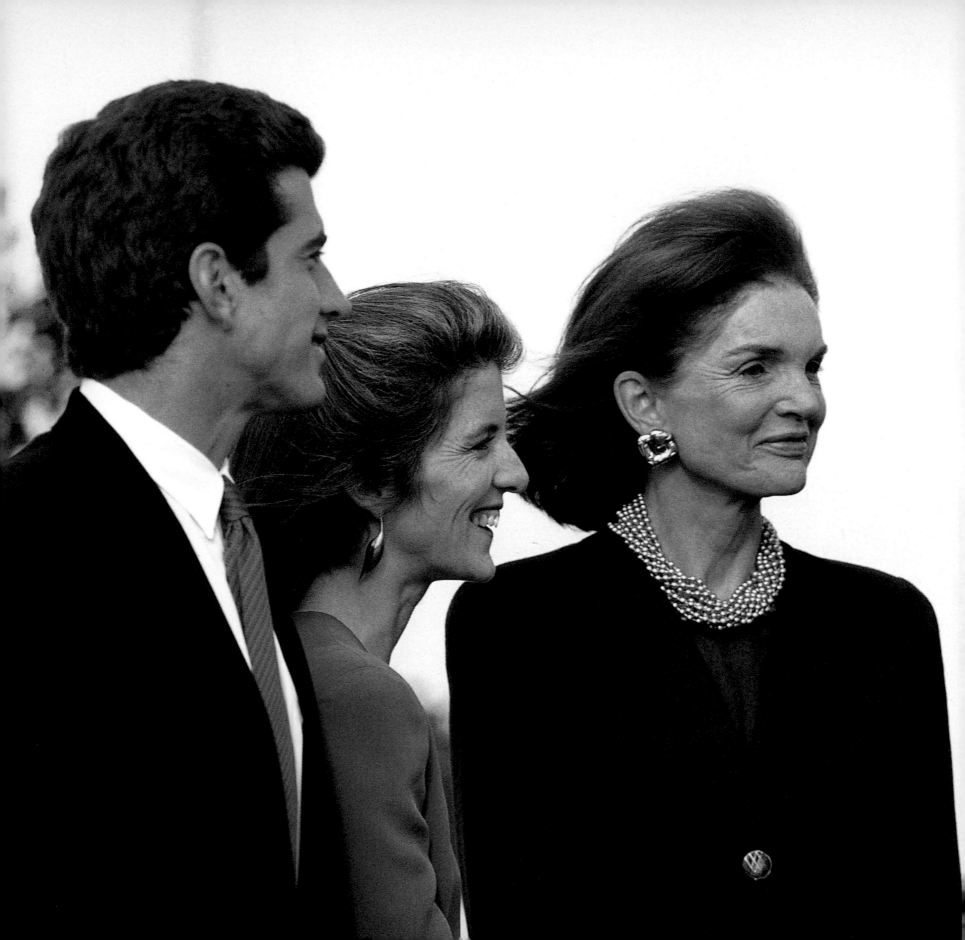

"More than any other woman of her time, Jackie Kennedy captivated our nation and the world with her intelligence, her elegance, and her grace. Even in the face of impossible tragedy, she carried the grief of her family and our entire nation with a calm power that somehow reassured all the rest of us.

"On a personal note, I'll always be grateful for her support of me in early 1992, and how she went out of her way to be helpful and kind to Hillary and to Chelsea in ways that are difficult to relate, but impossible to overestimate. When she passed away, I know that not only had our nation lost a treasure, but our family lost a dear friend as well."

— *Bill Clinton*

The Kennedy family with President Clinton at the dedication of the museum • **15**
at the John F. Kennedy Library, Boston, Massachusetts, October 29, 1993

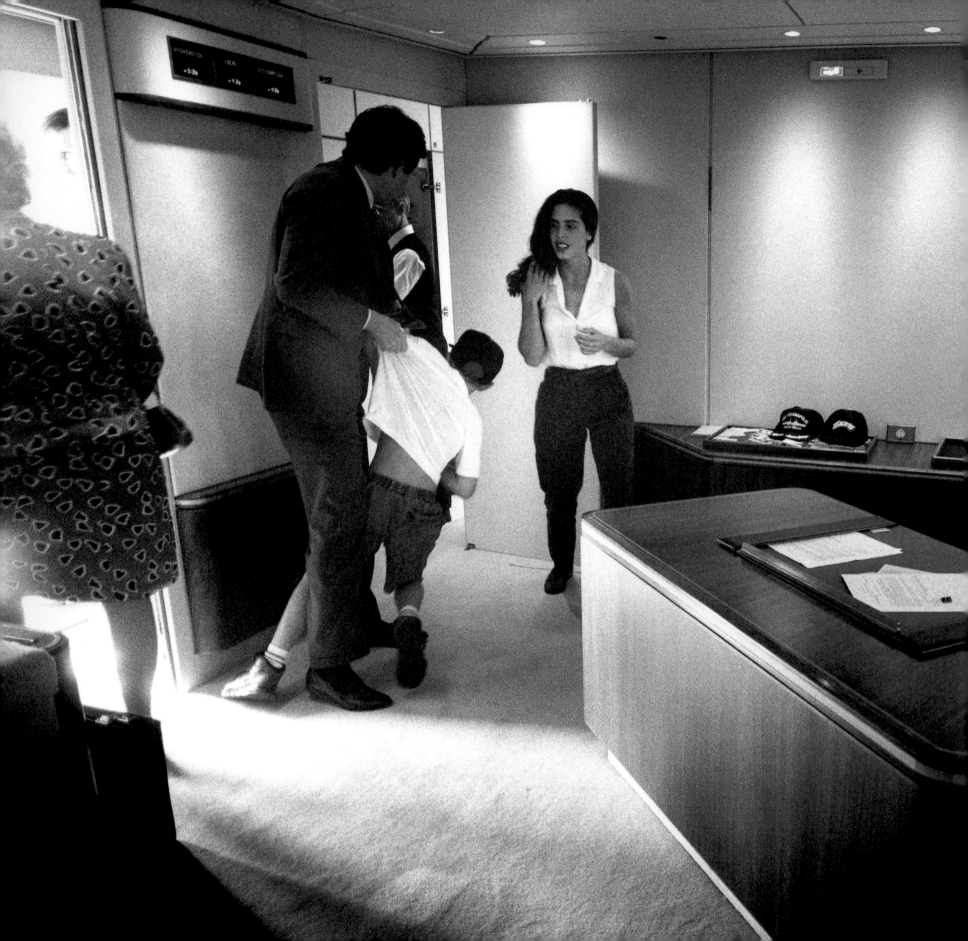

Having secured permission to photograph President Bush behind the scenes during the Republican convention of 1992, I thought this was a wonderful way to start the week in Houston. Walking into the President's office on Air Force One as it landed, I was amused to find several Bush grandchildren tearing around corners. Mrs. Bush was already almost out the door, and the oblivious President continued to study his notes for his next speech, without missing a beat. It reminded me of many a family, mine included. Just the setting was a little different. . . .

— D.W.

"This is my office on Air Force One, a beautiful presidential office. Behind Noelle is the presidential bedroom suite, which has a marvelous bathroom with shower. That's Marvin, grabbing the kids, saying 'It's time to go. Get yourselves ready.' Barbara's going out the door that leads to the exit of the plane itself, down the big stairway."

— George Bush

"I'm the only one ready, I can tell that."

— Barbara Bush

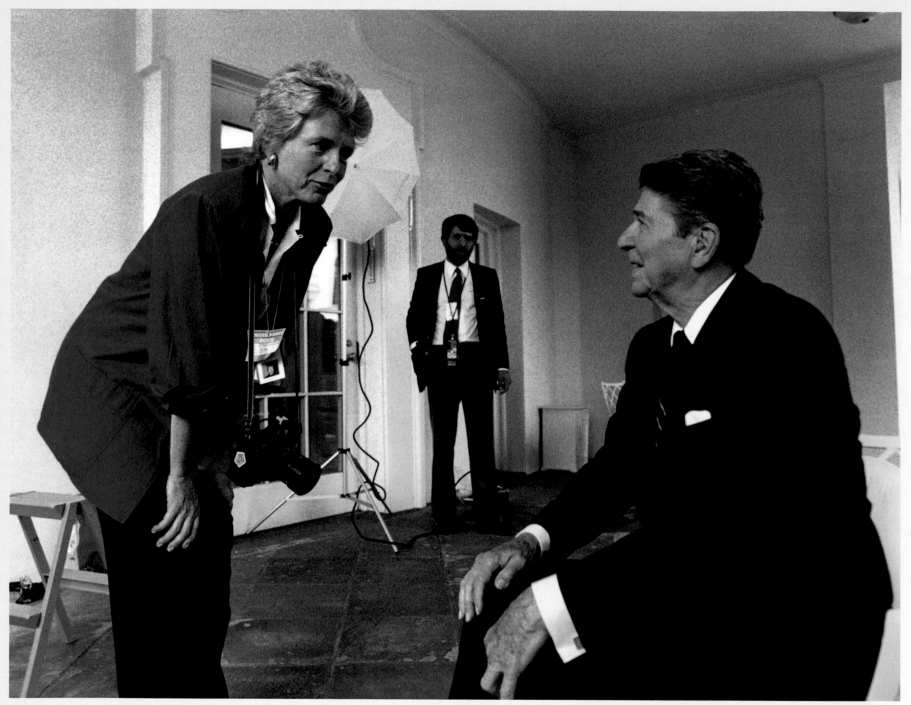

Bill Fitz-Patrick/The White House

Diana Walker and photo assistant George Hiotis with President Reagan, under the portico off the Oval Office, July 1986

Photographing the White House

IN THIS PHOTOGRAPH OF PRESIDENT REAGAN AND ME, I am asking him to tell me one of his favorite stories, an encounter between his mother-in-law and Mike Wallace. I was hoping for his characteristic look of humor and charm for my photograph to accompany *TIME*'s story for that week, "Why Is This Man So Popular?" He relaxed, sat back, and was his most engaging self. I remember that at the end of the sitting I told the President what fun I had had traveling with his wife during his first administration. Suddenly his face lit up and he began to speak glowingly about the First Lady. It was at that moment that I was able to capture exactly the expression I was after.

Looking at this photograph, I am still surprised to see myself talking to the President of the United States. When I was a child growing up in Washington, the closest I came to a President was on Inauguration Day. January 20 is my birthday, so as a present my family always took me to the Inaugural Parade every four years. Just growing up in the capital, however, gave me a certain sense of how politics, journalism, and public service intertwine to make Washington work, a familiarity that helped me in my career later in life.

But I had no idea when I was a child that I would end up having a life with a camera, traveling all over the world photographing heads of state. It sounds glamorous, but mainly it was hard work. There were times when I was lonely, exhausted, and down. But all in all it has been a great ride, and the pictures in this book remind me of much of a wonderful life. It helped that Mallory, my husband, and our boys, Willy and Taylor, encouraged me to go and were always there with love when I returned.

Appearances of the President of the United States, whether in the Rose Garden or the East Room of the White House or traveling from city to city or event to event, are prepared well in advance. There are toe markers where he should stand, lights to accommodate the cameras, even backgrounds with the appropriate logos or the message of the day. The staging of events is

necessary for his safety and to promote his agenda. Occasions when the President is in close proximity to the press, when unscripted questions can be asked of him, are carefully planned and strictly monitored by the White House staff. The press is positioned behind ropes or on risers or platforms, often quite far away. Thus an appearance by a President is often a performance, making it difficult and challenging to show in pictures much of his true character and personality. However, the pictures we take, even those taken with long lenses from a press pen, are important—the signing of a bill, the comfort being given to a policeman's widow, a handshake with a foreign leader—and keep readers of our newspapers and magazines informed of the President's activities and give some insight into his personality.

Our days are spent waiting in the White House press room for 50-second photo opportunities or piling into a van in the President's motorcade for an event at a nearby hotel. We keep our eyes on him constantly, especially when he is more at risk out in public. We travel wherever he goes, either on Air Force One or on a chartered press plane. Although we are competitive with one another, always looking for the best picture, we cooperate, and we have an informal protocol of who goes first into the Oval Office. On the road, especially traveling abroad, competition with the foreign press can be fierce, and sometimes whoever has the tallest ladder—a staple for photographers—wins. But we share information among ourselves on the technicalities—the exposure, the lenses, how best to ship film, or the best way out of a computer glitch while transmitting pictures.

Traveling in presidential motorcades with my newsmagazine colleagues, while always watchful for an impromptu stop by the President to greet a roadside crowd, I learned all about fly-fishing, turkey shooting, and French wine. I also learned a lot about shooting pictures. When "the picture" at the last event was described, I always silently despaired that I hadn't shot it that way, or I had missed it. And of course I wouldn't know until the next week. My film went to New York, where it was processed, edited, and presented to the editors who would choose what, if anything, would appear in next week's *TIME* magazine. I would speak by phone to my picture editors, either telling them what pictures I thought they should be looking for or worrying about being out of position or underexposed. But the editors were always aware of what the story was, keenly aware of what a good picture was, and understood the difficulties we sometimes encountered. They didn't want us to miss anything, however. I knew if I'd made a good picture, they would find it. It is a great feeling to open up *TIME* on a Monday and see an image you didn't know you had, spread across the page. It continues to be an enormous thrill.

TIME began to ask the White House for further opportunities for me to photograph the Presidents "behind the scenes," away from the lights and mikes, with no other photographers present save for the official White House photographer, who is always there. Our objective was to show our readers more of who the President really is, what he does, how he interacts away from the public

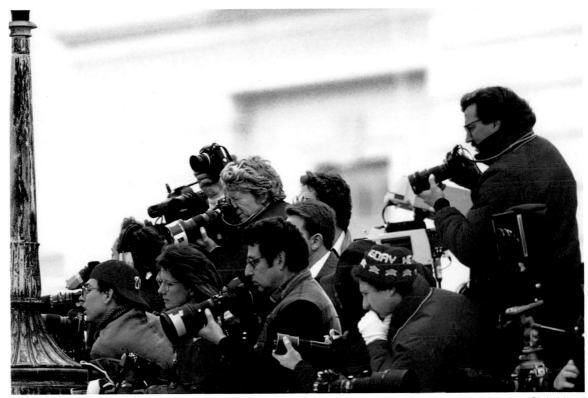

eye. These photographs would be shot in black and white for several reasons: First, the film is archivally stronger than color; second, black-and-white film is faster and thus requires less light, allowing us to forgo bothersome strobe lights; and third, it could signal to our readers that somehow the pictures were special, more intimate, and exclusive to us.

At the start of George H. W. Bush's campaign for reelection in 1992, the White House granted our requests for me to to take exclusive pictures for *TIME*, on specific occasions. I would enter and exit the room at the staff's bidding, never staying more than a few minutes, often using quiet range-finder cameras. I tried never to have conversation or eye contact with the President. I never repeated what I heard in these meetings, even to our own correspondent. I made up my mind years ago that photographers see, they don't hear. This was my mantra, and when some of my colleagues argued this point with me, I would remind them that when I shoot I am concentrating so hard that I don't hear. Oh yes, I pick up a word or two, or a tone, a sense of the mood, but to try to report what I heard would be pure folly. Reporting was not my job when I was photographing Presidents and First Ladies behind the scenes.

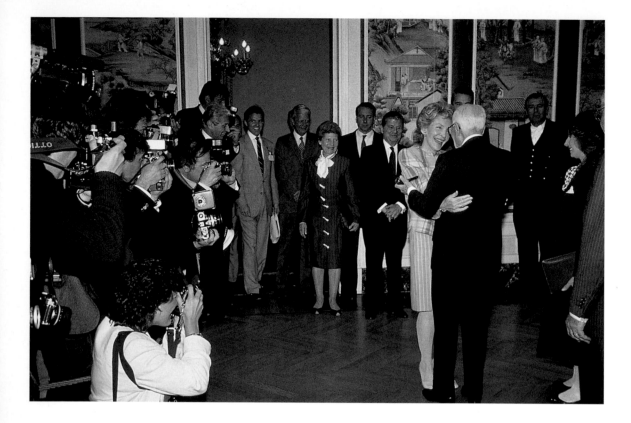

I believe strongly in the importance of this kind of photography because I think such images are as close as a photographer can get to what is real about a President. Observing relationships—a touch, a laugh, an attitude in private—can be illuminating. Even something as simple as President Bush moving furniture to make room for visitors, President Reagan writing a State of the Union speech on a yellow pad, or President Clinton showing exasperation at a less-than-perfect report can give us insights about our elected leaders.

Am I being manipulated by a staff interested in having their President featured the following week in *TIME*? Of course I am. But although the staff and the President himself have decided to allow me in, the White House never has any editorial control over our pictures. What happens when I am there is just what happens. These people are not acting. When I am allowed special access I am going to do my damnedest to take advantage of that access on behalf of all who want to know more about a President, the office, and how it works. This behind-the-scenes work has been the most satisfying of my career, and I am grateful to my editors for making it possible.

Photography had been my childhood hobby. Some girls played jacks and went to the

Nutcracker; I mixed developer and stop baths in my basement. Years later, after photo editing my school yearbook, being starstruck and acting in college productions, and working as a roving assistant at *Vogue* magazine, I married Mallory. We settled where we both had grown up, in Washington, and were bringing up our two boys. I was working part-time for my mother, who had a small dress shop in Georgetown. I had an interest in politics and had worked in the campaign of 1960, while I was in college, and in the 1968 campaign. I also learned much from spirited discussions with my father, a physician, who vehemently opposed our participation in the Vietnam War. My only direct exposure to politics was through our journalist friends and pals who had come to Washington to work in government.

I am someone who didn't get herself into her real profession until her early 30s, and I had to be pushed. Photography was still my hobby, but a life as a professional photographer had not been a serious consideration until a dear friend urged me on. She and I started a business together, shooting weddings, bar mitzvahs, and book jackets, until I was hired by the *Washington Monthly* magazine. I got $25 for every picture used, the ability to freelance, and credentials with which I could shoot on Capitol Hill and at the White House. This was a perfect deal for me. I'd shoot events on spec, build up a portfolio of photographs and tear sheets, and get on the train for New York, where I would visit photo editors who would either give me work or wouldn't. I'm still waiting for *Ms. Magazine* to call back! I eventually arrived at *TIME, People,* and *Fortune,* and I began to work steadily for *TIME,* going on contract in 1979.

Breaking in to the life of a White House photographer in the late seventies was tough. Back then there were few female photographers covering the President. I felt a little removed and irrelevant, as I wasn't good at the technical talk, I wasn't familiar with the dos and don'ts at the White House, and I wasn't any good at discussing the Redskins' new quarterback. I had few connections with other photographers, having had no previous experience in newspapers or the wire services. But eventually I came to be accepted. In photojournalism the evidence of whether you have it or not is in the picture printed (or not printed) on the page.

Early in my career I was sent over to the White House occasionally by the *Village Voice* or the *Washington Monthly* to photograph President Ford. Later, when I began to receive assignments from *TIME,* I went more often to cover President Carter and was sent along on trips with Rosalynn Carter. It was an excellent way to break in to presidential coverage, as traveling with a First Lady is similar in many ways to being with the President, except that the entourage is much smaller, and access to the First Lady is much easier and closer. My first foreign trip for *TIME* was to Thailand, where Mrs. Carter visited Cambodian refugees who had escaped the Khmer Rouge and settled in camps over the border in Thailand. It was a thrilling assignment for the new kid on the block. In 1983–84 I covered Walter Mondale's campaign for the Presidency, after which I came back to the

White House, where I worked on a rotating basis with my *TIME* colleagues through the final days of the Clinton Administration.

I started off the Reagan years following the First Lady. As low person on the totem pole, on international trips I would often do the evening assignments, and what fun that turned out to be for me. I enjoyed witnessing such wonders as the pageantry of Queen Elizabeth's banquet for 90 guests at Windsor Castle, an evening in Moscow at the Bolshoi Ballet, or an elegant dinner for the Reagans hosted by the Emperor of Japan.

I am often asked what it is like to be around a President of the United States. Do I have my favorites, after covering the White House for so long? Do my own political beliefs intrude? The truth is I have enjoyed every administration. I have learned much about the character of our Presidents from photographing them. For instance, I remember a Friday afternoon in 1985 when I was in the Oval Office, attempting to take an important lead picture of President Reagan. Our courier was waiting outside the door to take the film to New York for a story closing that night. Tension was high as I placed the President next to his two new appointees, the chief of staff and the national security adviser. Backing up to begin the shoot, the clock ticking, I knocked a carafe of water off the President's desk. To my horror the presidential seal on the rug turned dark and soggy, and stewards appeared from every door to clean up the mess. Seeing and hearing how embarrassed I was, the President kindly remarked, "Well, at least it wasn't tomato juice!" I thought to myself, "What a guy" and pulled myself together and began to shoot.

When President Bush was in Gdansk, Poland, with Lech Walesa, a small pool of photographers was allowed up on the stage behind the presidents and their wives. We had asked to be there, expecting the presidents would turn around and wave at the crowds of people who were hanging out of windows behind and above them. This would be a wonderful picture. I was ready when the Bushes and the Walesas turned our way, but when I pushed on the shutter release, it went nowhere. I was out of film! As I feverishly switched lenses with camera bodies and pulled my camera up as fast as I could, the presidents had turned back to face the audience. I had missed the picture. Without thinking, I called out, "Mr. President, sir, please, just one more time?" And around he turned, bringing the Walesas with him, raising his arms to wave, calling out, "How's this, Lady Di?" I was saved, and the picture ran in the lead of *TIME*'s world section the following week. How grand he was to do that. And so much for my vow never to ask or interfere in the action in front of me.

President Clinton knew how I worked behind the scenes. He knew I wanted to remain removed, and we almost never conversed. I was standing in a hallway at Robben Island, where he and President Mandela had just visited the cell where Mandela had been incarcerated for all those years. I was extremely moved by what I saw, and more in awe of Nelson Mandela than ever. Suddenly Clinton spotted me, and he called me to come over to where he was standing alone with

Mandela. He introduced me to President Mandela in a most lovely way, and that moment, that handshake and exchange of words, will be with me always. It was an extraordinary kindness of President Clinton, simply out of the blue.

As to whether my own political beliefs have any bearing on my coverage of Presidents, perhaps I will let this book answer that. How journalists vote is not an issue. Of course we photojournalists must keep ourselves informed of who's who and what's what and try to understand the subtleties of politics and where the President is on issues and relationships so as not to miss a significant action or a telling moment between leaders. Each President has his own way of dealing with the press. In some ways I think they all prefer photographers: We don't ask questions, we don't take notes. They understand, I think, that photographers simply want to make the best pictures they can.

I hope this collection of pictures I made of the Presidency indicates progress in my work as a photographer, and I hope my progression from the open photo op to the behind-the-scenes work demonstrates the merit of that kind of exclusive photo opportunity. The photographs were not chosen for their historical importance, nor are they presented in chronological order. They are simply pictures I like. Over the years I have worked with many photographers I respect and care for, many who do what I do, but better. What each of us brings to our work is part of who we are, our own point of view, made from our own life experiences. Once in a while, when you have the experience of all things coming together—the light, the action, your position, your equipment— and you squeeze the shutter, you feel a thrill; it's like "bingo!" Getting it right brings enormous joy and satisfaction. The great Henri Cartier-Bresson tells us in an interview in *Dialogue with Photography,* a book by Paul Hill and Thomas Cooper, "To take photographs is to hold one's breath when all faculties converge in the face of fleeing reality. It is at that moment that mastering an image becomes a great physical and intellectual joy....It is putting one's head, one's eye and one's heart on the same axis."

I have never known a photographer who didn't love to take pictures. What a luxury it is to love your job, as I have loved mine. Certainly we photographers are far from principal players, but we are necessary and important to the dance because we bring what we have seen to the public in the best way we can. This book is my particular view of our leaders and other important figures in Washington over the last 20 or more years. It has no backstairs stories, no political comments or criticisms. It is simply the Presidency and how I saw it. The former Presidents and First Ladies graciously agreed to look at many of the photographs for this book and contributed their memories of some situations pictured herein. I am deeply grateful to them for their participation and for all of their kindnesses throughout the years. Perhaps when you are finished with *Public & Private* you will know the former Presidents and First Ladies better, see more of their humor, their humanity. This is what I have tried to do in my pictures for as long as I can remember.

1974-1976

THE GERALD FORD YEARS

Going to the White House for the first time was intimidating. All I could do was follow the other photographers around and make sure there was film in my camera. I never was first through a door or fast enough to get a good position at a ceremony. I was a beginner, and did I make mistakes. As you can see from these images, I was so new to it I was cutting off the Fords' feet (page 29). Not only did I need to become a better photographer, I had to learn the drill at the White House. The first rule was the most obvious: Be respectful and courteous toward the President and the First Lady, their guests, and their staff. The same went for my fellow journalists, and I had to try to remember not to jump in front of someone else's camera. Learning to maneuver around the Secret Service was key. Don't argue, just move. Each time I popped in to the White House, shooting for a variety of magazines, I learned something about where to stand or how to shoot. This was my introduction to photographing the Presidency, and the Ford family's distinct congeniality made it a wonderful way to start. Gerald Ford embodied calm and integrity, and the country's relief after Watergate was palpable.

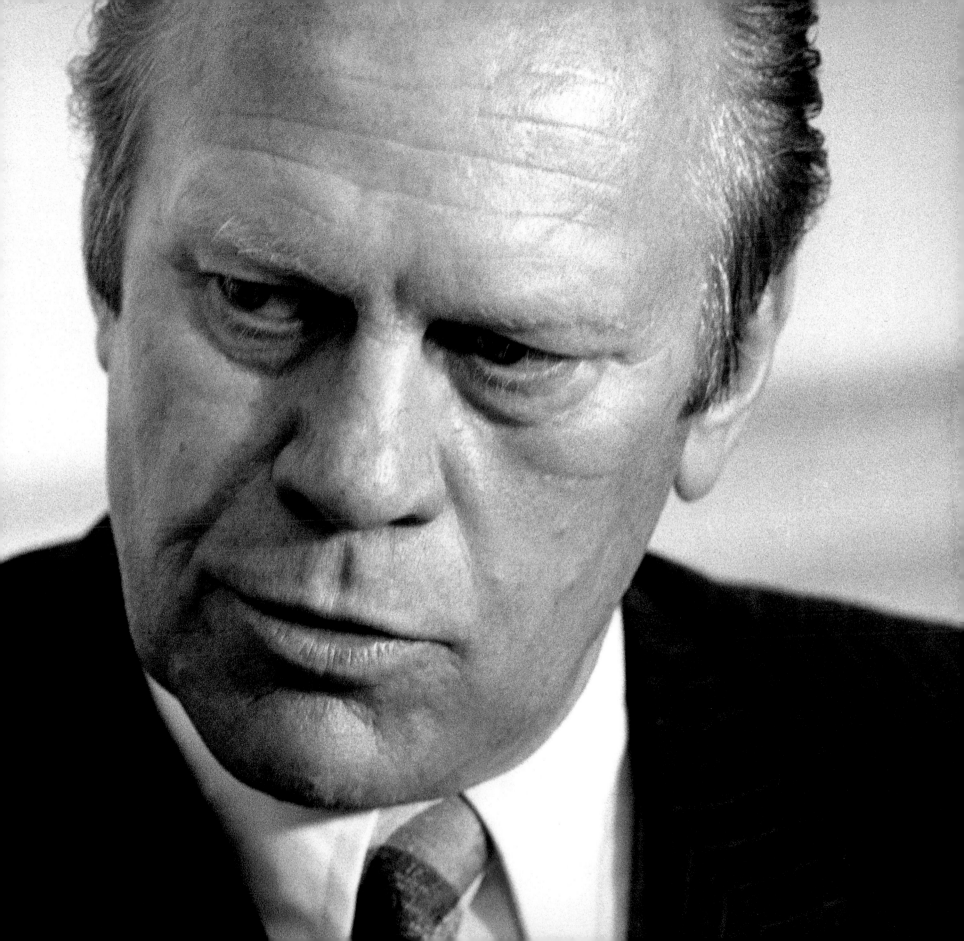

"I knew Lyndon very well. When I was in Congress and he was President, we had many differences, but my wife, Betty, and I always loved Lady Bird. We see her off and on when we go to Texas. So Lady Bird is a favorite of ours, and we were, and are, excellent friends." — *Gerald Ford*

"We were walking out to greet Prime Minister Rabin of Israel, an outstanding prime minister. I wish we had him today. Rabin and Sadat were the outstanding pair that produced the Sinai II agreements."

— *Gerald Ford*

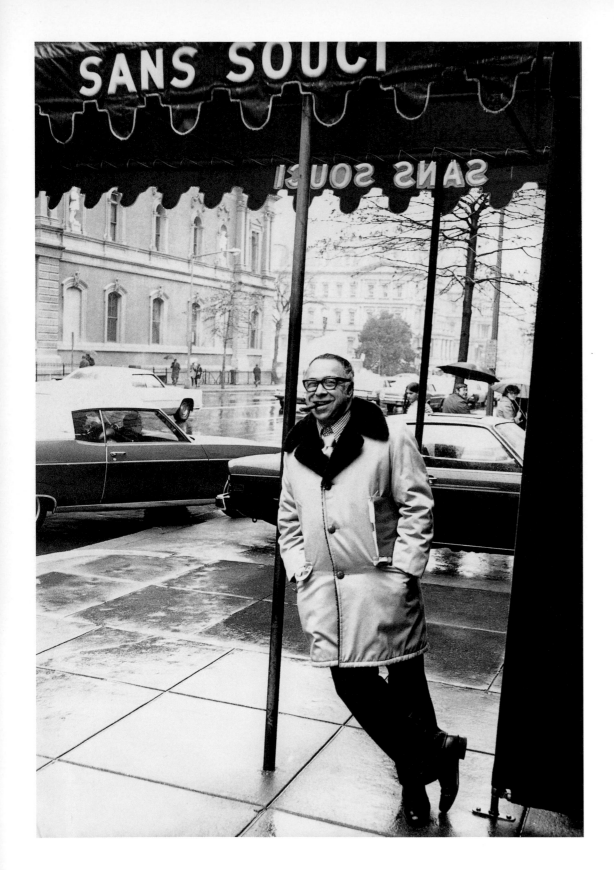

Art Buchwald doesn't need a caption on his picture. We know who he is: a beloved writer of humor who continues to make us smile. He's also the best friend you could ever have. On any day you could find him at his regular table at Sans Souci, his favorite restaurant in the seventies, with perhaps Mary McGrory, Edward Bennett Williams, and George Stevens, Jr. nearby.

— *D.W.*

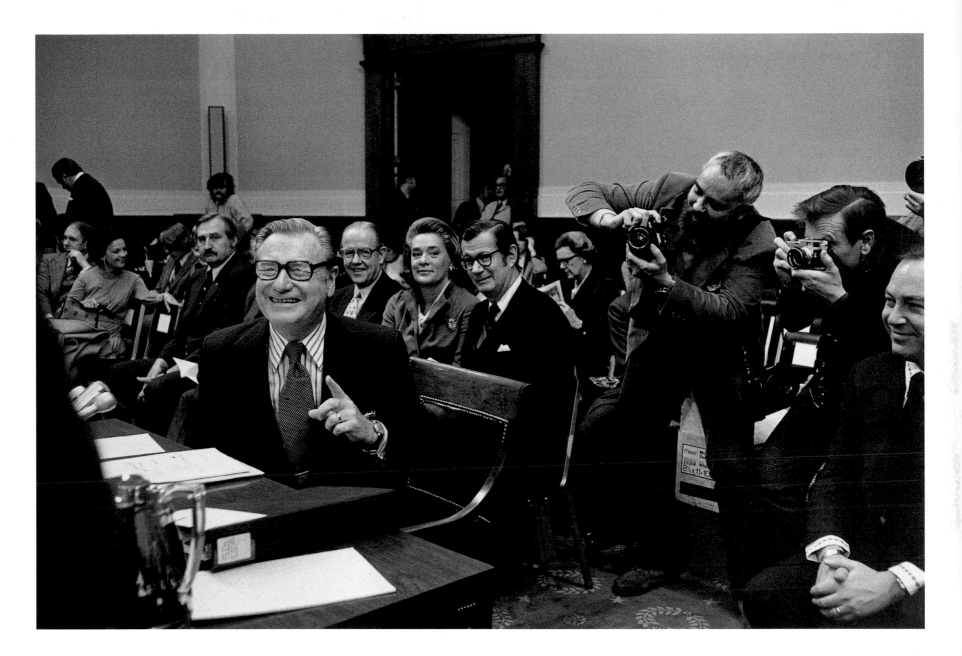

"Nelson Rockefeller and I were good friends but not intimate friends. We were good political friends and allies because we represented the moderate wing of the Republican Party. I was pleased that he accepted my recommendation that he become Vice President."

— *Gerald Ford*

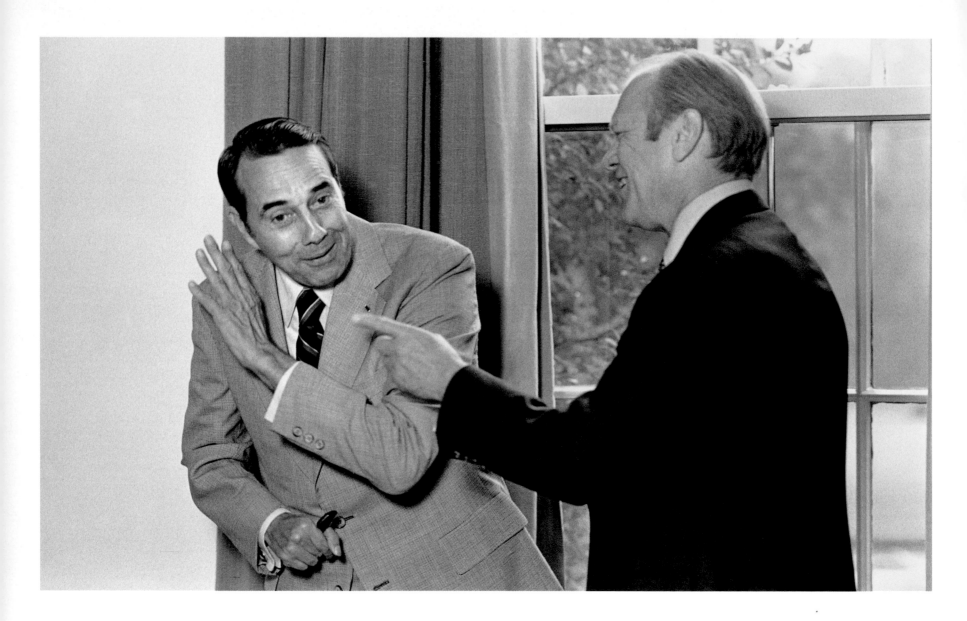

"I picked Bob Dole as my vice presidential candidate in '76. He turned out to be a very good partner,

despite the press. He and I carried every state west of the Mississippi except Minnesota and Texas.

Dole was an important factor in that result. He's a nice guy, great sense of humor."

— *Gerald Ford*

"Nixon decided Kissinger could be both secretary of state and head of the NSC [National Security Council], and when I became President I inherited that relationship. I thought that was a conflict of interest, because the NSC is supposed to be a monitor of proposals that come to the President from all departments, a think tank for the benefit of the President in deciding what Treasury, State, and others wanted. About a year after I became President, Henry agreed to give up the NSC and become only secretary of state, and I made Brent Scowcroft head of NSC."

— *Gerald Ford*

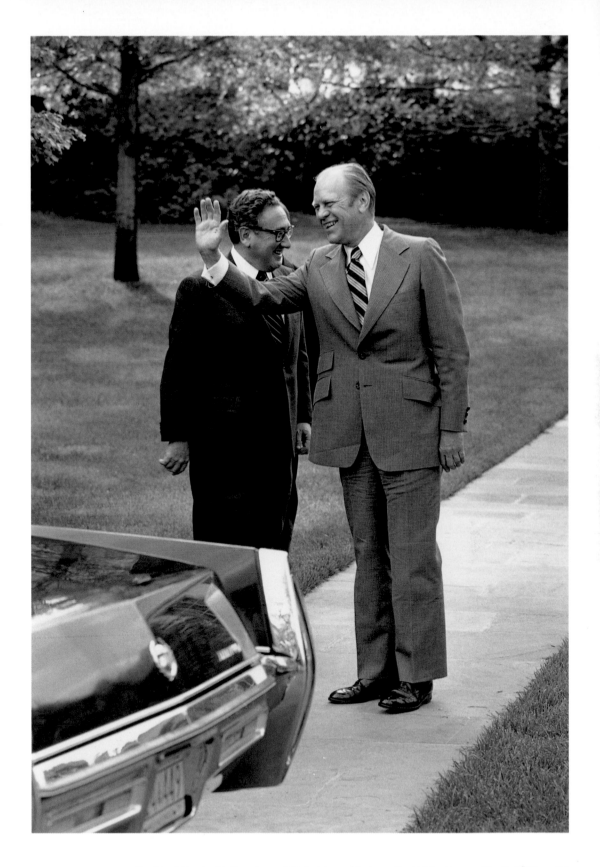

President Ford with Secretary of State Henry Kissinger, the White House, May 7, 1975 • **33**

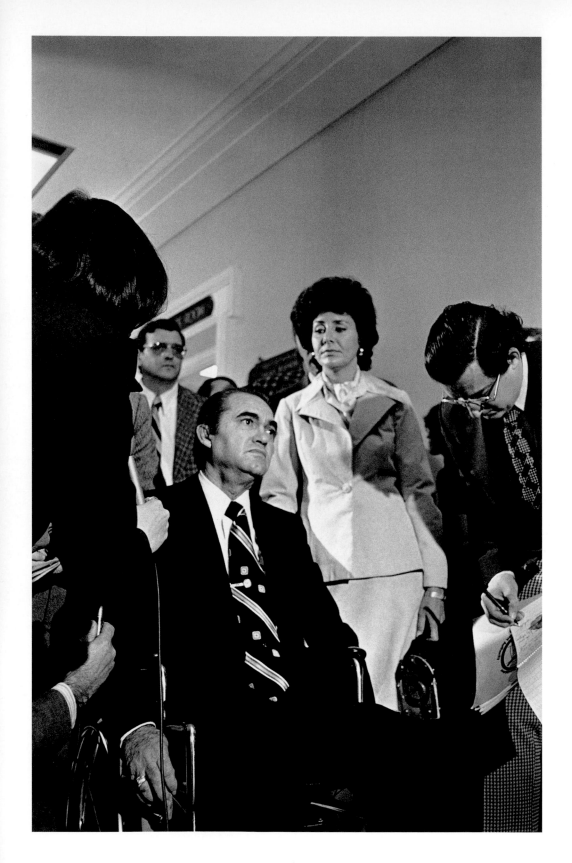

I had seen George Wallace once before, by chance, many years before he was shot, campaigning with vigor on a flatbed truck down in Talladega, Alabama. Turning the corner after finishing an assignment on the Hill, I was surprised to find him in the halls of Congress that morning. I was struck by the expressions of sadness and pain on the faces of Governor Wallace and his wife, Cornelia, as they spoke with the press.

— *D.W.*

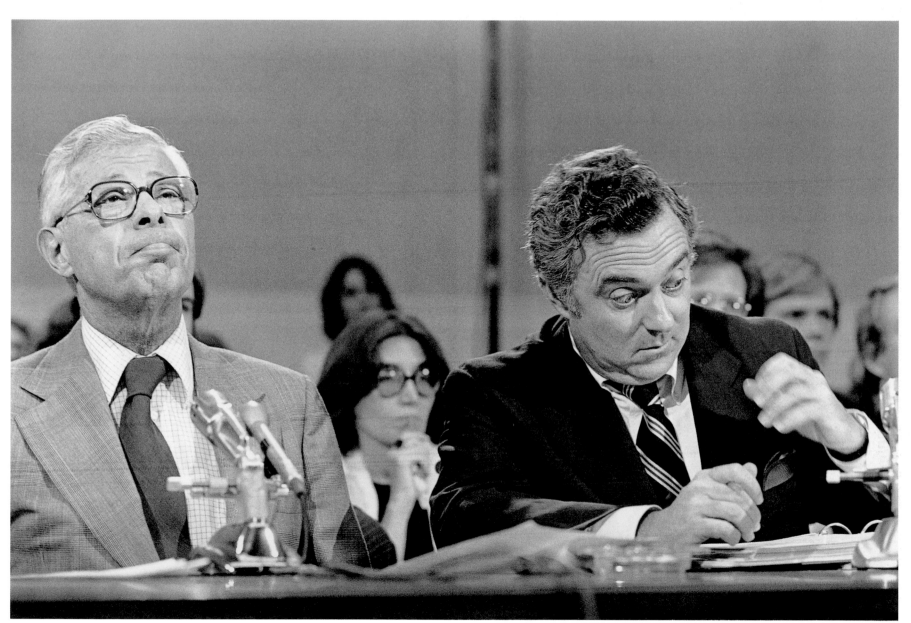

Daniel Schorr, appearing before the House Ethics Committee with his counsel, Joseph Califano, refused

to divulge the names of sources who provided him with a copy of the Pike Report, a confidential and

secret House investigation into suspected illicit activities of the CIA and FBI. Schorr's copy was published

in the *Village Voice*. The committee finally rejected proposals to cite Schorr for contempt. — *D.W.*

Sometimes a public moment can appear to be a private one. To all the world, this might look like a private stroll in the Rose Garden by the Emperor of Japan and President Ford. Who would know that at least 30 Japanese and American journalists and photographers were crowded behind ropes in the driveway, jostling for position to get a clear view of the emperor's departure.

— *D.W.*

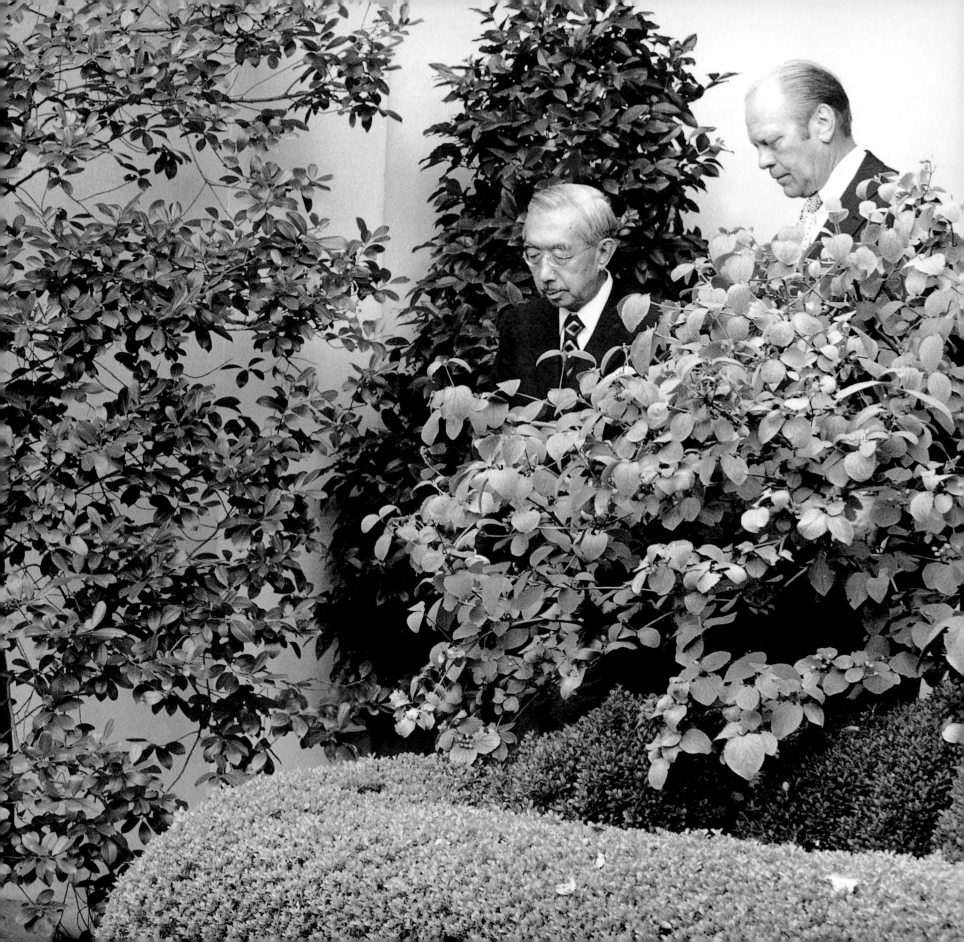

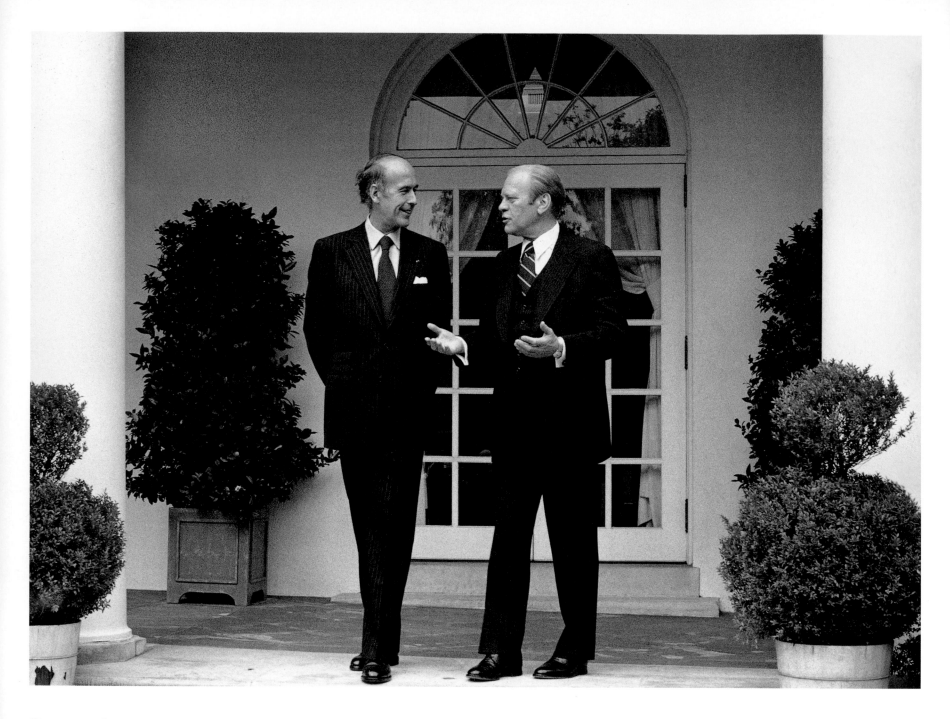

"In 1975, when the United States had energy and economic problems, plus the goblins of Watergate and Vietnam, Giscard of France, Helmut Schmidt of West Germany, Harold Wilson of Great Britain, and I started the G4. Giscard comes to a forum that I have in Vail, Colorado, every summer. After that, he and his wife usually rent an automobile and drive around the United States." — *Gerald Ford*

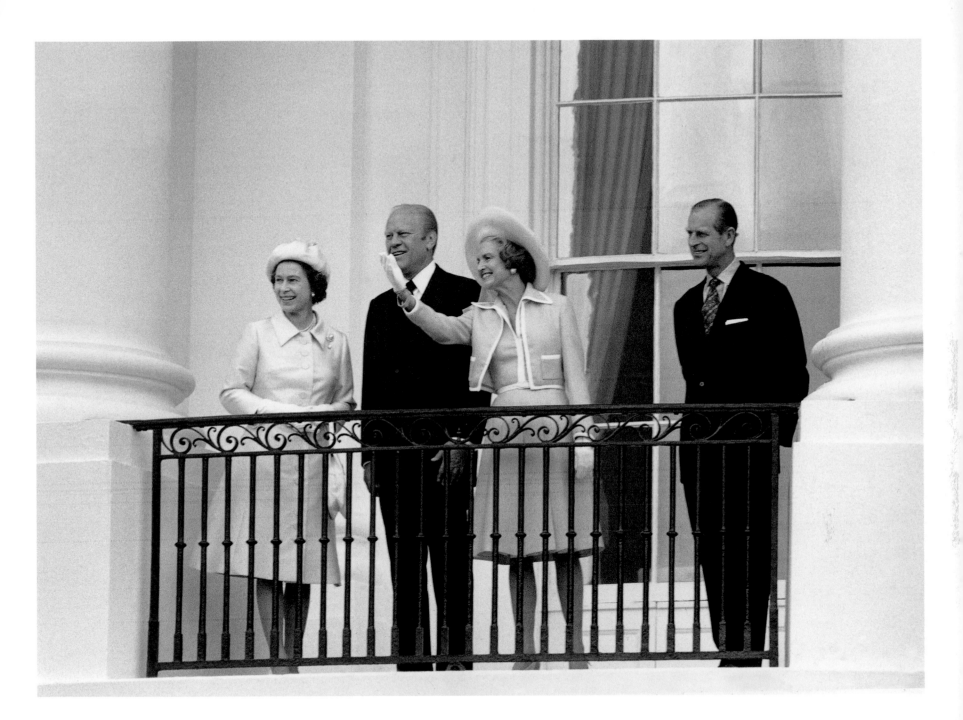

"We took Her Majesty and the Prince up in the elevator to the private quarters, as is customary before a state dinner. The door opened and there was our son—I won't mention which one—standing without his shirt on. Betty and I were embarrassed. Her Majesty said, 'Don't worry, we've got one just like that.' " — *Gerald Ford*

The morning after the election of 1976, President Ford, who had lost his voice in the last days of the campaign, listens as Mrs. Ford speaks for him. The press room was jammed, and I remember thinking how brave and dignified the Ford family was. Questions from the press focused almost instantly on whether and just how much Ford's pardon of Nixon had affected the outcome of the election. — *D.W.*

"It hurt deeply to witness the disappointment and regret my husband suffered due to his loss. It was hard to hold back the tears as I spoke—but we as a family knew we must stand tall and congratulate Governor Carter and his family and the country for a just and fair election." — *Betty Ford*

"The reaction of the public to my pardon of Nixon was worse than I anticipated, I have to be honest. But I never wavered. I think today, even more than I did then, it was the right thing to do. People said, 'Why didn't you wait until he was indicted, or wait until he was convicted?' 'Why didn't you wait until the Supreme Court decided whatever it would decide?' That would have meant for the next two years the issue of a possible pardon would still be the press's interest, and we had to get that off the agenda and work on more important problems affecting the economy." — *Gerald Ford*

40 • President Gerald Ford, with son Jack and daughter, Susan, the White House, November 3, 1976

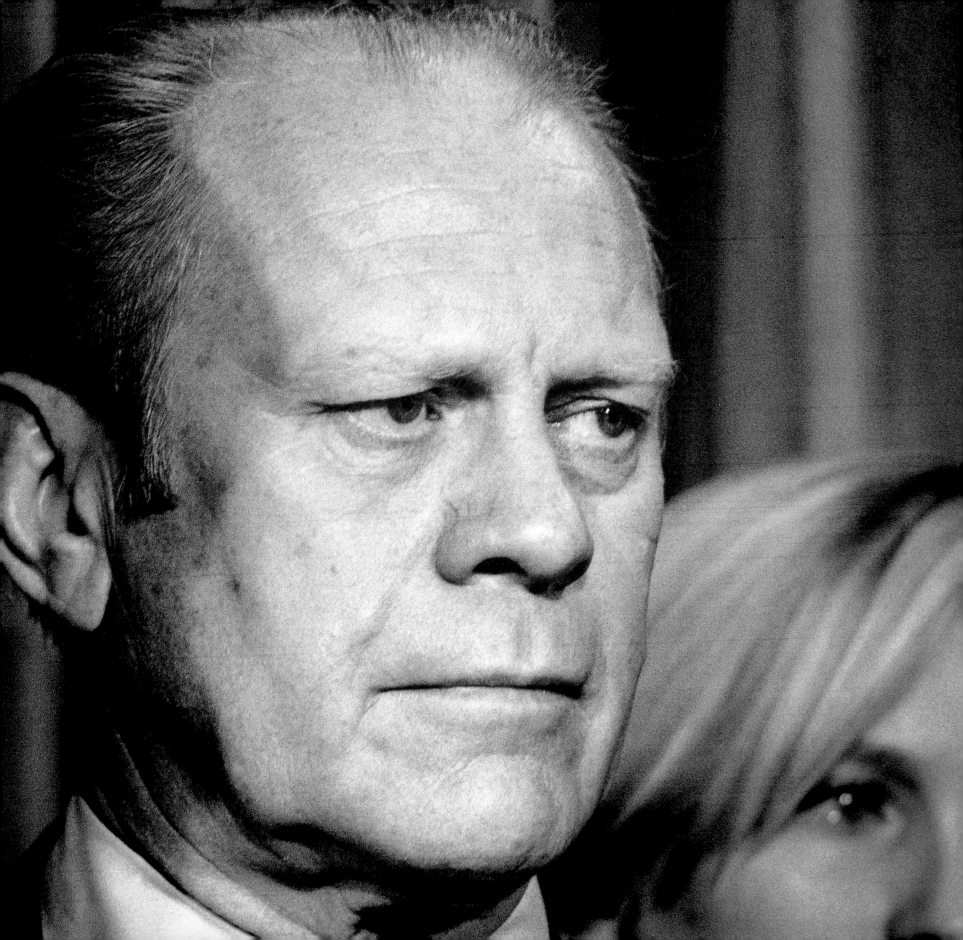

1976-1980

THE JIMMY CARTER YEARS

In the late seventies I was freelancing for *TIME*, substituting at the White House when needed, and doing general assignments around town. My first presidential trip was to several western states with Carter. Earth Day in Denver took on huge meaning for me, as getting there was my first trip on Air Force One. After the American hostages were seized in Iran, President Carter stayed in Washington, trying to obtain their release. I was asked by *TIME* to follow Mrs. Carter as she traveled abroad and visited all the states where primaries were to be held for the election of 1980. Mrs. Carter was impressive always, representing the United States and the President with dignity and true grit. I distinctly remember her defending herself to a cheeky journalist in Boston who asked how she had the nerve to come to Senator Kennedy's state, since he might challenge the President for the nomination. Without missing a beat she replied something like "May I remind you that my husband is the President of Massachusetts, too." Back in Washington, my view of President Carter was colored, I think, by the gravity and stress that I felt showed in his face and demeanor during the hostage crisis, which unfortunately lasted through his final days as President.

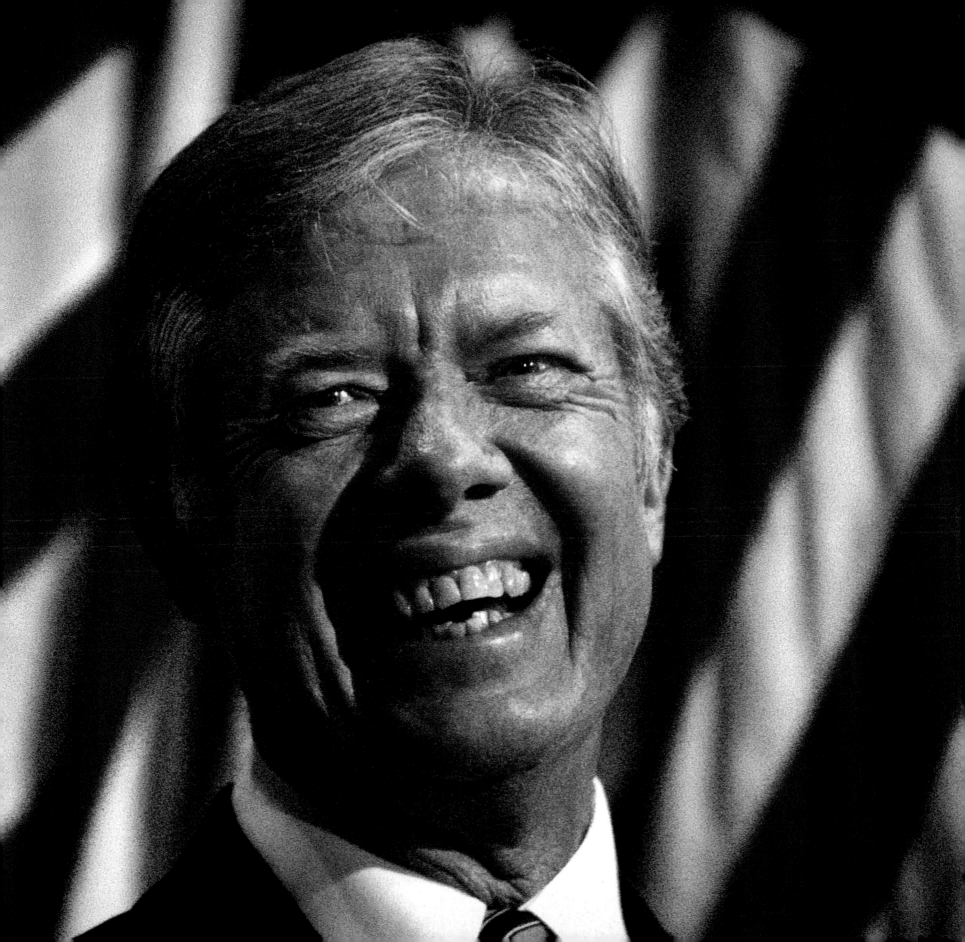

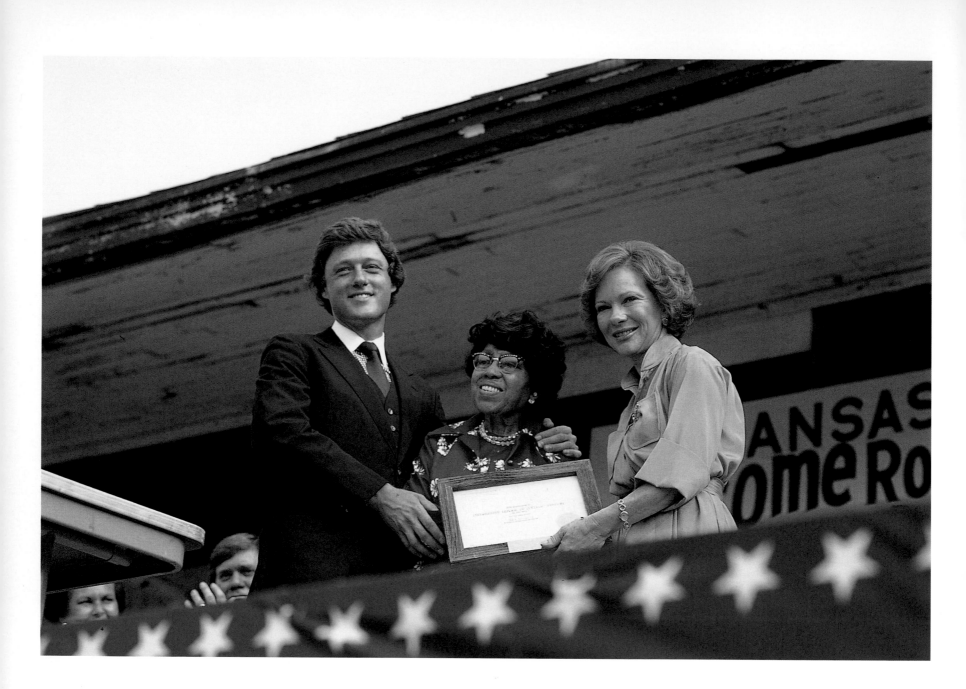

When I followed Rosalynn Carter on a trip to Pine Bluff, Arkansas, I don't think I even knew the name

of the governor standing here with civil rights pioneer Rosa Parks. When I uncovered the picture in

preparation for this book, I was so surprised. — *D.W.*

I remember being struck that night at the convention to see Senator Kennedy, who had challenged

President Carter for the nomination, raise his clenched fist. His speech to the delegates earlier in

the week has been called the greatest of his career. — *D.W.*

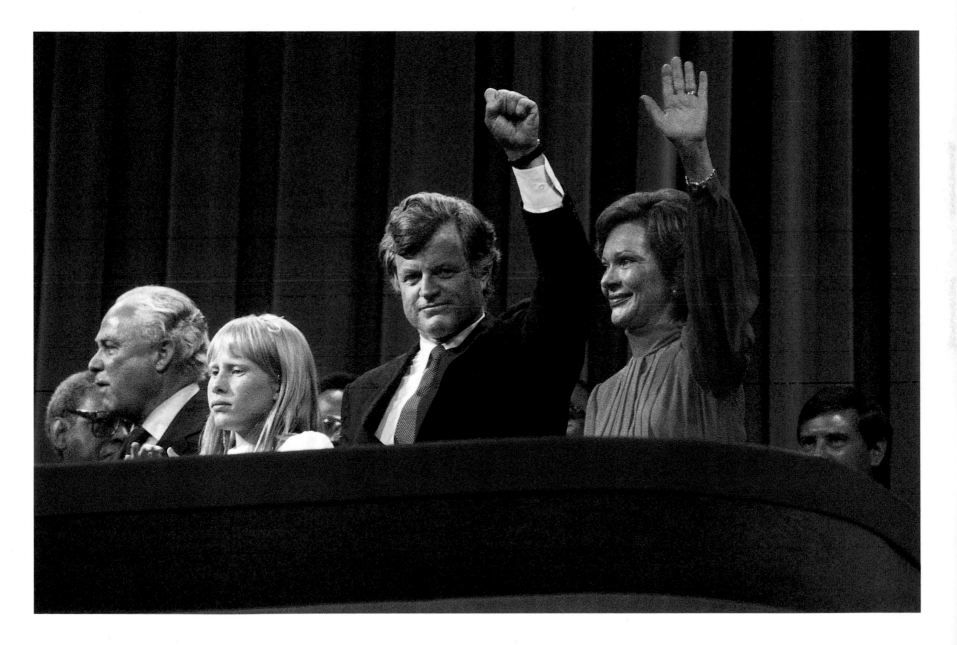

Robert Strauss, Amy Carter, Senator Edward Kennedy, and Rosalynn Carter at the Democratic National Convention, New York City, August 12, 1980 • **45**

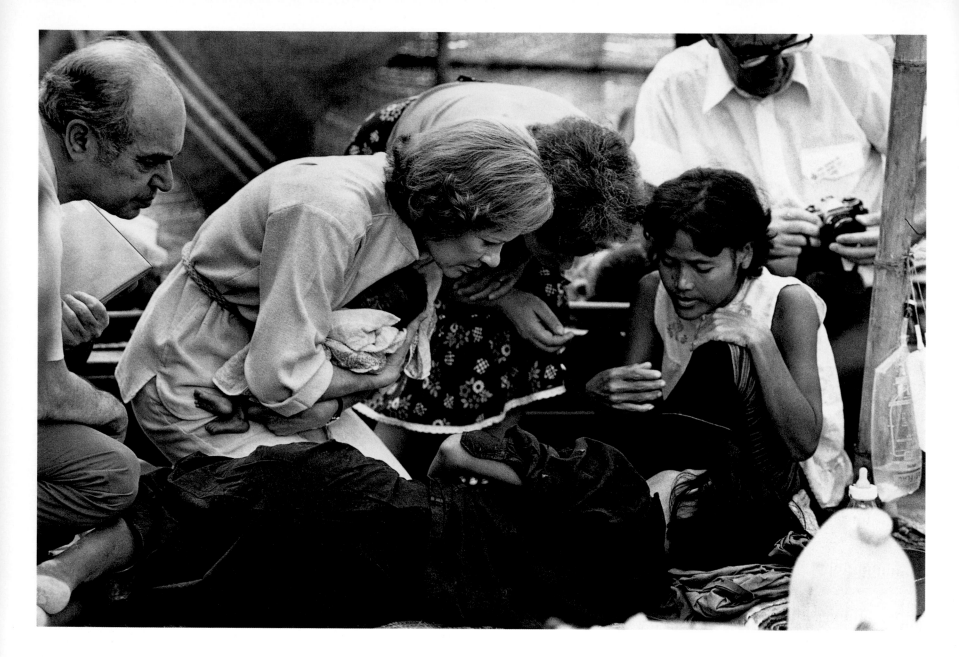

"This was devastating to me. The refugees had just come in from Cambodia to the Thailand border.

I picked up a baby and put it down on a blanket on the ground. They started crying, and when I turned

around the baby had died." — *Rosalynn Carter*

"I was trying to put together an approach that would bring peace to the Mideast region. I was trying to see all the leaders of that region, and I had just met with King Hussein of Jordan. Secretary Vance was a very devoted and idealistic, peace-loving man." — *Jimmy Carter*

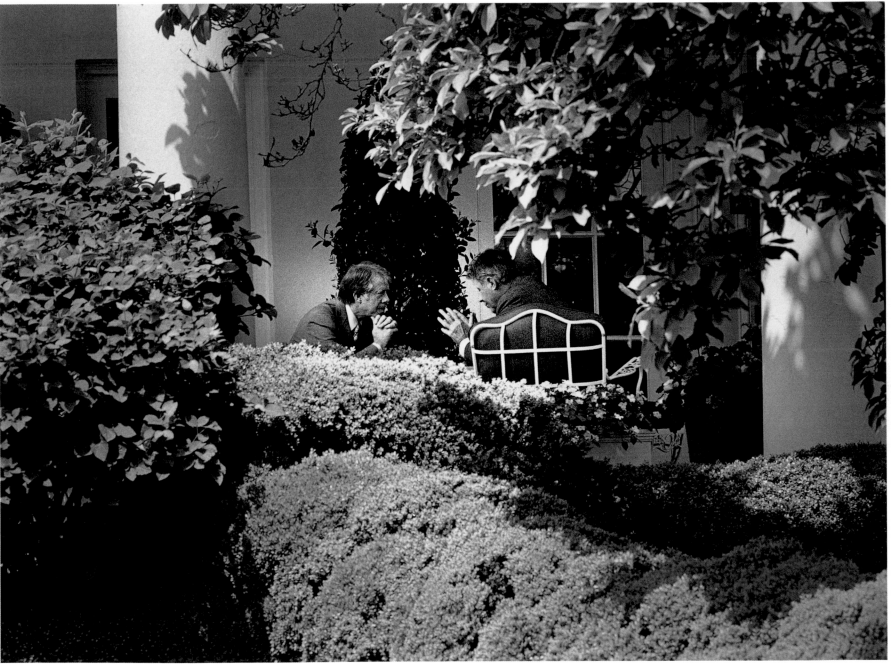

Secretary of State Cyrus Vance confers with the President on the colonnade of the White House, April 1977 • **47**

"This was on the 30th anniversary of the founding of Israel. I announced that I was appointing a commission to commemorate the Holocaust and I asked Elie Wiesel to be the chairman. He was describing what the commission might do, or giving some of his own experiences, I'm not sure which.

"Vice President Fritz Mondale is at my left and so is Majority Leader Robert Byrd. Fritz and I lunched on a weekly basis, and he was invited to every meeting I ever had. I never excluded him from anything. We would meet regularly for breakfast every Friday morning with the secretary of state and the national security adviser and the secretary of defense, for a private meeting on foreign affairs. In addition to that, Fritz and I would meet at least once a week to discuss domestic and political affairs. Our relationship was just about perfect."

— *Jimmy Carter*

48 • President Carter listens to Elie Wiesel at the National Civic Holocaust Commemoration Ceremony, Rotunda of the U.S. Capitol, April 24, 1979

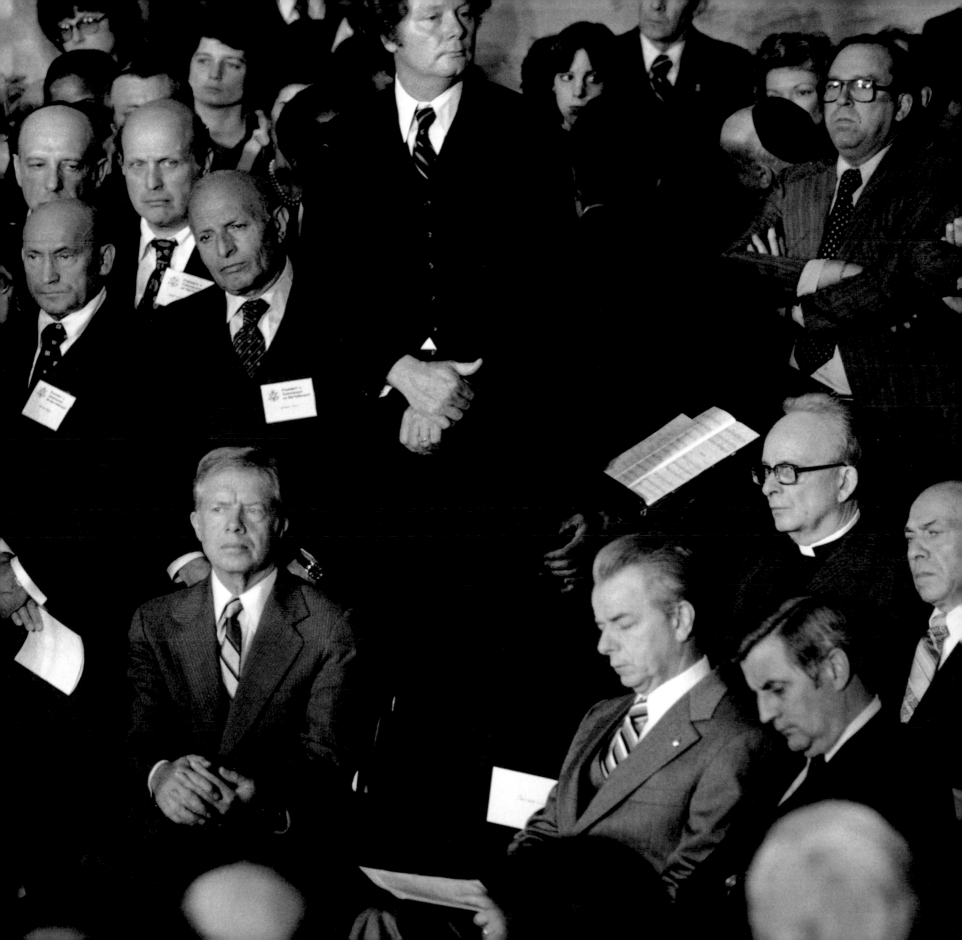

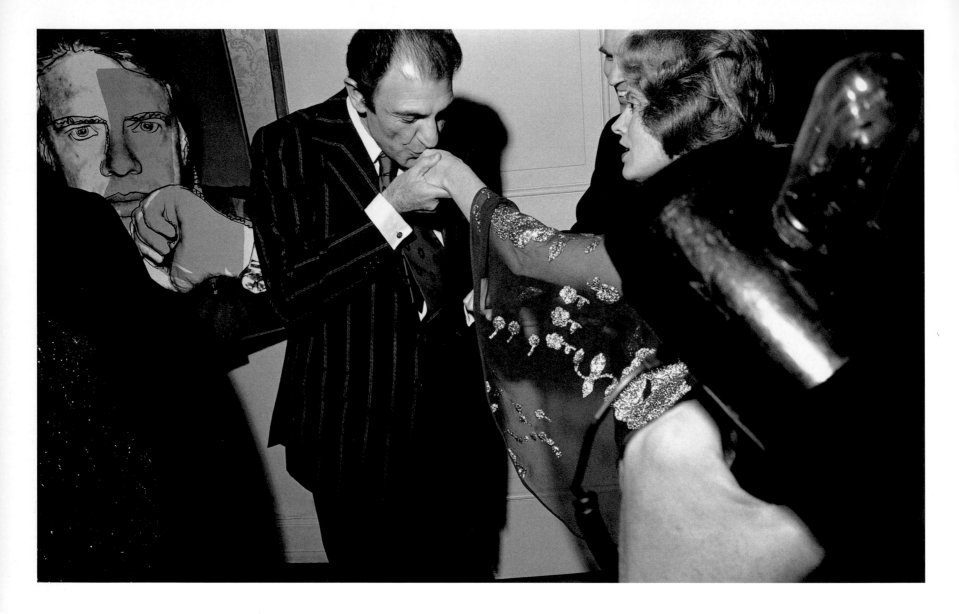

Before the fall of the Shah of Iran, Washington society was entertained during the
seventies by the Ambassador of Iran, Ardeshir Zahedi, here welcoming Buffy and
Bill Cafritz to his glamorous party honoring Andy Warhol. — *D.W.*

The relationship between administrations and the press is complex, and some socializing is all part of the mix of Washington. Ben Bradlee (top), Hamilton Jordan, Sally Quinn, Jerry Rafshoon, and Betty (Mrs. Herman) Talmadge attend a Georgetown party given by a Jimmy Carter appointee. — *D.W.*

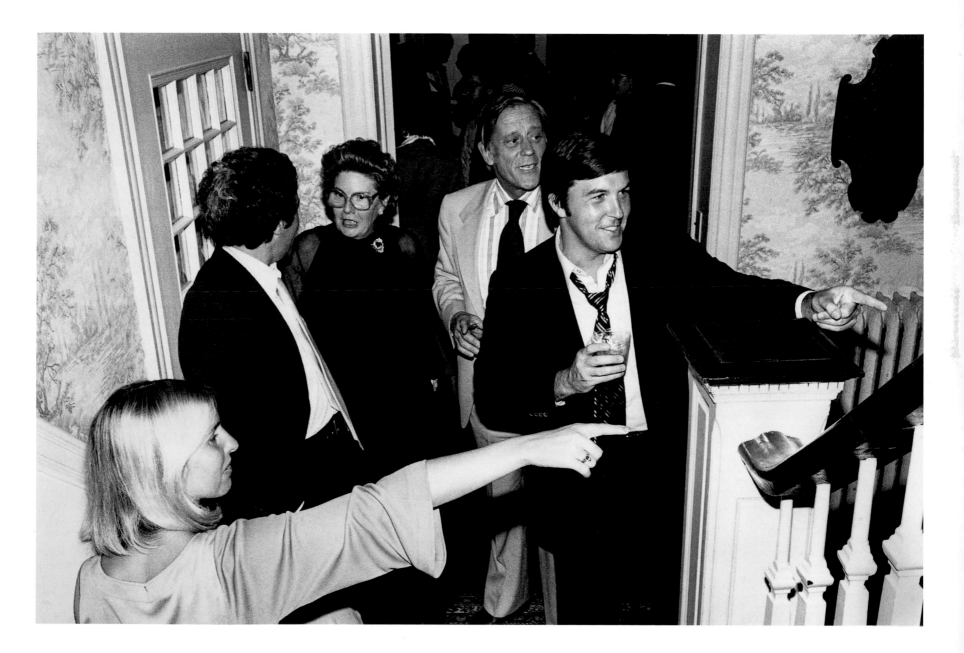

In this photograph, perhaps because of the barren appearance of his new private-sector office,

Ambassador Richard Helms, former head of the CIA (1966–73) looks to me every inch

the man who kept secrets. — *D.W.*

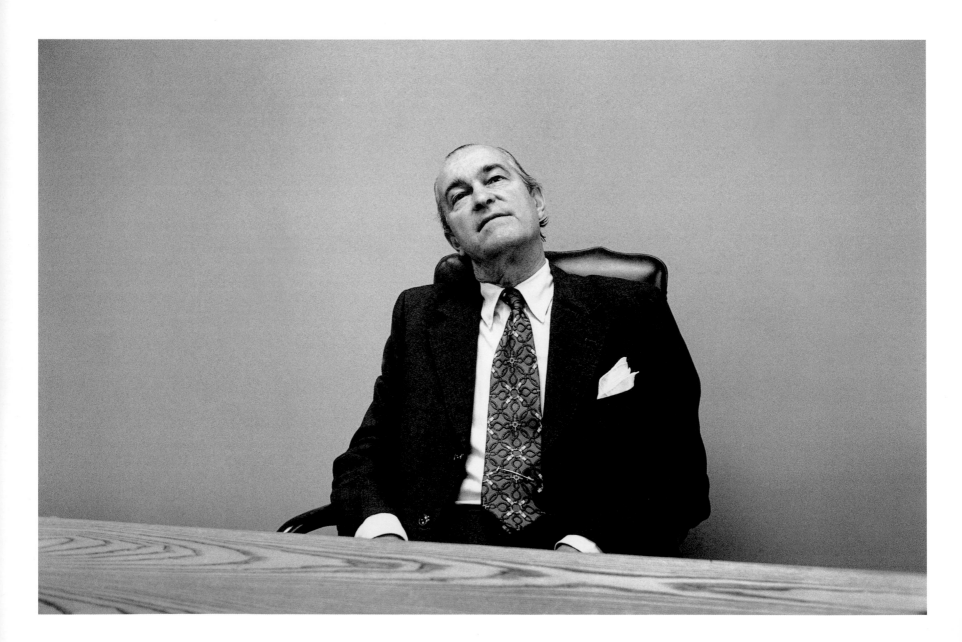

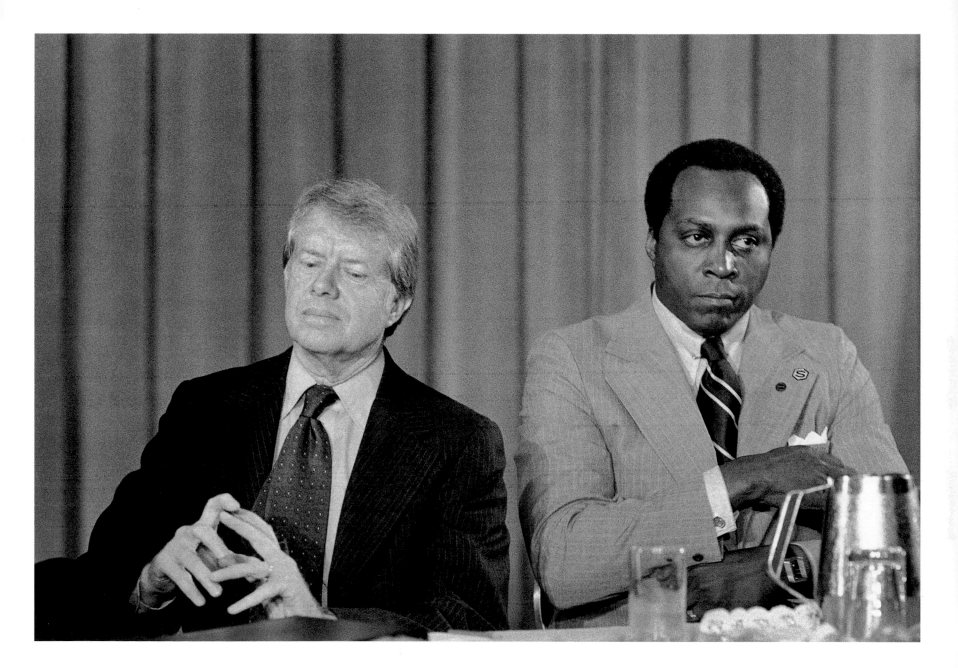

"I don't think this photograph...well, I would question it. Although we're looking in opposite directions,

we're probably listening to somebody else make a speech, and the fact that we're turned away from each

other doesn't mean we're antagonistic." — *Jimmy Carter*

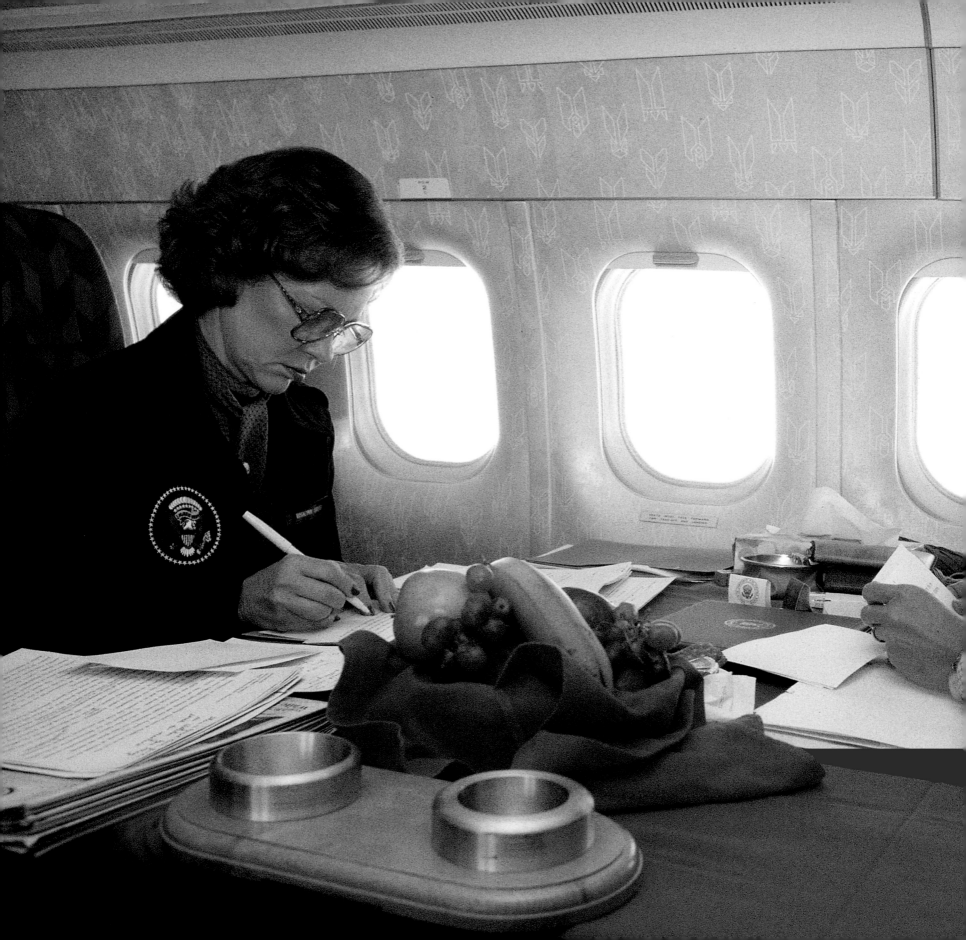

I asked for the opportunity to take this behind-the-scenes picture on the plane because it was somewhat unusual for Mrs. Carter and Mrs. Mondale to fly together. They were on their way to a joint appearance in Iowa at the start of the 1980 campaign.

— D.W.

"Joan and I had a happy working relationship. We campaigned together, but not often because she would go in one direction and I'd go in another. We both worked hard. Being First Lady was a wonderful experience for me. I loved it all, even the bad."

— Rosalynn Carter

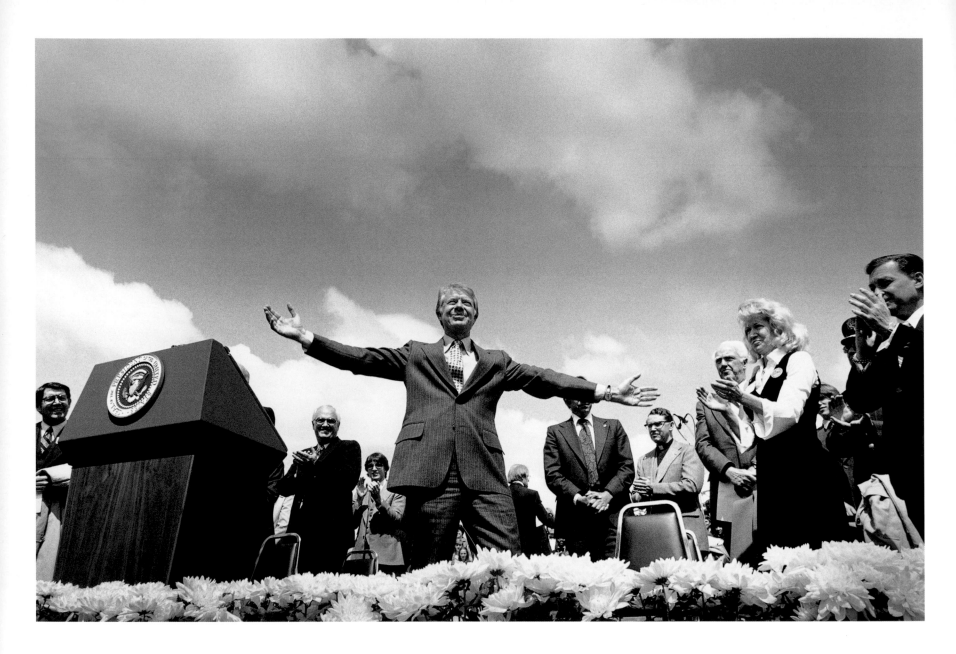

"Environmentalists were my friends. The audience was very complimentary and friendly.

And Spokane was such a beautiful city. I still remember it." — *Jimmy Carter*

"Every two weeks congressional leaders came to the White House for a breakfast meeting. Tip O'Neill was a great admirer of grits. Once we had pancakes without grits, and Tip was very upset, so we had grits brought to him." — *Jimmy Carter*

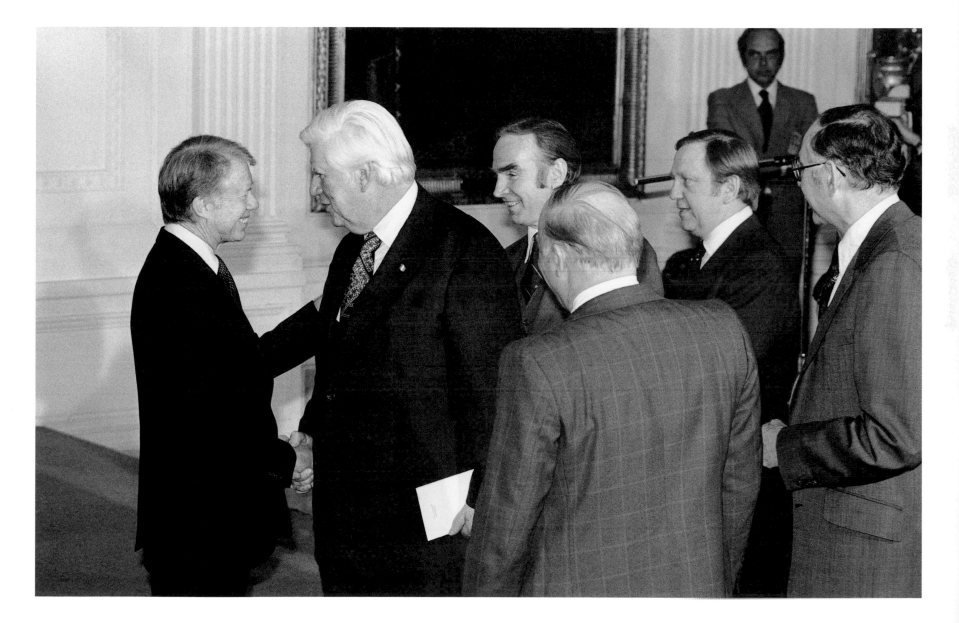

President Carter with House Speaker Tip O'Neill, Representative Jim Wright, and Representative • **57**
John Brademas at a Middle East briefing in the East Room of the White House, March 14, 1979

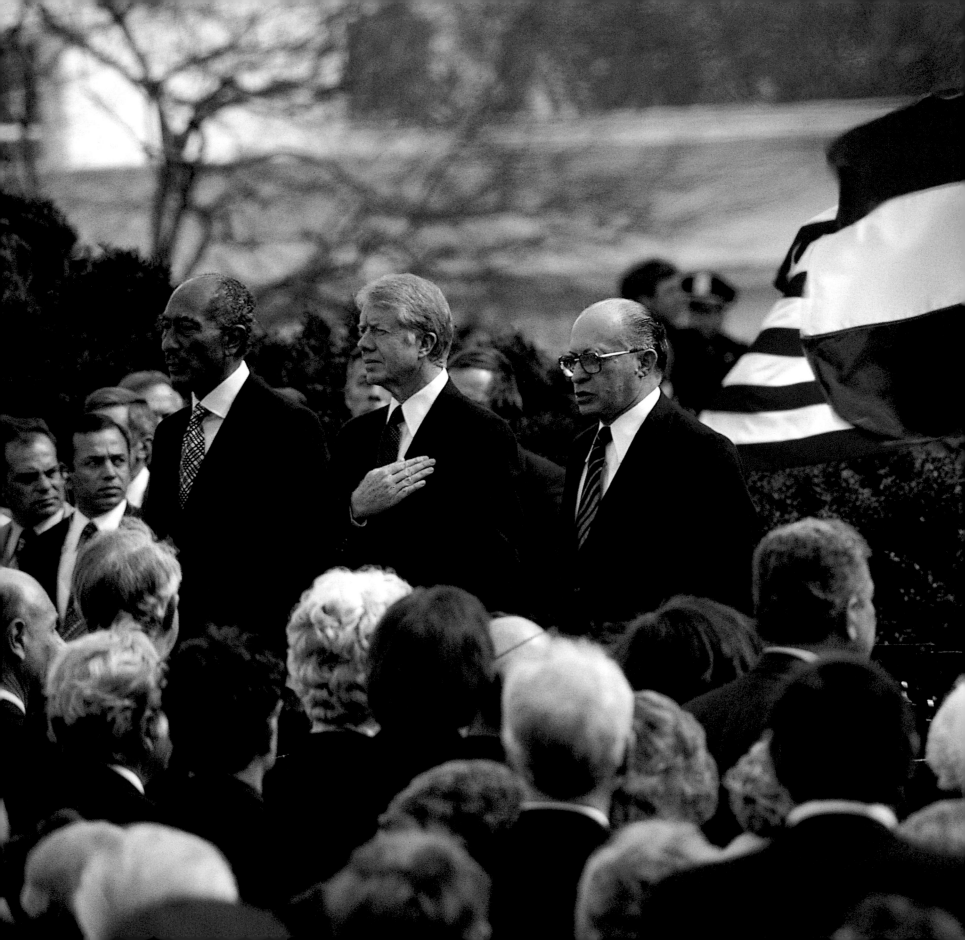

This was by far the biggest media event at the White House that I had seen to date—so many cameras, so little space. The enormous historical importance of this moment seemed huge, thrilling, and promising.

— *D.W.*

"That's when we announced the peace treaty between Israel and Egypt. By the way, not a word of it has been violated in the last 23 years. Sadat was the greatest foreign leader I ever met. Honest, generous, trusted me maybe too much with Egypt's responsibilities and concerns. He and I never had any differences, and if he ever told me something I could depend on it for the rest of my life. I can say that I had great admiration for him. He and Begin despised each other. After the third day I realized I could not let them be in the same room together, it was a counterproductive effort, so for the last ten days we were at Camp David, Begin and Sadat never saw each other. I went back and forth between them. But this day was a love fest. You know, Begin had his arms around Sadat's neck, they were exchanging kisses, and it was a euphoric moment."

— *Jimmy Carter*

Egyptian President Anwar El-Sadat, President Carter, and • **59**
Prime Minister Menachem Begin of Israel, March 26, 1979

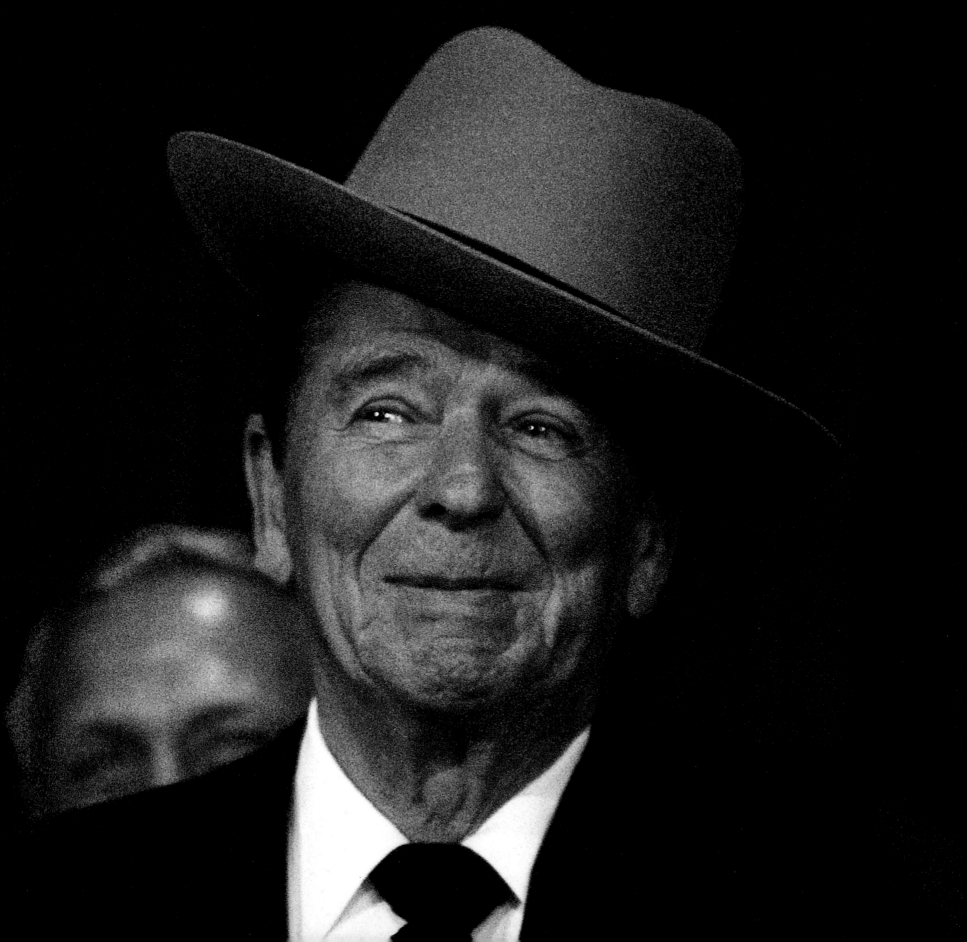

1980 - 1988

THE RONALD REAGAN YEARS

The Reagan White House created events that were well advanced, well presented, and well lit. Add to this the familiarity of the President and Mrs. Reagan with cameras, and the life of photographers was made easier. I traveled often with Mrs. Reagan here and abroad as she put forward her anti-drug campaign, "Just Say No." I began what I continued to do with each subsequent administration, which was to photograph "behind-the-scenes" situations where mine was the only press camera allowed. I observed Mrs. Reagan to be caring, funny, and warm, most especially to those in need of comfort. Later, covering the President, I found him always a delight to photograph because he had such charm and a lovely sense of humor. In 1984 I left to photograph the campaign of Reagan's challenger, Walter Mondale. I came to have the highest regard for the integrity, stamina, and grace of Walter and Joan Mondale. I returned to the White House full of a new sense of what it takes to be President and a better understanding of just how extraordinary the people are who run for the highest office—and most especially those who win it.

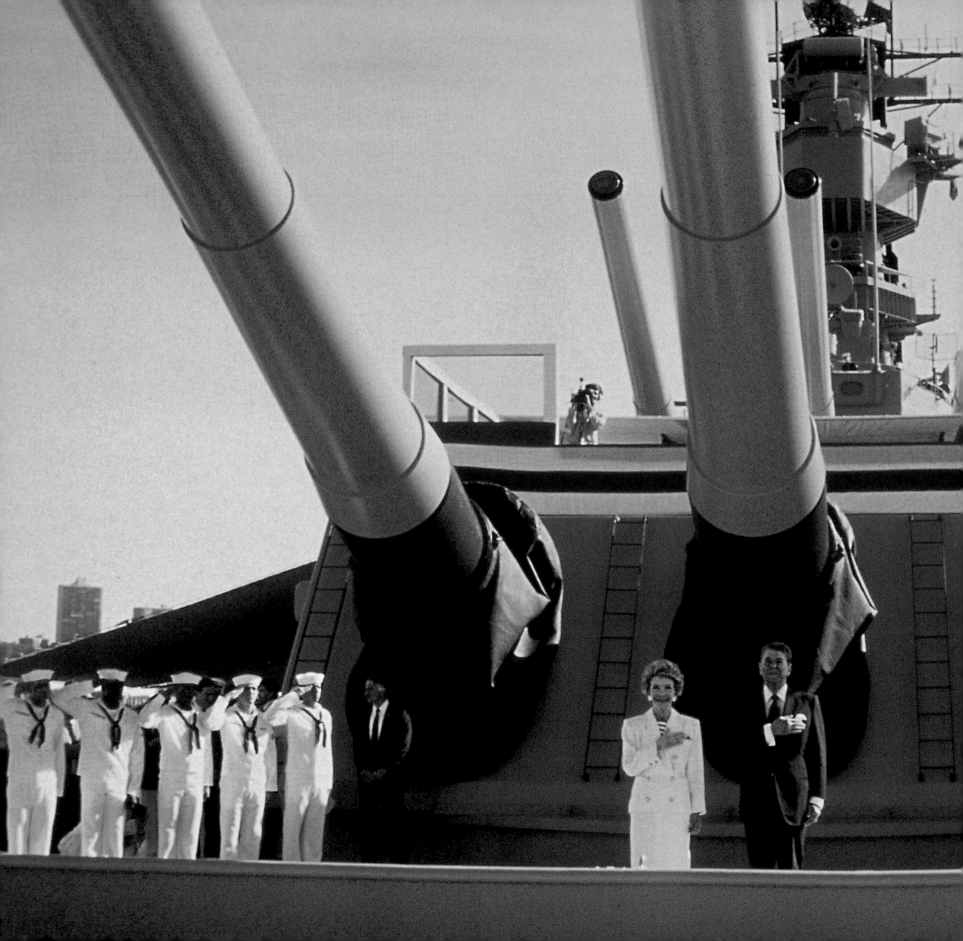

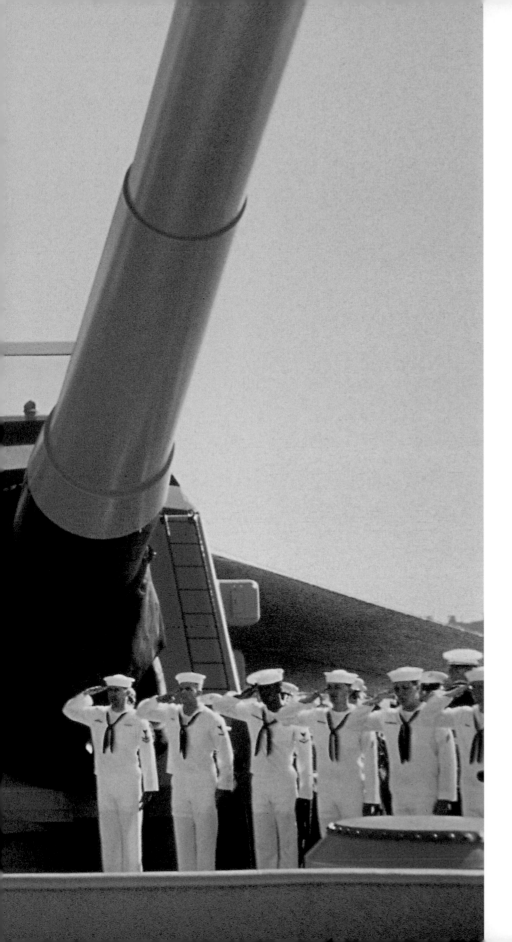

What a scene! It looks almost like a Busby Berkeley musical. On the deck of the U.S.S. *Iowa*, President and Mrs. Reagan start off the celebration of the centennial of the Statue of Liberty.

— *D.W.*

"I didn't think Ronnie was going to go into politics. No, I thought I'd married an actor. But then after the Goldwater speech, I began to expect that maybe And also, if I had really thought about it, I think I would have known that being an actor wasn't enough for him, which is why he got into Guild activities—he needed more."

— *Nancy Reagan*

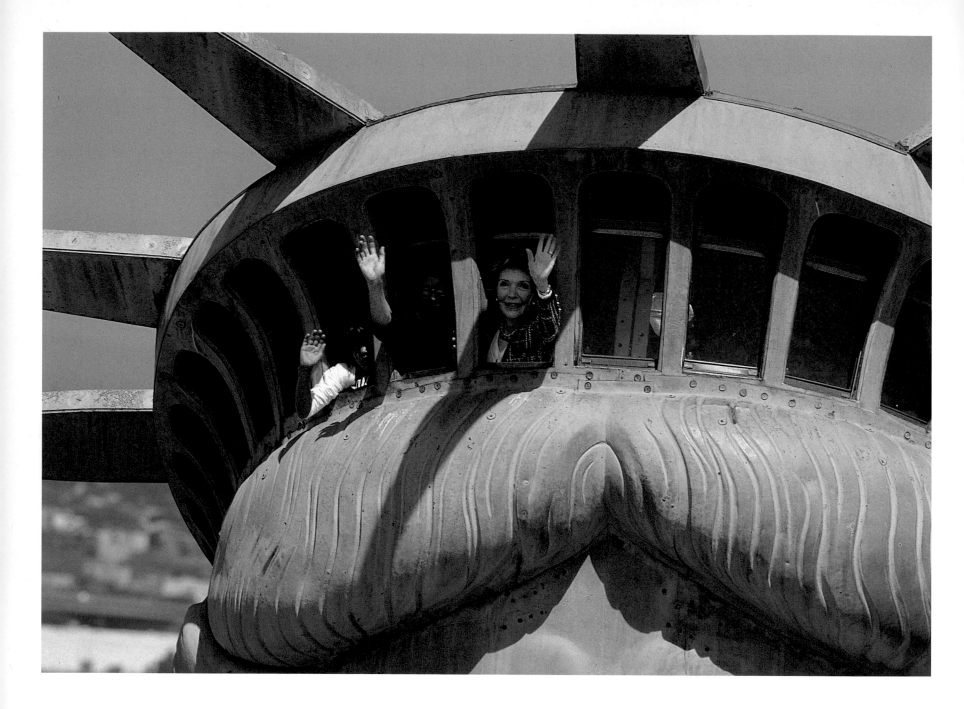

64 • Nancy Reagan at the Statue of Liberty, July 5, 1986

The White House planned this extra-
ordinary photo op to celebrate the
100th birthday of the Statue of Liberty.
A Marine helicopter took a small pool of
photographers up the outside of the
statue to make a picture of Mrs. Reagan
and some kids waving from the windows
of Lady Liberty's crown. It was an
amazing experience, and I knew I had
better hold tight and make a picture,
as I wasn't ever going to be back up
there again!

— D.W.

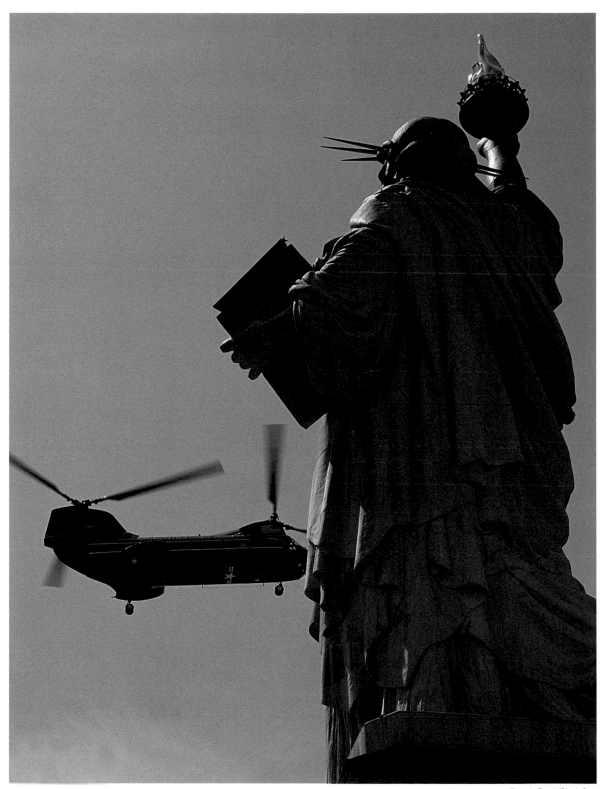

Dennis Brack/Black Star

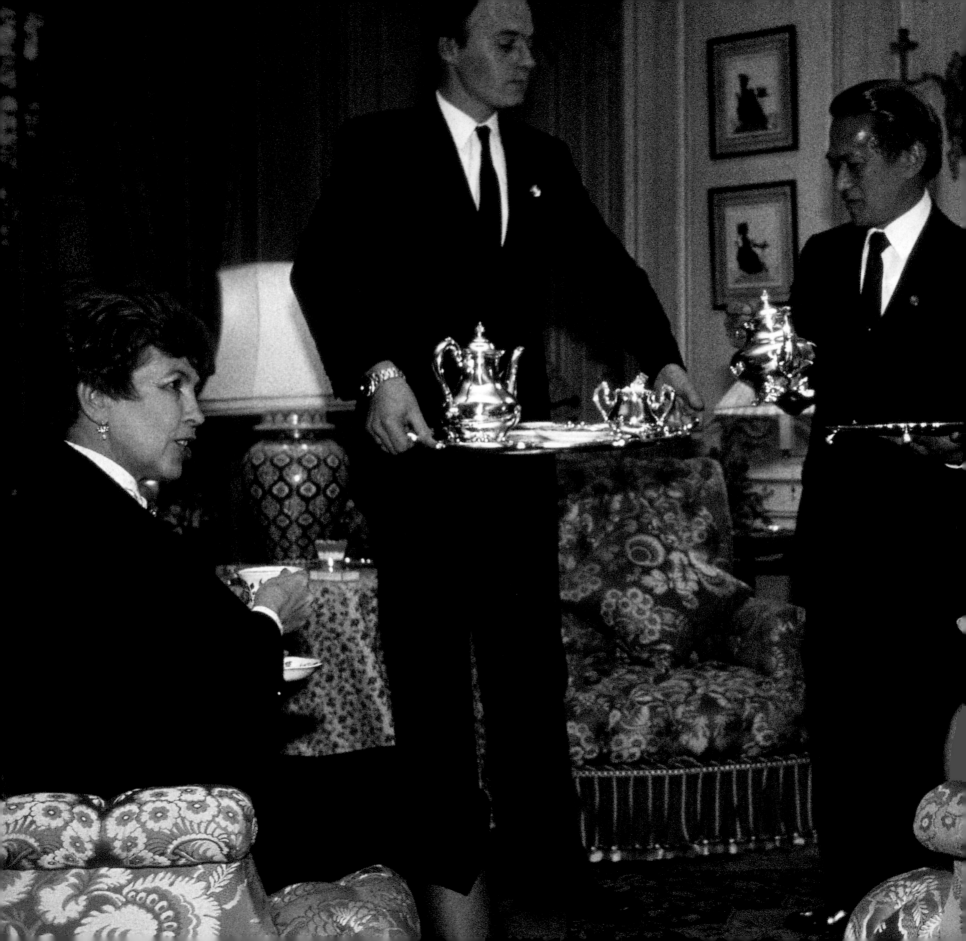

My pal Elaine Crispen, Mrs. Reagan's press secretary, arranged for me to be the only photographer in the room with Mrs. Reagan and Raisa Gorbachev when they met for tea during the Geneva summit. It seemed clear that this was not going to be an easy relationship.

— *D.W.*

"I did not really have anything in common with Raisa Gorbachev. She was not an easy woman. He's very warm, with a sense of humor. She's not so warm. But he adored her, and she was an important part of his life."

— *Nancy Reagan*

The *Challenger* memorial service was a terrifically tough event to cover. The shock was with us all. Photographers must sublimate their own feelings, but in your head you never forget. To be in the presence of the families of the lost astronauts, to see their bravery as they stood with the President—it was hard to shoot; I couldn't see for my tears. I remember the pool of photographers on the way home; we were, for once, speechless.

— *D.W.*

"You just keep saying to the families, 'I'm so sorry, I'm so sorry.' There's nothing more you can say, really. I know we both hugged everybody. That's all we could do. It was so sad."

— *Nancy Reagan*

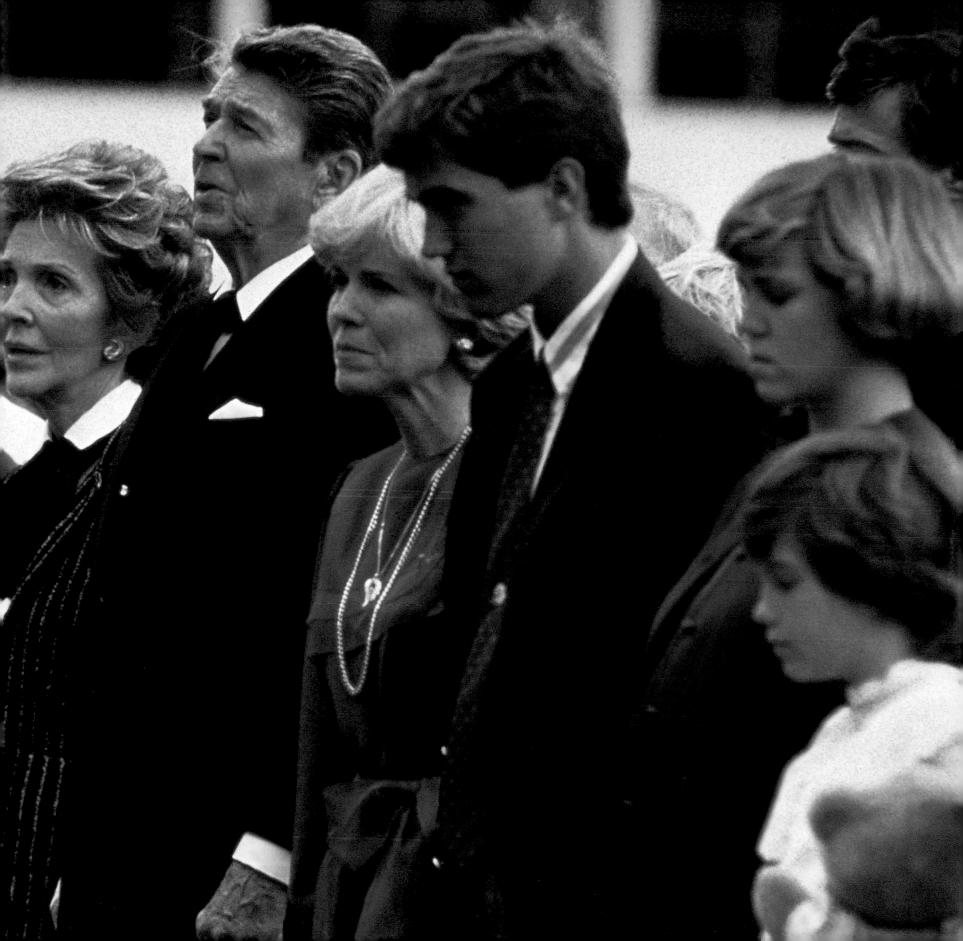

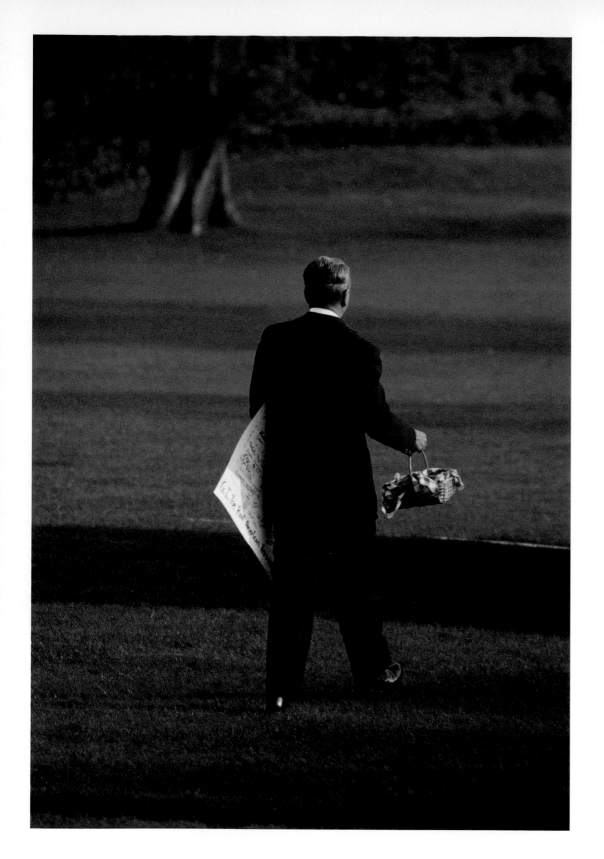

Mrs. Reagan had been diagnosed with breast cancer and had been successfully operated on at Bethesda Naval Hospital. There seemed something so poignant to me about this image of the President heading to the helicopter to visit the First Lady, carrying an enormous get-well card from the staff under one arm and a small basket of cookies in the other.

— *D.W.*

"I've never seen this picture before—you were holding out on me, Diana. That's a sweet picture, very sweet."

— *Nancy Reagan*

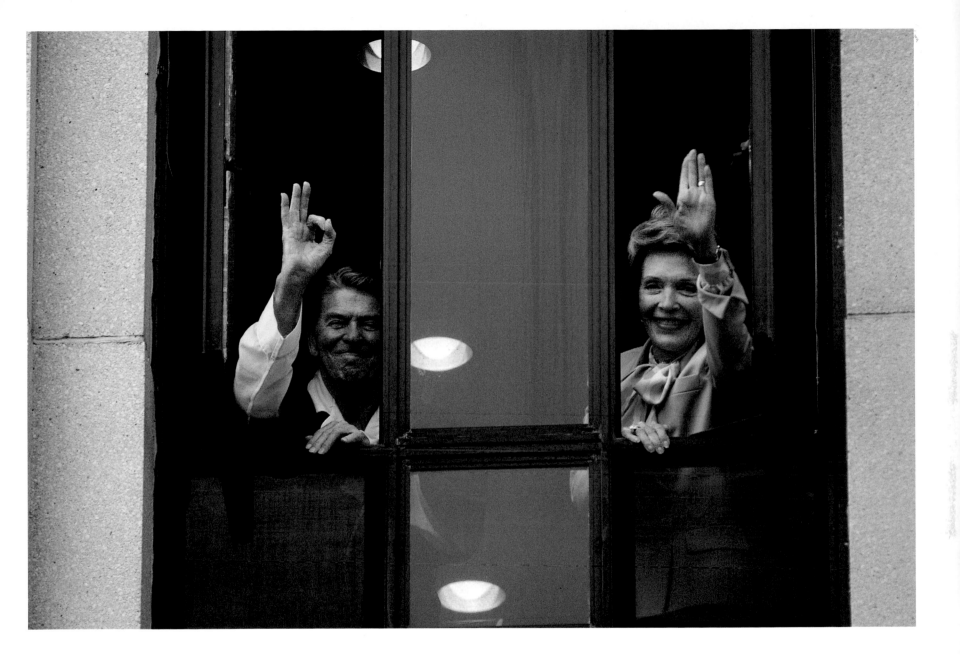

A pool of photographers stood vigil in the driveway of the hospital for days after President Reagan's cancer surgery in 1985. Suddenly, two windows opened. Using very long telephoto lenses we were able to shoot this picture of the upbeat President, indicating everything was A-OK—a very reassuring image for the front pages of newspapers around the world. — *D.W.*

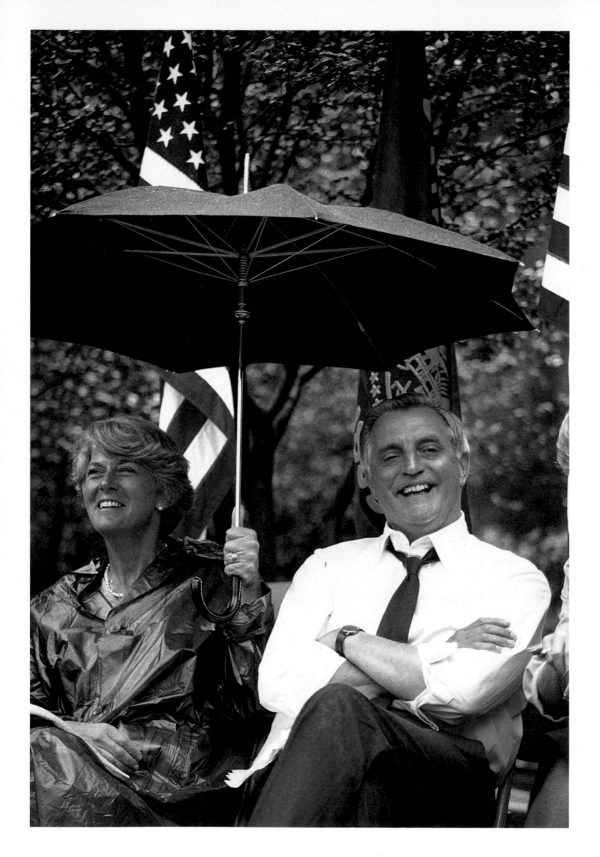

The traveling press photographers stood outside in the Mondales' driveway in St. Paul as prospective running mates visited. When Mondale appeared outside with Geraldine Ferraro, it seemed to me through the lens that his demeanor suggested she would be his choice. I was relieved that, the choice being made, we would cease this driveway stakeout, where we were so inundated by mosquitoes that one of my colleagues wore a beekeeper's outfit.

— *D.W.*

"I told you Gerry would be a good candidate: She's holding my umbrella!"

— *Walter Mondale*

"It was the best photograph of the campaign because it truly defied nature and, moreover, made me look happy as I headed once again to my hopeless campaign in New Hampshire. Why I looked happy, I will never know. What I was saying to myself when I went up that ramp was this: 'Oh damn, another day in New Hampshire!'"

— *Walter Mondale*

Walter Mondale takes the time to visit with a lone potential

voter, fisherman to fisherman, on a campaign stop in

Florida—an unusual way for a candidate to spend his time

on the hectic campaign trail, but a very refreshing one.

— *D.W.*

"Can we change places?"

— *Walter Mondale*

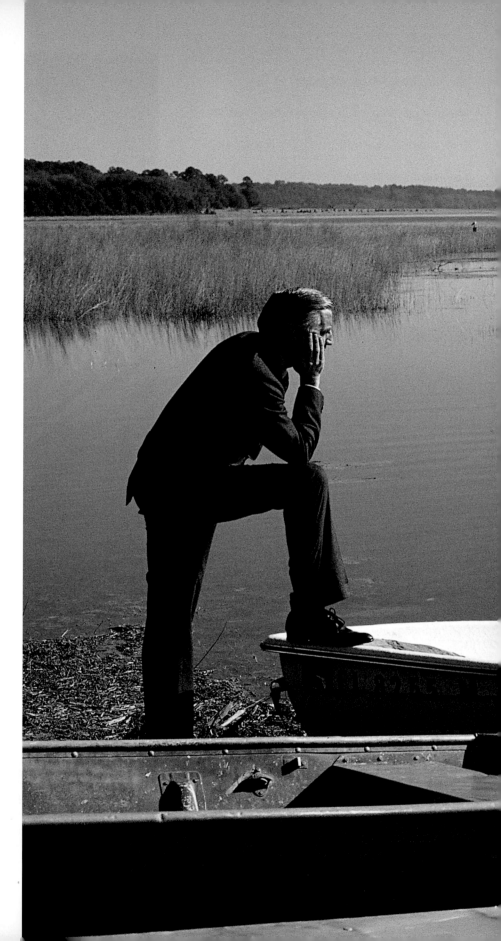

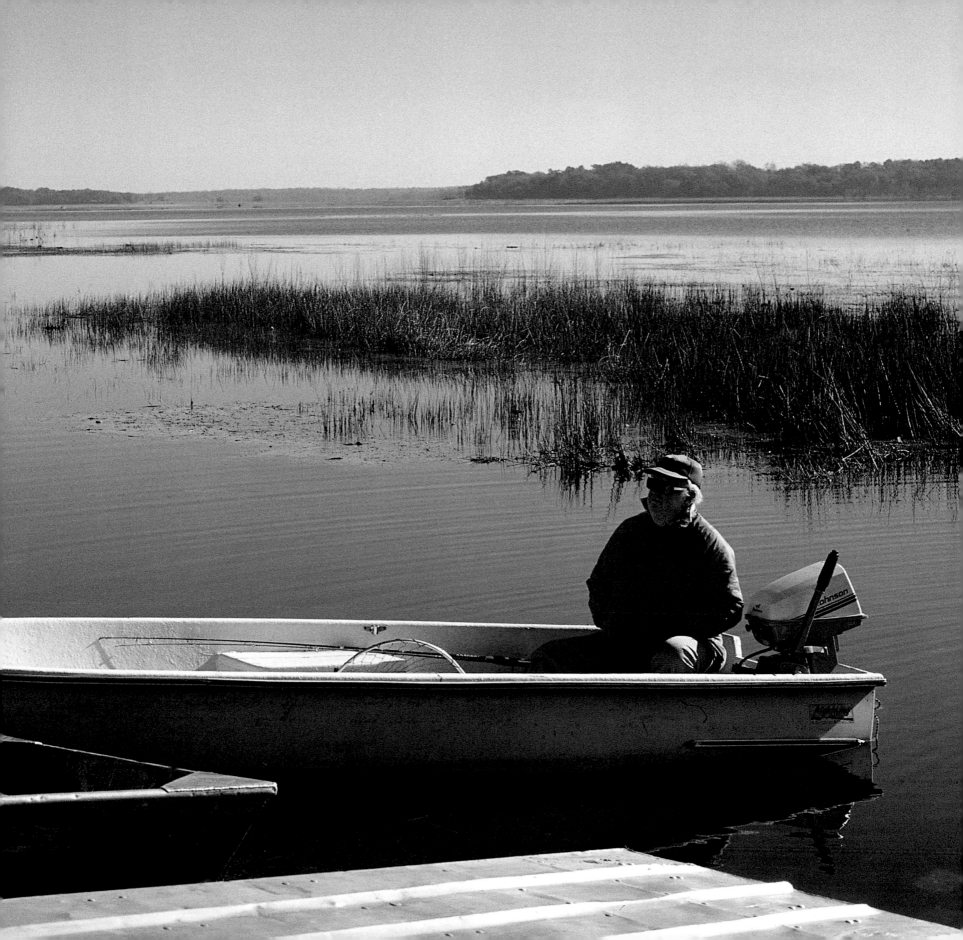

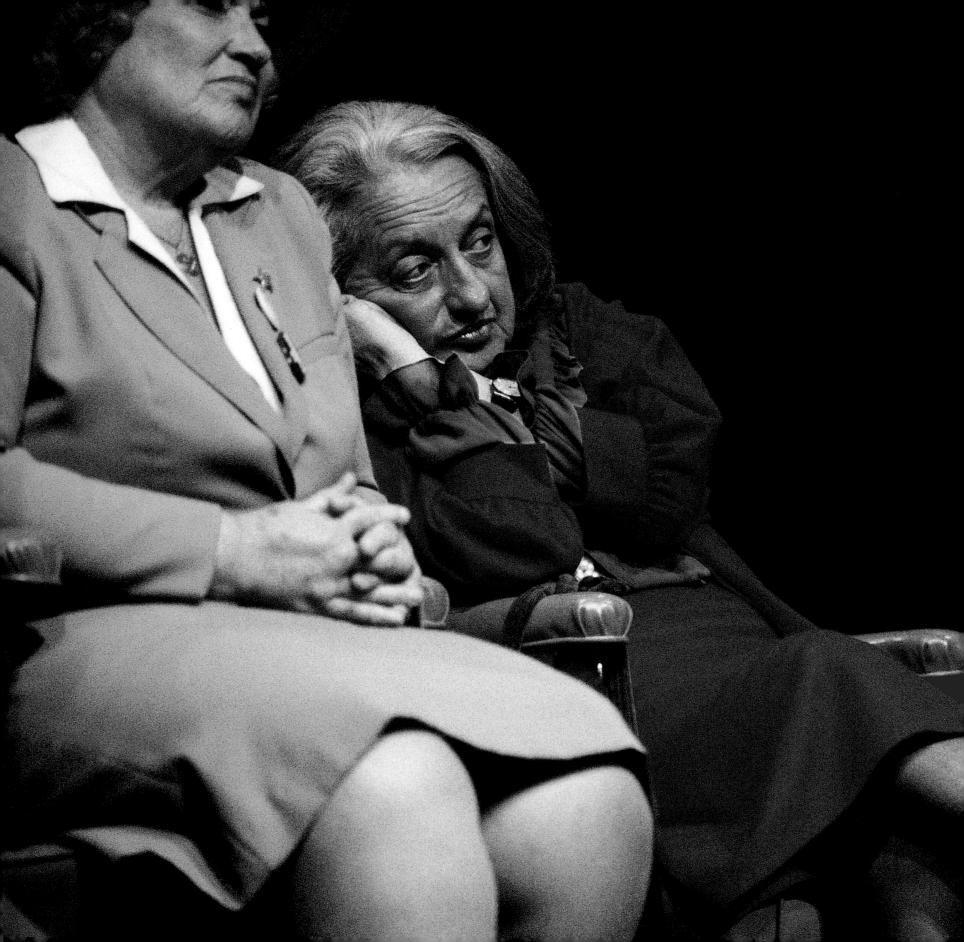

While following the principals from place to place, photographers often look for opportunities to make pictures of other players at events. Here, two pioneers in the women's movement, Bella Abzug and Betty Friedan, listen to their candidates, Walter Mondale and Geraldine Ferraro, at a campaign rally in New York before the 1984 election.

— *D.W.*

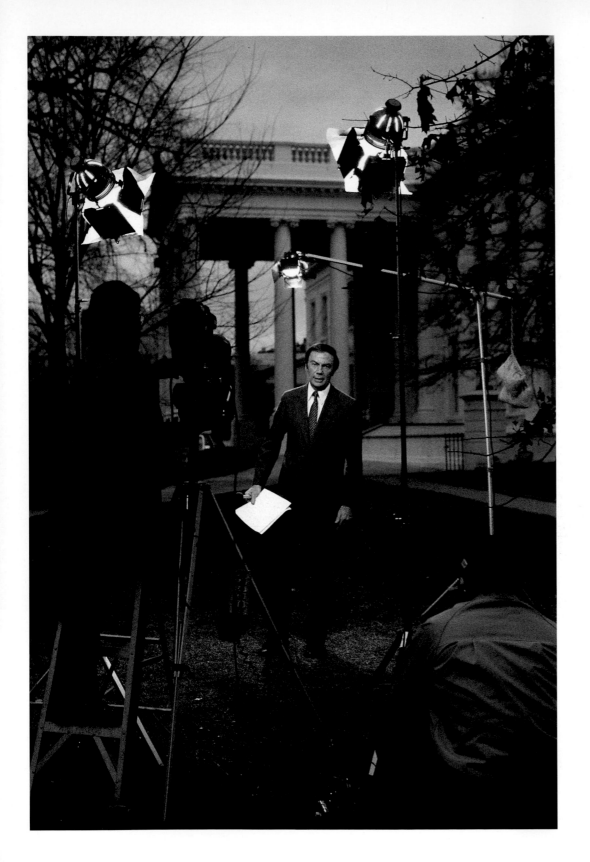

Because President Reagan was often kept at some distance from the press, Sam Donaldson, White House correspondent for ABC, would shout out questions to the passing President. Reagan would frequently answer Sam, sometimes with answers that made news, or sometimes with quips or one-liners. It was not the ideal way to work, but it was often neccessary and sometimes it bore fruit.

— *D.W.*

In the quarter century I have covered politics, one of the most enduring players has been

civil rights champion Jesse Jackson, who ran for President in 1984 and 1988. He has always

been interesting to photograph because of his vitality and forceful personality. — *D.W.*

When I was sent to photograph Herblock, I expected to meet a tough customer because of the power of his

brilliant cartoons. What I found was a funny, sweet, wonderful gentleman, surrounded by tins of

pens and pencils, newspapers all around, books piled high, and a comfortable couch in the corner to nap

on. He was a true gent, and utterly unforgettable. — *D.W.*

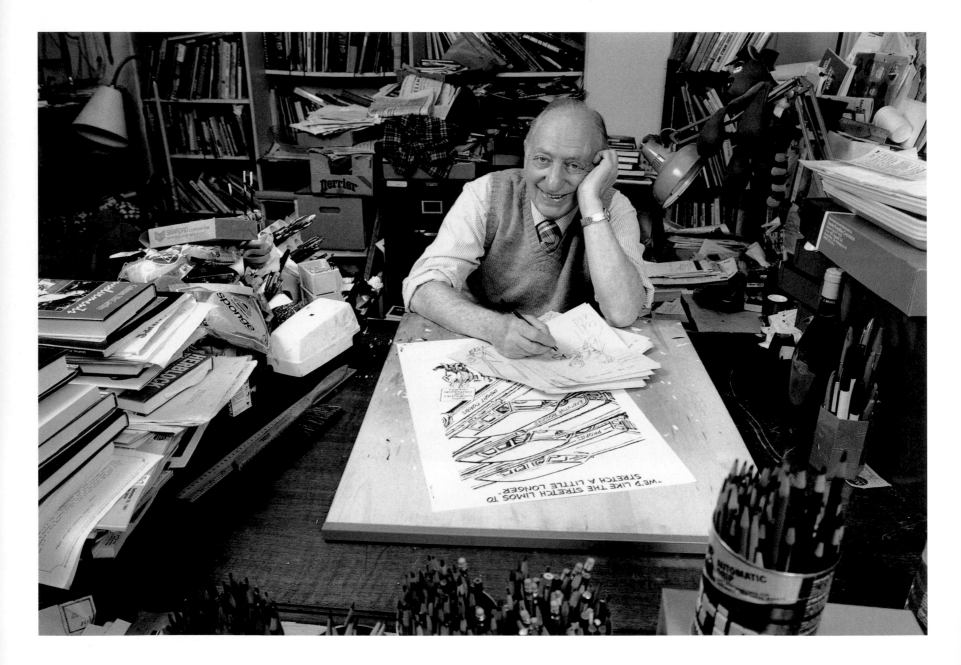

Claude Pepper served as a member of the House of Representatives for 27 years. A courtly man, champion of the elderly, he was accustomed to being photographed. When I struggled with the reflection of my lights in his glasses, he graciously pulled out glasses he kept for just such occasions: glasses with no lenses. The congressman was a pro. — *D.W.*

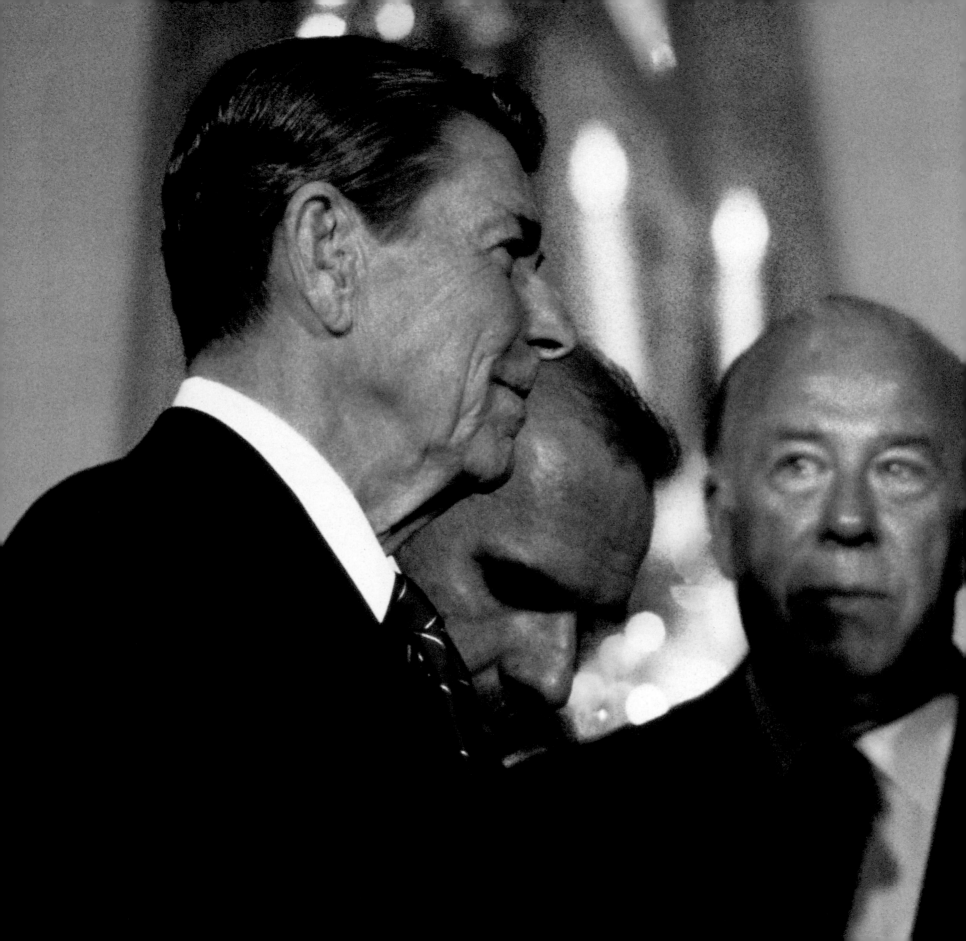

There was a rumor in the press office that President Reagan was going to a reception at the Waldorf Astoria during the United Nations meetings and would perhaps meet, for the first time, Soviet Foreign Minister Eduard Shevardnadze. A colleague from *Newsweek* and I saw the two leaders approach one another. I don't know exactly how we got there, but the next thing I knew I was down low in front of Reagan, George Shultz, and Shevardnadze with several photographers above me, all of us scrunching together to find space to make this picture.

— *D.W.*

This behind-the-scenes picture was taken in the Oval Office, as Reagan met with Secretary of State George Shultz, National Security Adviser Bud McFarlane, and Chief of Staff Donald Regan to discuss an upcoming summit meeting. — *D.W.*

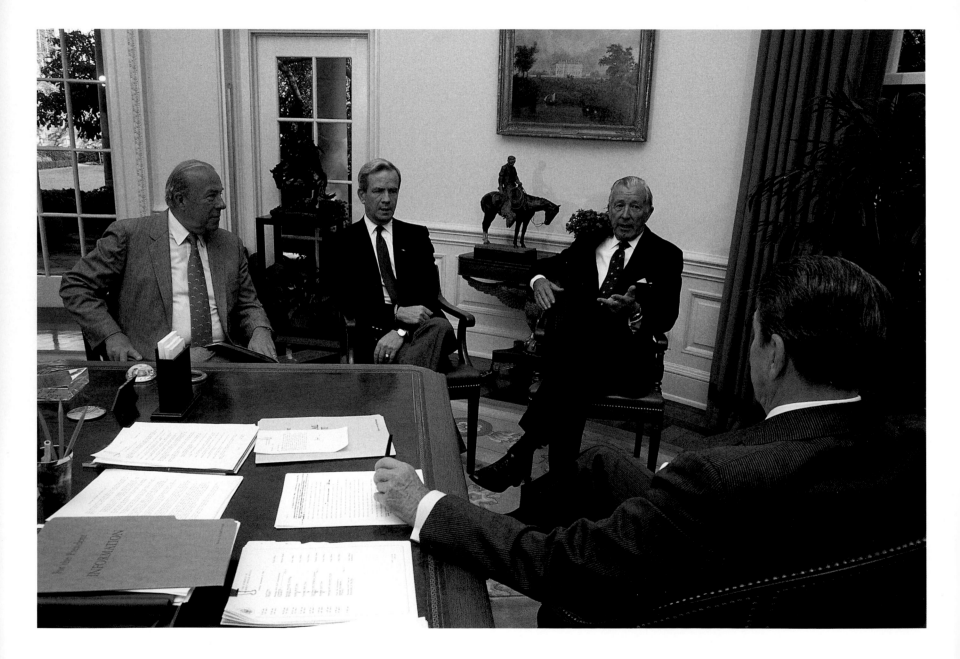

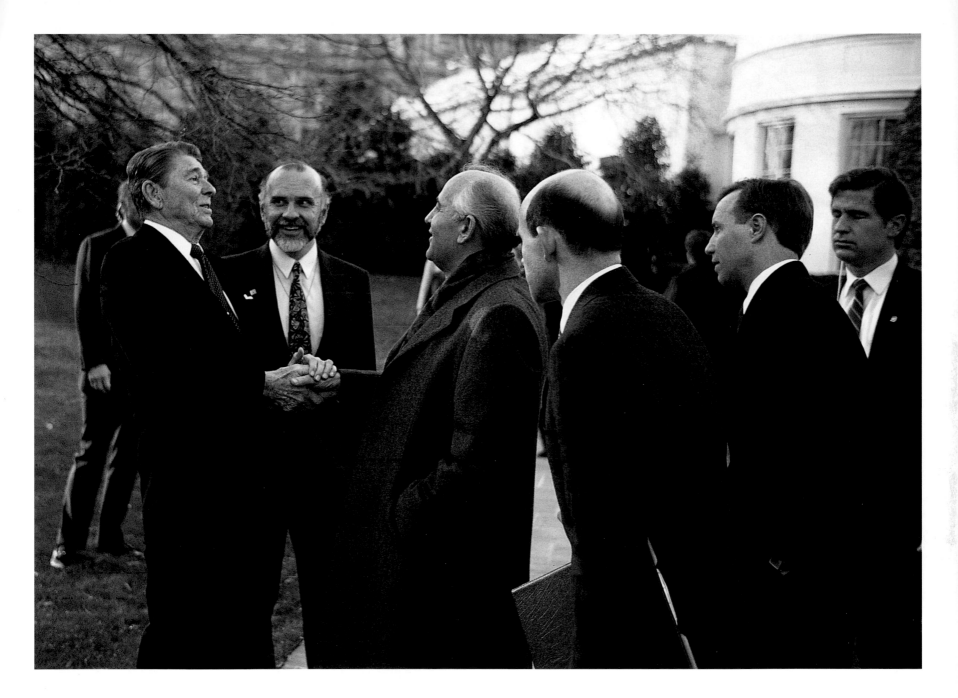

"This was the first time Gorbachev came to the White House. It was the first

time there had been a summit meeting here. Ronnie and Gorbachev liked

each other right away. We both got along well with him." — *Nancy Reagan*

During the eight years of Ronald Reagan's Presidency, many heartbreaking events occurred. Here, the Reagans attend a memorial service at Camp Lejeune for the 241 Marines lost in the bombing of their barracks in Lebanon, and the 18 who died in Grenada.

— *D.W.*

"We had a lot of tragic events, and they were all terrible. You can see the expressions on our faces—on a gray, rainy day, which only added to it."

— *Nancy Reagan*

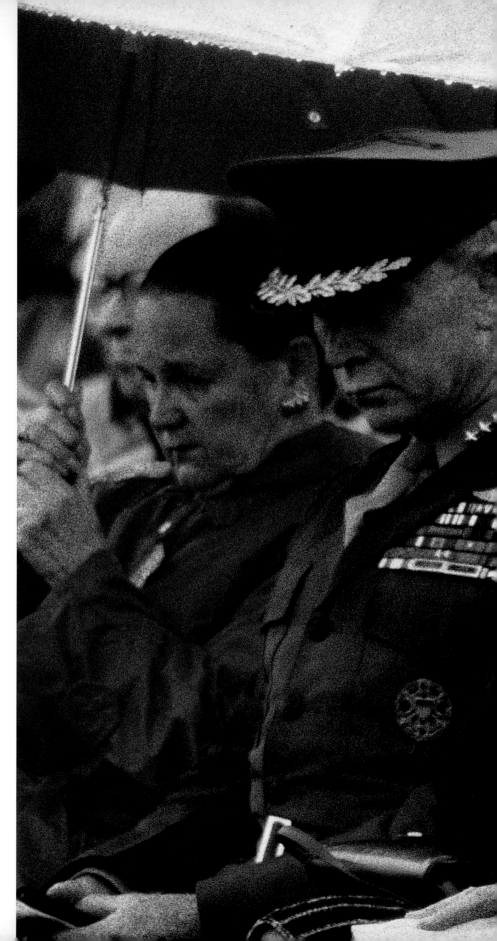

86 • North Carolina, November 4, 1983
Following pages: Miami, Florida, September 10, 1987

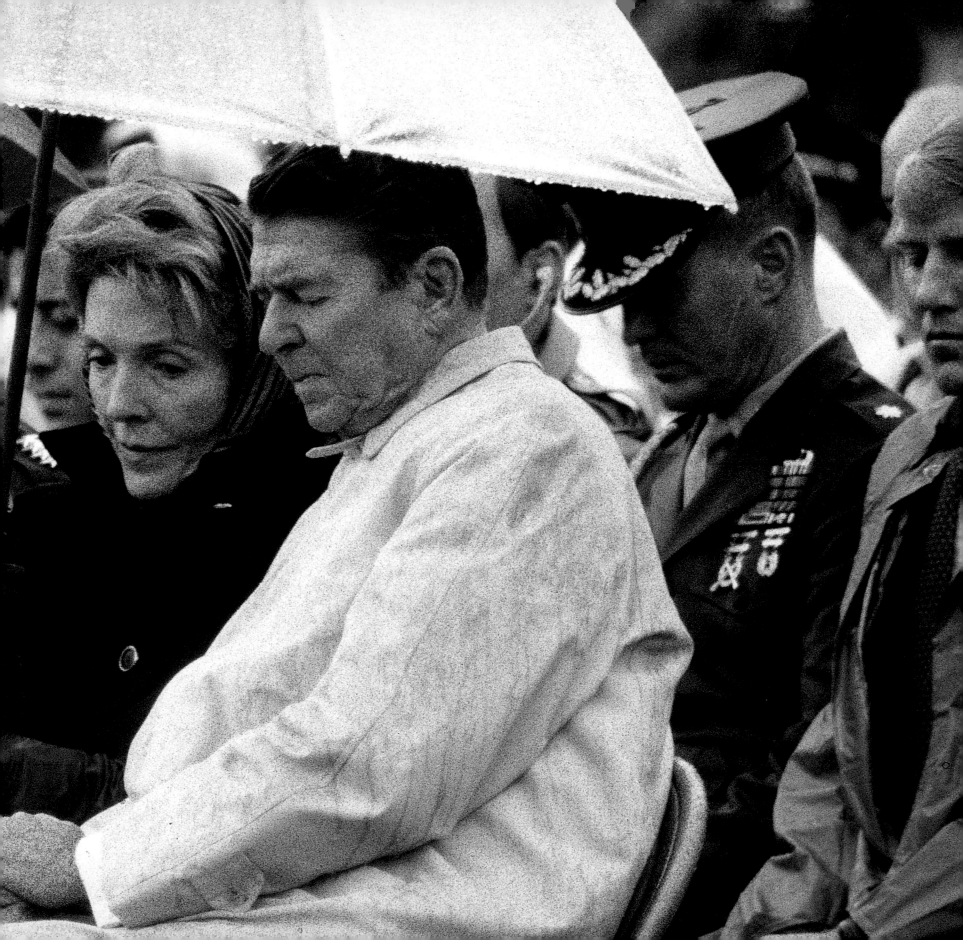

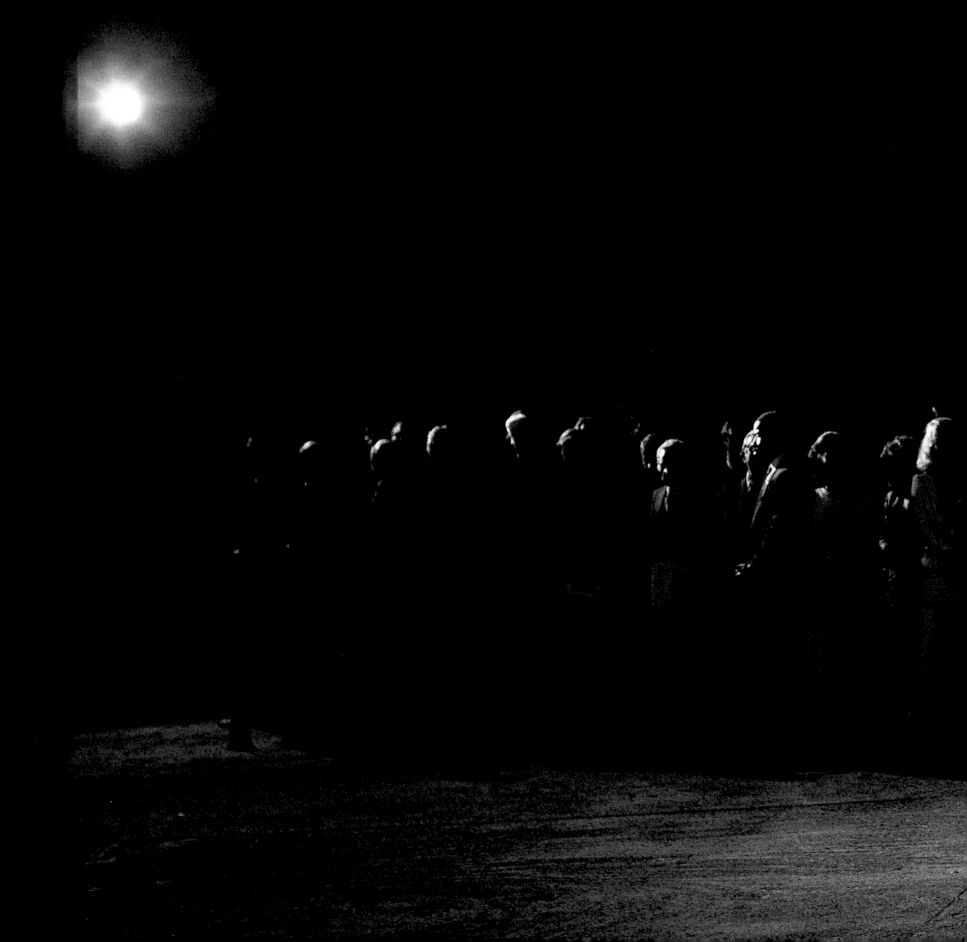

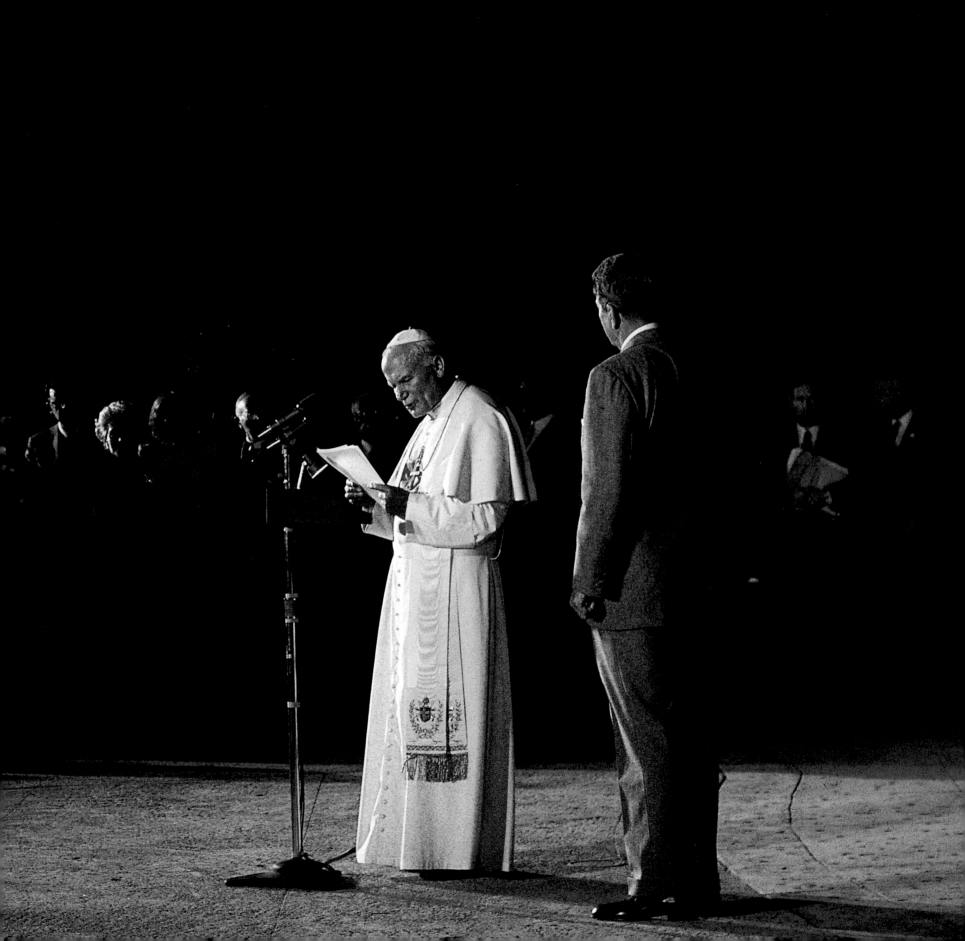

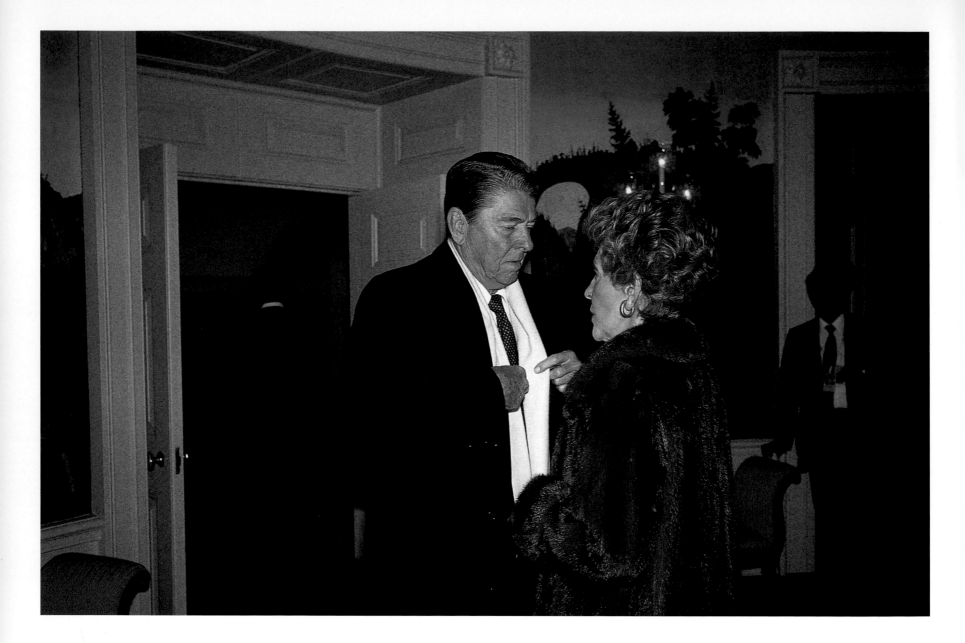

"It was possible to have a normal life in the White House—when we went upstairs, or when we were at Camp David. And we went practically every weekend unless we had to stay in town." —*Nancy Reagan*

I asked the press office if I could stand up on the edge of the balustrade to find a differ-

ent view as Reagan was met by a crowd on his return to the White House from cancer

surgery. I was scared to death I'd lose my balance and fall on the President. — *D.W.*

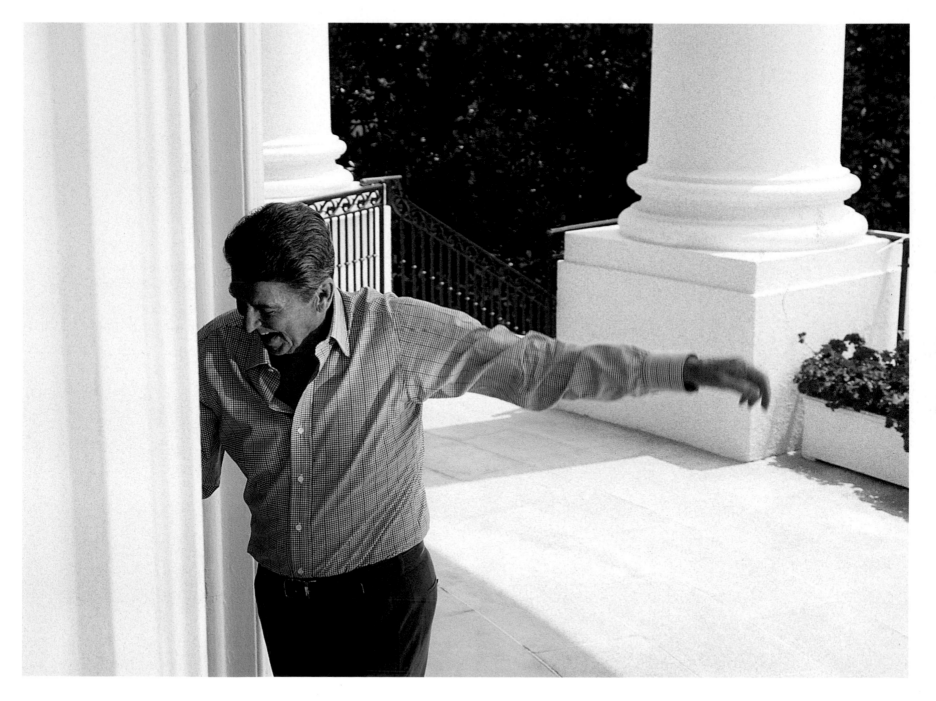

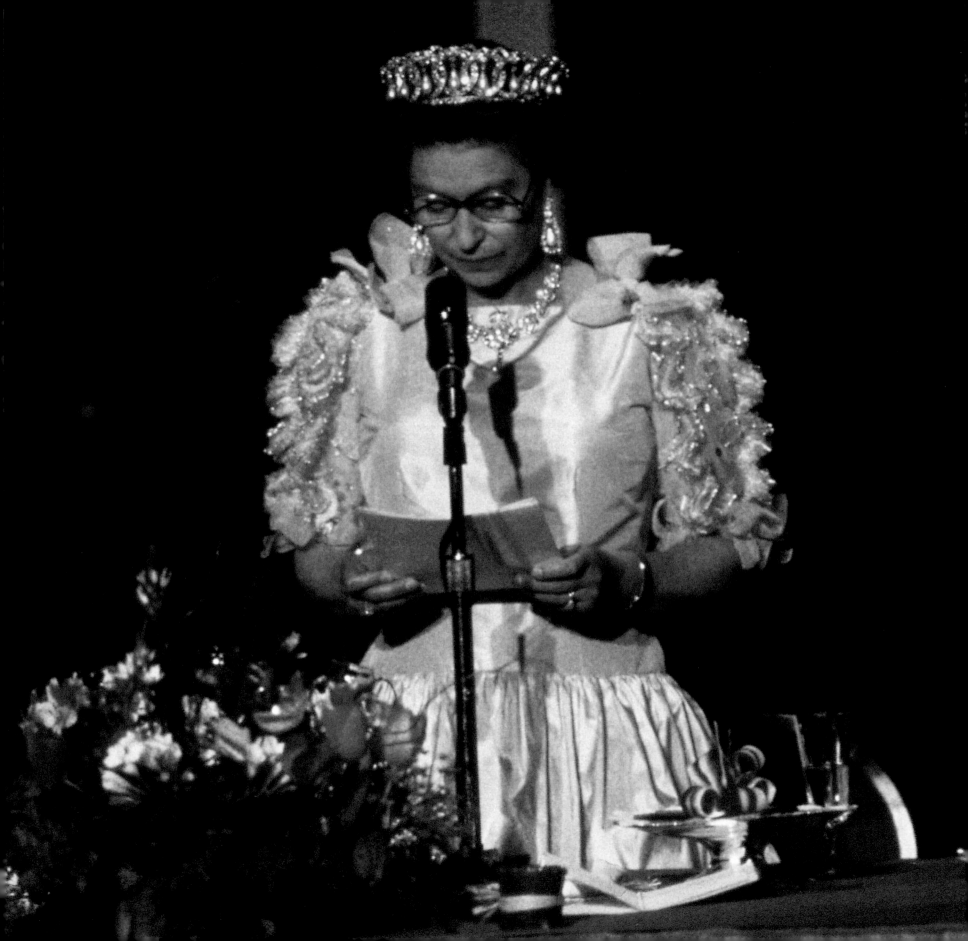

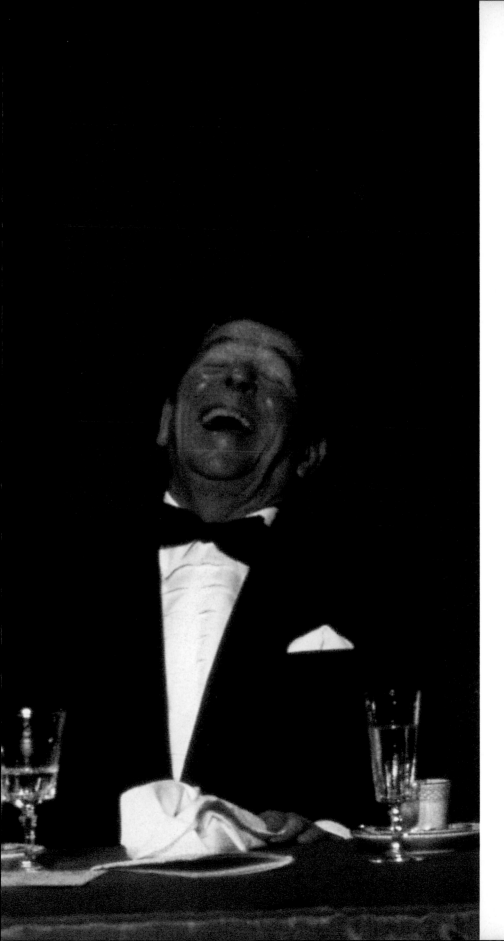

I came without a tripod that evening to the state dinner the Reagans were giving for Queen Elizabeth in San Francisco. I remember borrowing a monopod, which I promptly broke. I could only get it halfway up, so I took this picture almost sideways and doubled over—and not from laughter.

— *D.W*

"The queen had visited our ranch on a day when the rain just wouldn't stop. In her speech she said she knew the Puritans, when they came to the New World, brought many customs from England, but she hadn't realized they brought the rain with them, too. As you can judge from my reaction, she is very good at telling a joke."

— *Ronald Reagan (1990)*

1988 - 1992

THE GEORGE BUSH YEARS

President George Bush's long career in public service and his years as Ronald Reagan's Vice President had made him and Barbara Bush very familiar figures to White House photographers, as we were to them. The President and Mrs. Bush always seemed very thoughtful toward everyone, whether guests, staff, or press. Gracious and fun loving, the President always remembered the names of those he called—affectionately, I hope—his "photo dogs." One morning, when I was with a small pool of photographers in the Oval Office, I remember the President saying something like, "Good morning, guys, Ron, Wally, Chick, Frank...and, oh yes, Lady Di!" That nickname stuck throughout my years on the White House beat.

There was plenty to photograph during the Bush Administration aside from official business. His children were often at the White House, and the joy of his grandchildren running out to meet "Gampy" as he got off the helicopter was a treat to record. The President had a horseshoe pit built near the White House pool, he drove a cigarette boat fast along the coast of Maine, and he often enjoyed golf, tennis, and fishing. Through it all, his nearly worn-out photographers trailed behind.

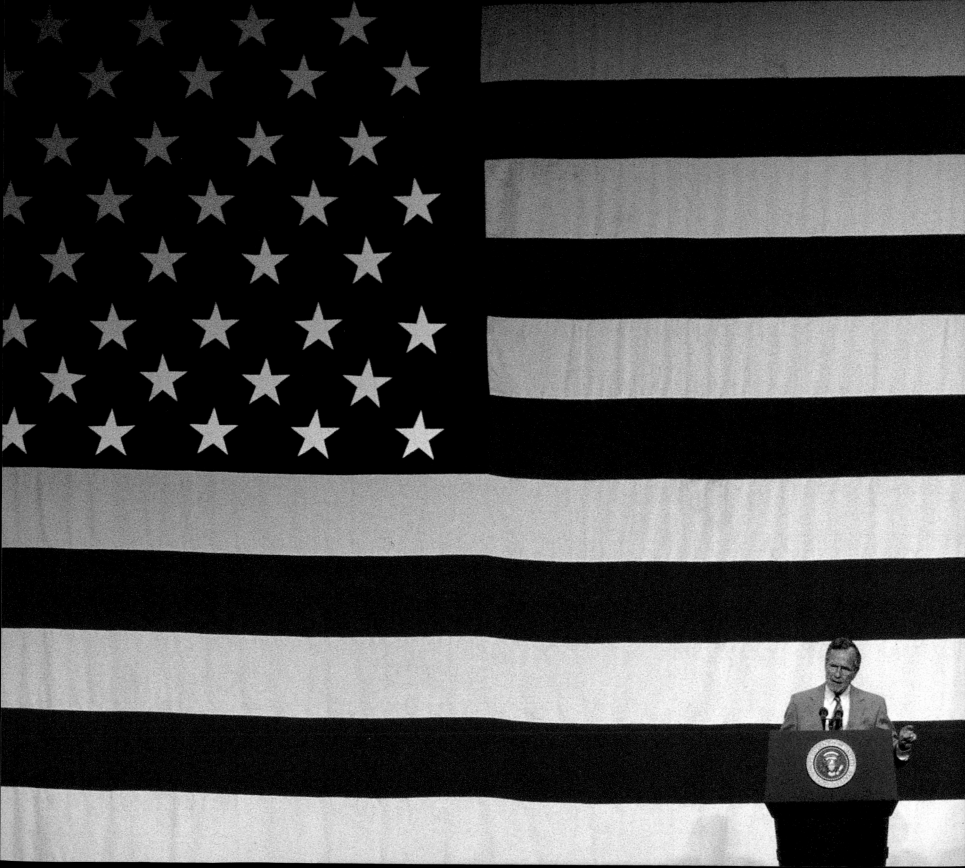

Everywhere a President makes a speech, there is usually some kind of backdrop with a flag, a logo, a symbol. With a backdrop the size of this one, it's hard to find the President.

— *D.W.*

I can't remember what is happening in this picture, but when kids are part of an event there is always fun and color—and often they steal the show.

— *D.W.*

During the pre-Inaugural festivities at the Lincoln Memorial, President-elect Bush held one of his grandchildren, Ellie LeBlond, on his lap. Suddenly, I caught Bush opening his mouth at the direction of Dr. LeBlond, who wanted to see her grandfather's tonsils with her little flashlight.

— *D.W.*

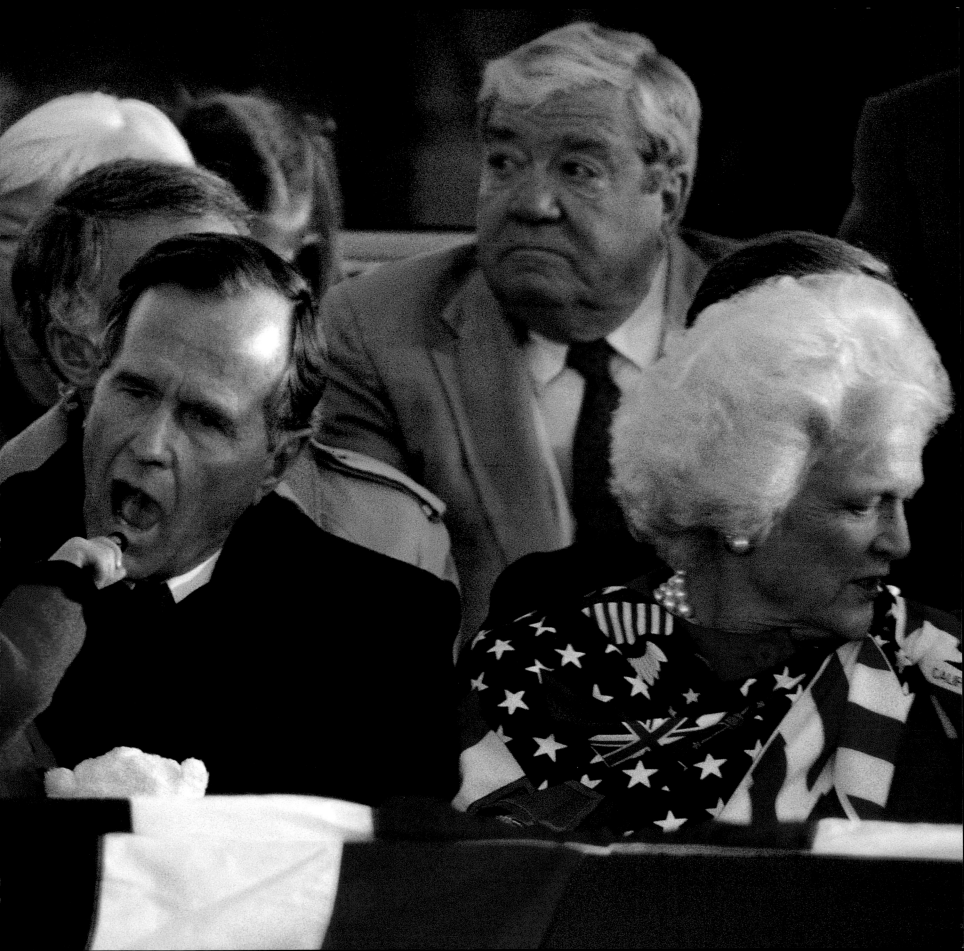

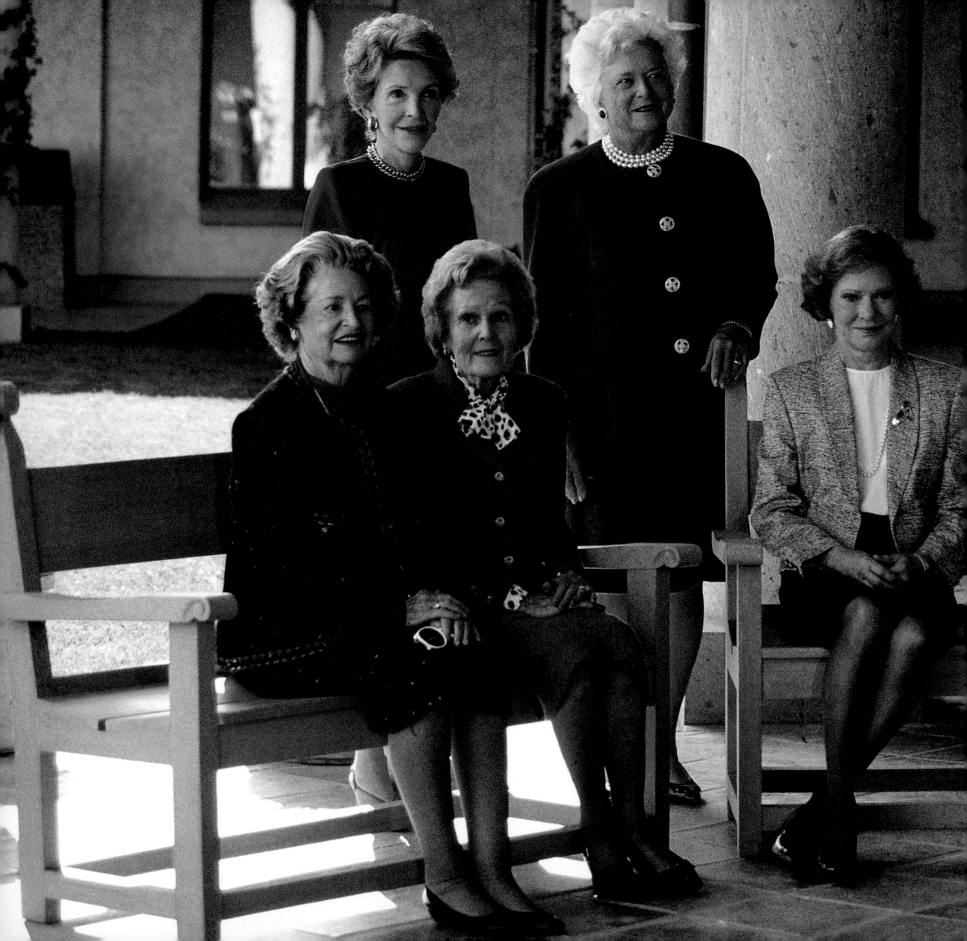

As the First Ladies posed for photographers at the opening of the Ronald Reagan Library, I thought then, as I do now, how very much these women have in common as a result of their similar experiences. But each had her own interests and agenda and each made the most of being First Lady in her own unique way.

— *D.W.*

Left to right: Lady Bird Johnson, Nancy Reagan, Pat Nixon, Barbara Bush, Rosalynn Carter, and Betty Ford, Ronald Reagan Library, Simi Valley, California, November 4, 1991 • **103**

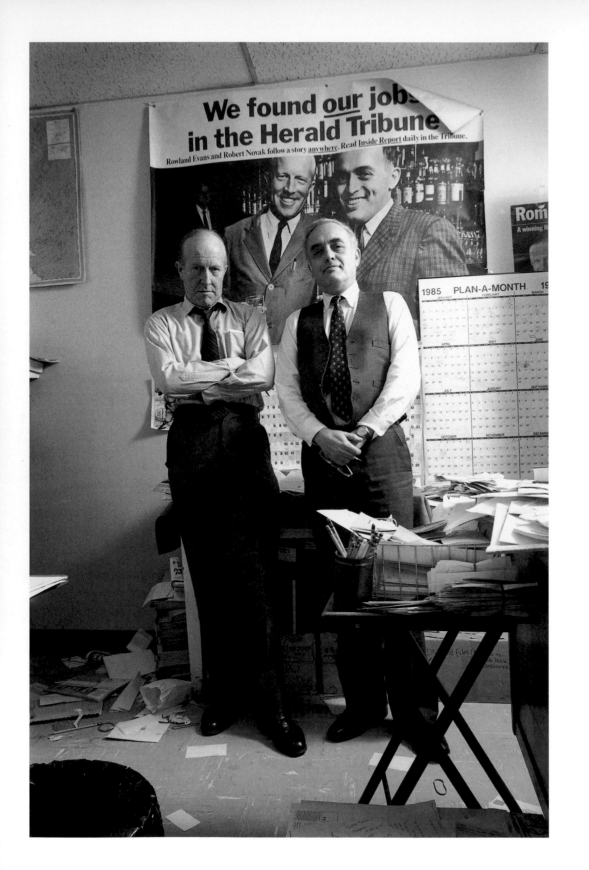

Rowland Evans (1922–2001) and Robert Novak wrote a syndicated column and did television together until Rowly's retirement in 1993. Bob Novak continues his column of inside reporting on the political scene.

I photographed them in their office, where information gathering seemed to have priority over housekeeping. On a personal note, Rowly had been a family friend since I was a child. I remember his look of surprise when he discovered that the photographer crawling around his feet at a Mondale press conference in Iowa turned out to be little Diana, all grown up.

— *D.W.*

"I don't remember, but it's quite possible I gave him those glasses. He was such a good sleeper in meetings that we named a Scowcroft award for him, given annually for the person who fell most soundly asleep during a Cabinet meeting. You get marks for a quick recovery, too. It was a wonderful award. He never fully appreciated it."

— *George Bush*

"Isn't that funny. What a great man."

— *Barbara Bush*

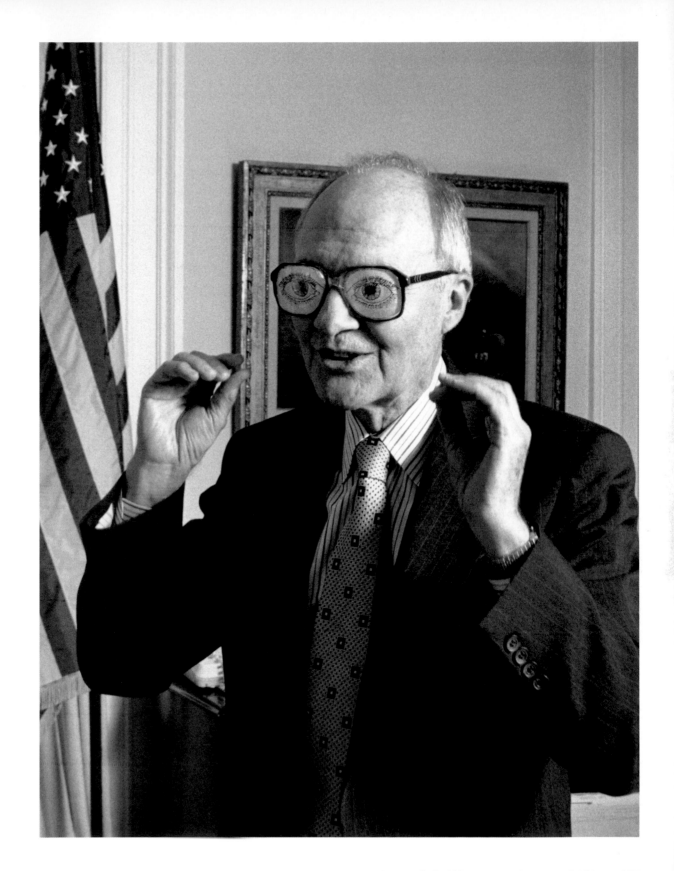

Brent Scowcroft, the White House, October 10, 1991 • **105**

"By then, you know, I'd been nominated Vice President in '80 and '84, then President in '88, so this wasn't quite as unique a feeling, but there's always something special about it. It's not scary like it would be if it was your very first time. But it was great, and it was a warm reception. It's a friendly audience when you go to a party convention. So this is pretty easy, actually."

— *George Bush*

Following pages:

"A very emotional day because I'm very emotional about our military and those willing to serve. I shook hands with every single one of those cadets in the graduation class. I don't remember the exact year or the date, but I do remember the emotion of seeing these wonderful young men and women who want to serve their country."

— *George Bush*

106 • Republican National Convention, Houston, Texas, August 20, 1992
Following pages: Air Force Academy Falcon Stadium, Colorado Springs, Colorado, May 29, 1991

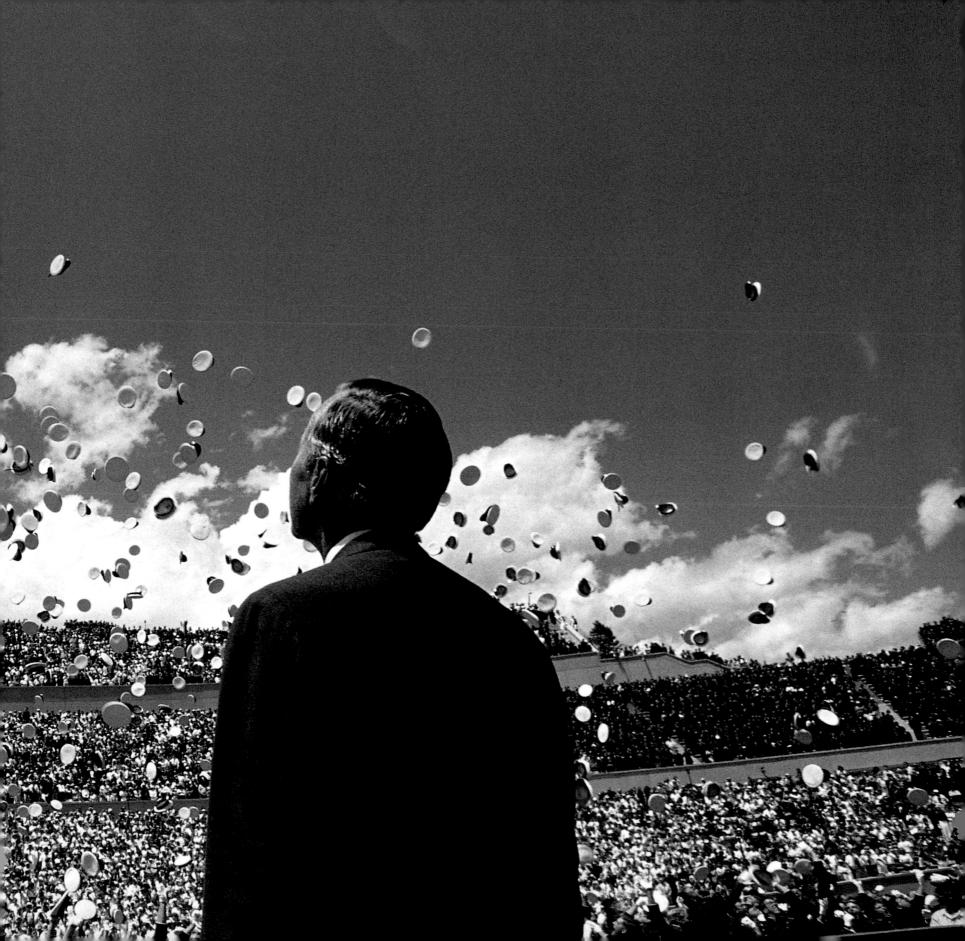

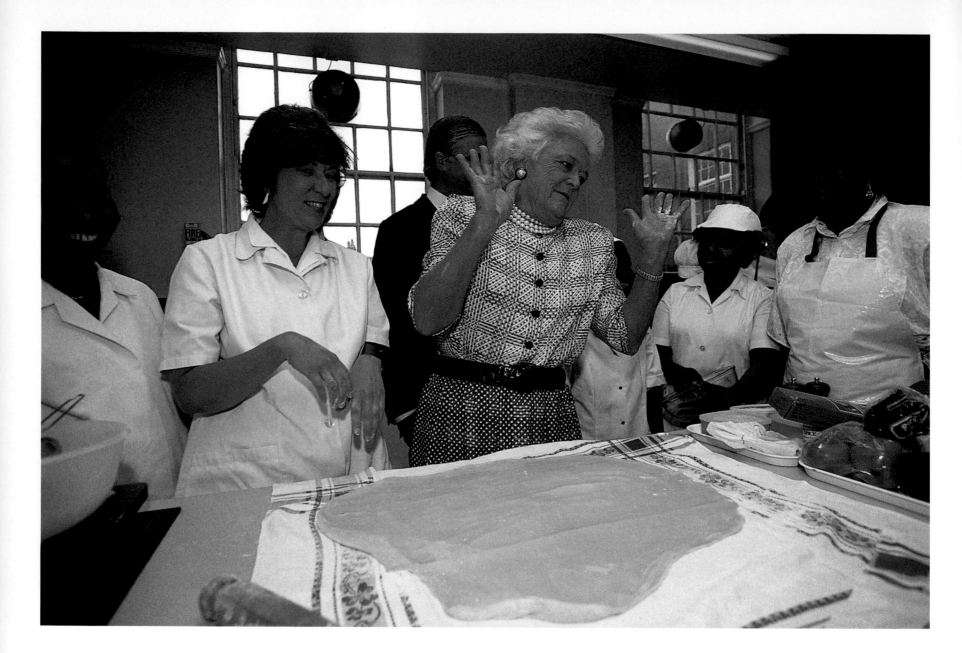

First Ladies are often called upon to be good sports and do unusual activities, such as flamenco dancing for Nancy Reagan or spinning a basketball for Rosalynn Carter. Here, Barbara Bush is presented with a piecrust at an adult education center in the Brixton section of London. Mrs. Bush had delighted participants with a remark about how her piecrust was not exactly something to write home about. — *D.W.*

"Surely I wouldn't have stood there in those shoes if I'd known you were taking that picture!

No, I'm kidding. The truth is, that's very real. I was taking the dogs for a walk. Aren't they cute?

Everybody in the White House certainly helped with those puppies." — *Barbara Bush*

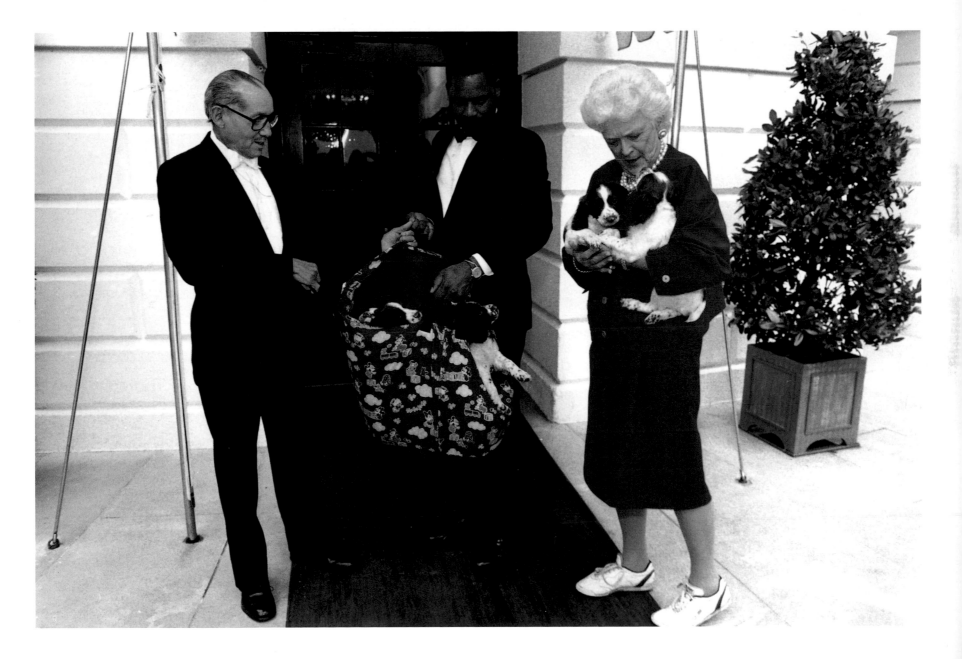

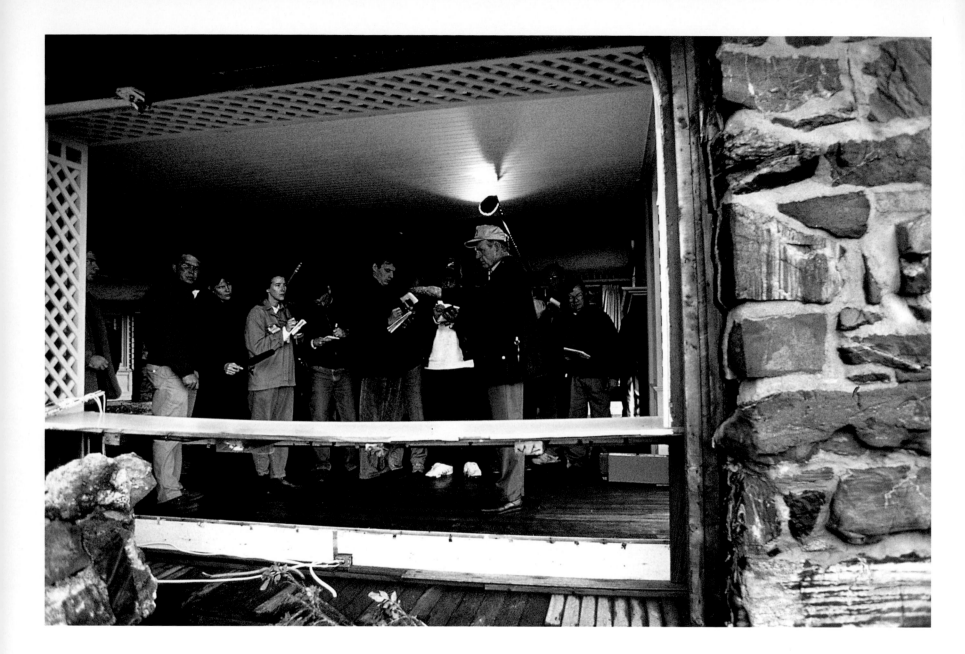

112 • Walker Point, Kennebunkport, Maine, August 1991

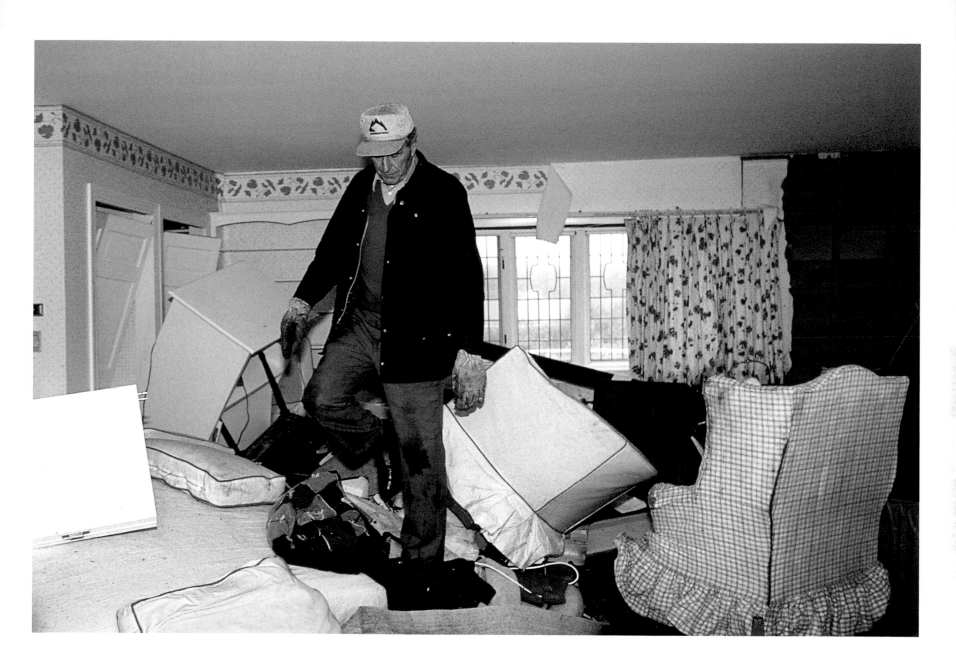

Presidents so often have to visit disaster scenes caused by earthquakes, fires, and floods. Here, President Bush

leads the press on an inspection of his own home in Maine, which suffered severe damage from Hurricane Bob

in 1991. Seeing the President step over his own bedroom furniture was poignant — *D.W.*

"Gorbachev and I were riding solo in a cart and being followed closely by the Secret Service and his security people, and he almost tipped me over. I let him drive, a huge mistake. Camp David contributed to the atmosphere so well because there everybody could relax. This, I think, is about the only shot taken with a necktie. We had a great time up there and got a lot done." — *George Bush*

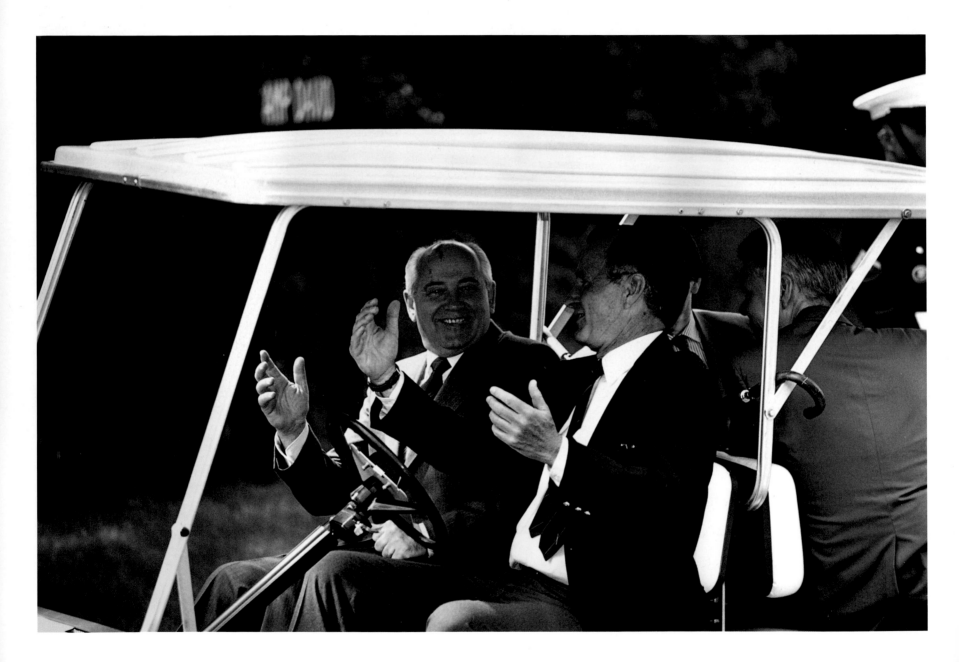

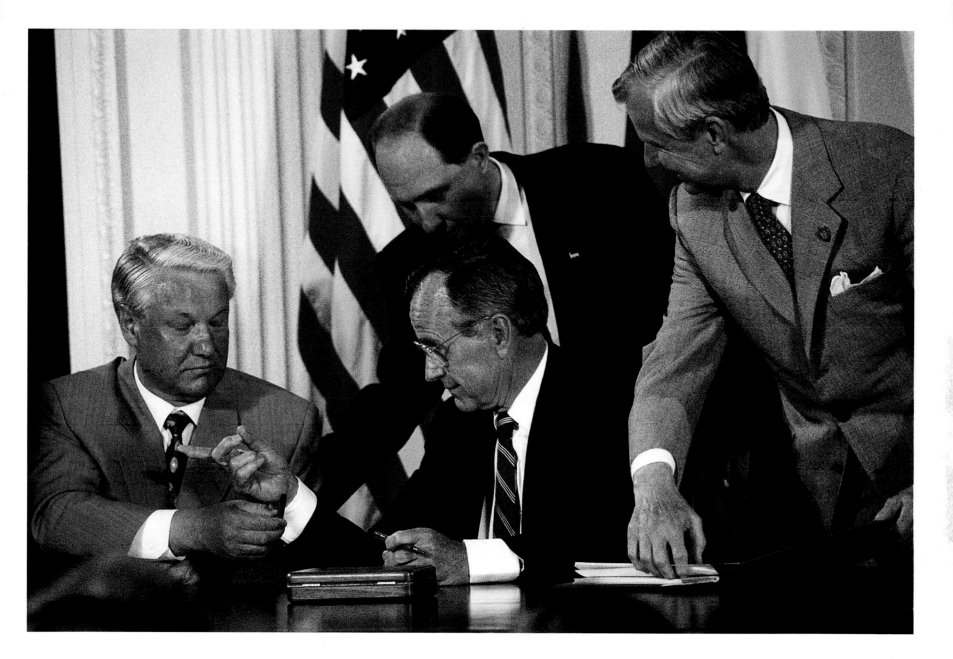

"When I got to know Yeltsin, we had a very pleasant personal relationship, and he was good to work with. We signed a very important arms control treaty in the last few days of my Presidency—the Start II agreement to eliminate all the multi-warhead intercontinental ballistic missiles. On a personal basis, his mother was sick one time and I sent a crew over from Bethesda Naval Hospital. Yeltsin was extraordinarily grateful for the medical attention that our heart team gave to his mother." — *George Bush*

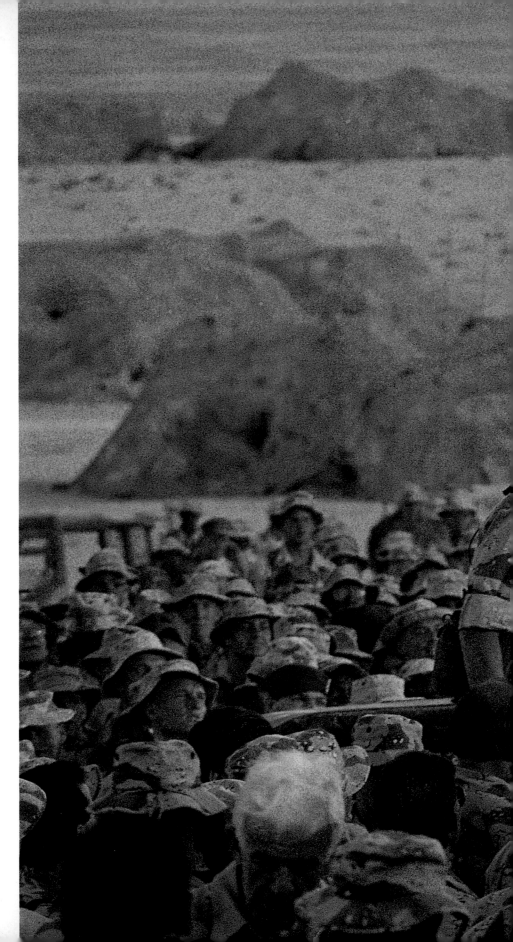

I was following President Bush as he visited American troops in Saudi Arabia on Thanksgiving at the time of Desert Storm. The sun was going down, and I felt I didn't have an image that showed the drama of where we were. At last we had a clear view of Bush standing above the troops. He began to throw souvenirs to the soldiers—tie clips, key rings. The light was beautiful but going quickly, and as I squeezed the shutter, all I could do was hope I was steady and that my exposure was right, because I knew I'd have a picture.

— *D.W.*

"I had a pretty good idea on Thanksgiving of 1990 that we were going to have to fight. We were still trying diplomacy and using the United Nations and all that, but I had my mind set that we were going to have to go to war, and the irony is that troops we talked to were saying, 'We're ready. We want to get it over and go home.' And nobody in the United States believed they could get it over with such speed and such efficiency and with so little loss of innocent life. But when I looked out at these faces, at this point I know I was thinking, 'How many of these kids are going to die for their country?'"

— *George Bush*

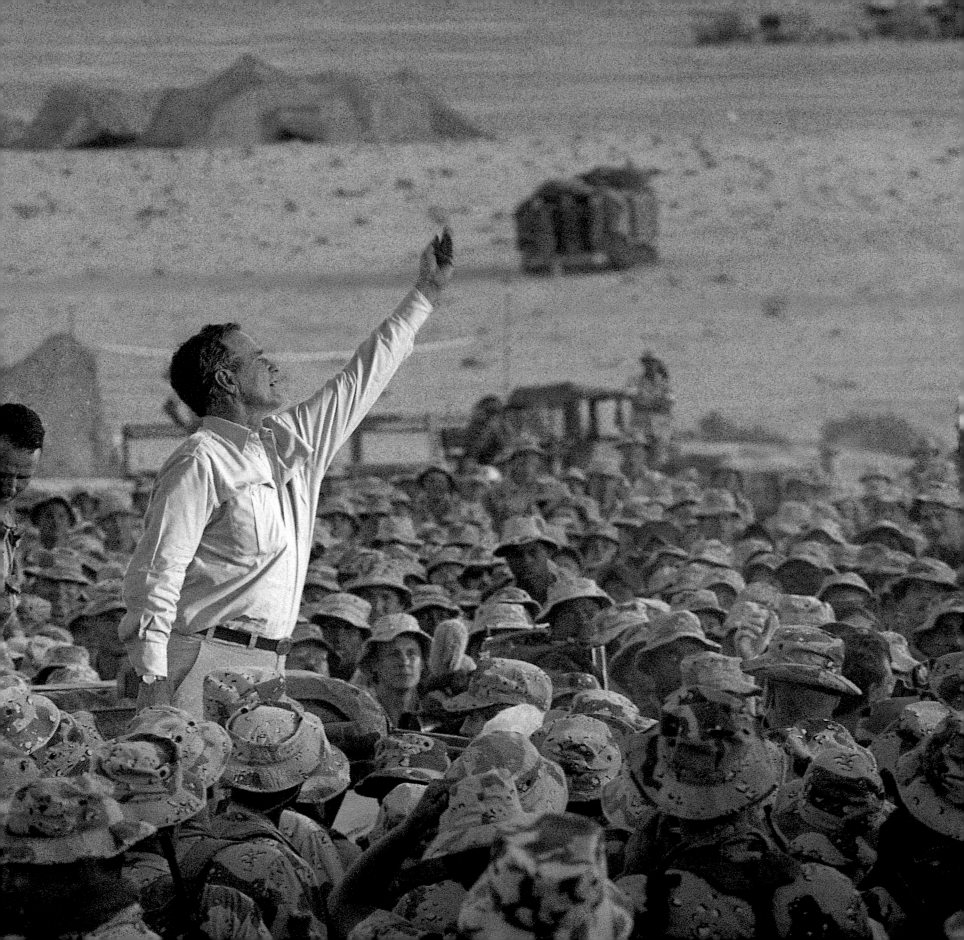

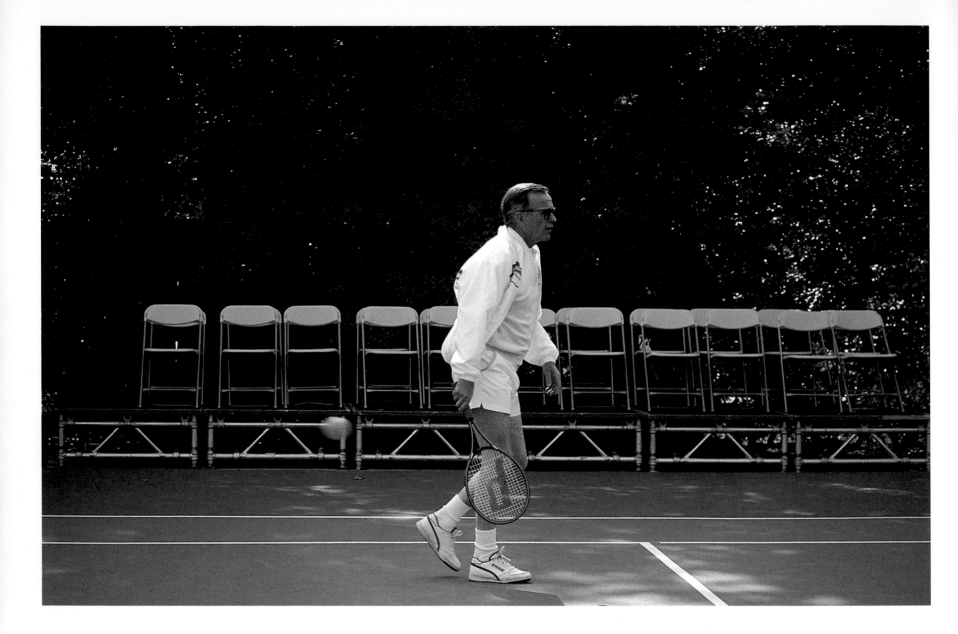

Always the athlete, Bush had regular tennis games at the White House.

Here, he warms up for a match with Bjorn Borg. — *D.W.*

As we watched the President enjoying a demonstration of ancient Japanese imperial court

ball in Kyoto, there was no question in the photographers' minds that Bush would jump in

and give it a go. — *D.W.*

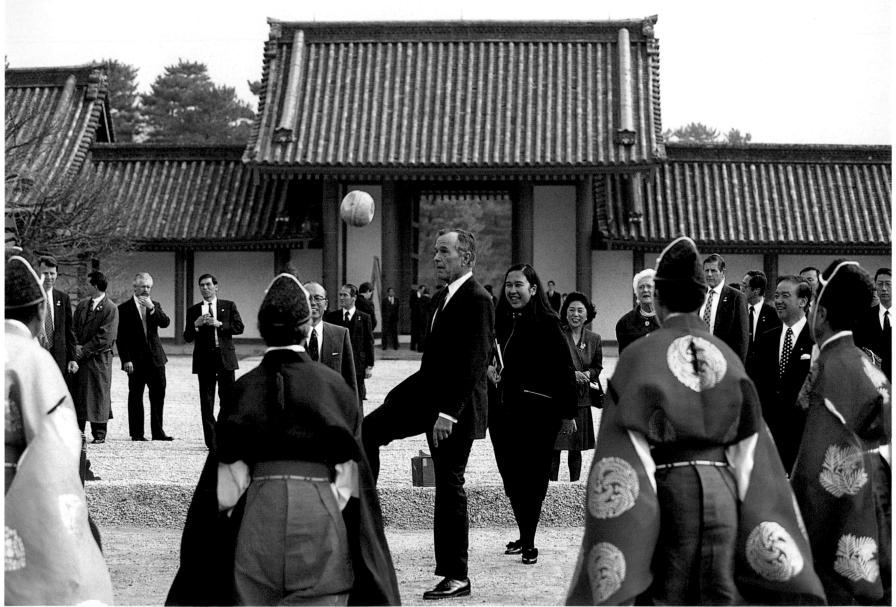

Probably the most impressive and exotic spectacle I saw while I covered the Presidency was the funeral of Emperor Hirohito of Japan. Arriving at the gates to get into position before dawn, we waited in the cold rain. Each guest was handed an identical see-through umbrella, making their entrance into the funeral pavilion a unique and beautiful sight.

— *D.W.*

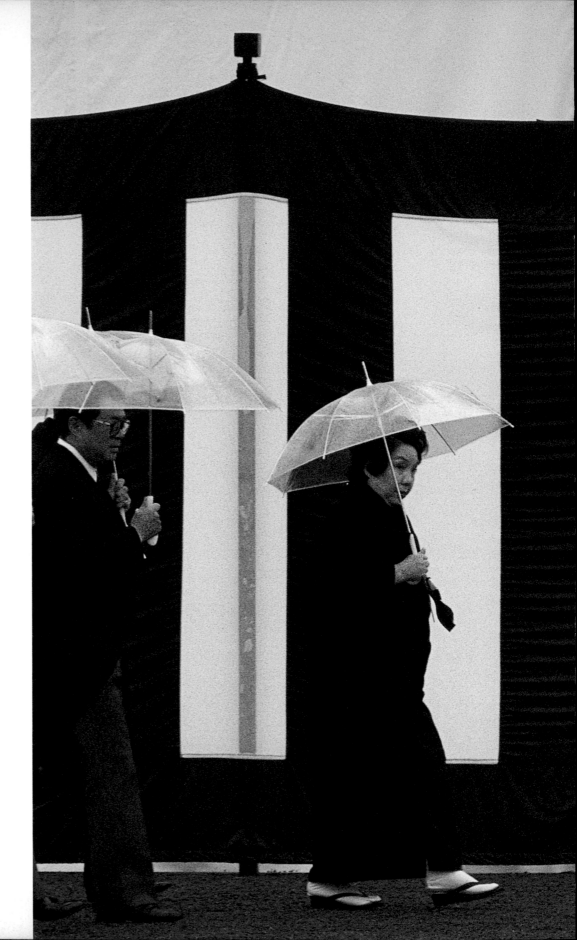

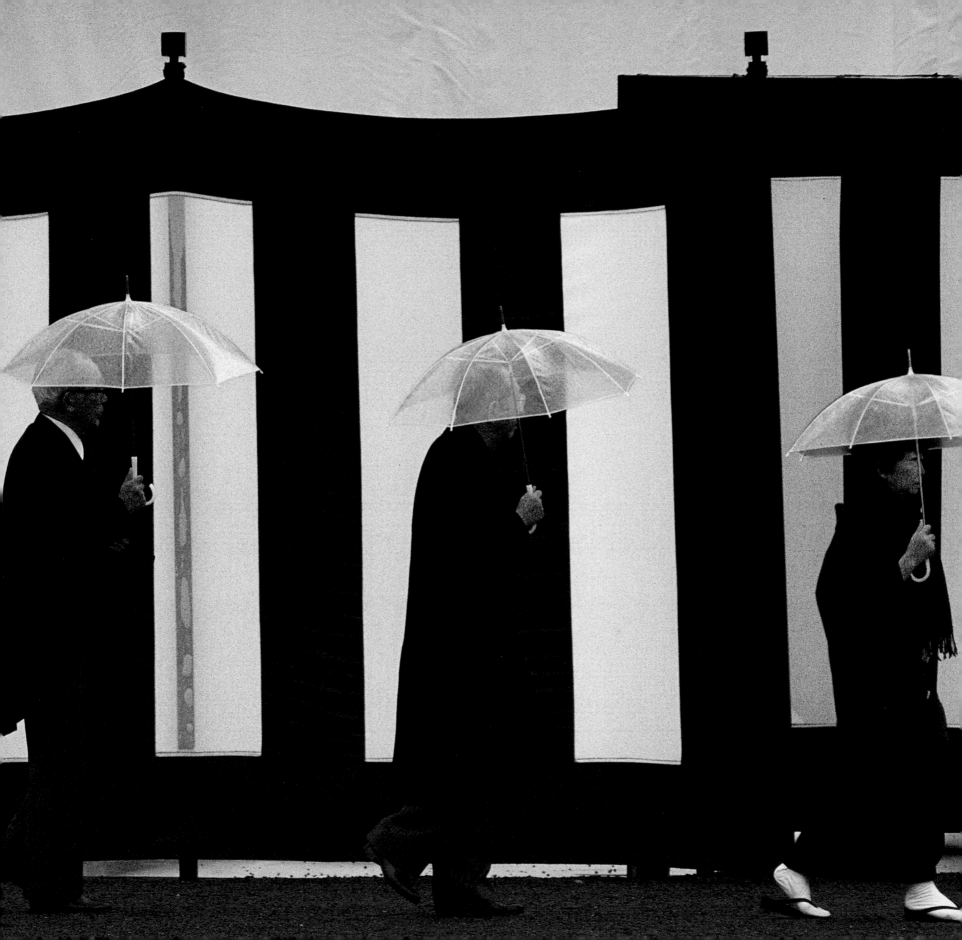

"Dan Quayle. Nice man. He was very loyal and very unfairly criticized."

— *George Bush*

With the election of 1992 closing in, Bush refuses an umbrella at a rally,

preferring to get soaked. This seemed to me to be an extra effort to

connect with his audience, to drive his message home.

— D.W.

In Houston, the day Bush arrived at the convention, he and Mrs. Bush made a call on former President and Mrs. Reagan in their hotel suite. After a photo op for the press corps in the hallway, I was allowed to follow the Presidents and First Ladies into their private meeting. Later, President Reagan addressed the convention and endorsed Bush's nomination for a second term. Two years later Reagan announced his Alzheimer's disease to the American public.

— *D.W.*

"Nancy's had a tough road. That was 1992. I mean she's had a terrible time with all that. Pretty courageous."

— *Barbara Bush*

"Doro. What a girl. She's wonderful, you know. She is."

— *Barbara Bush*

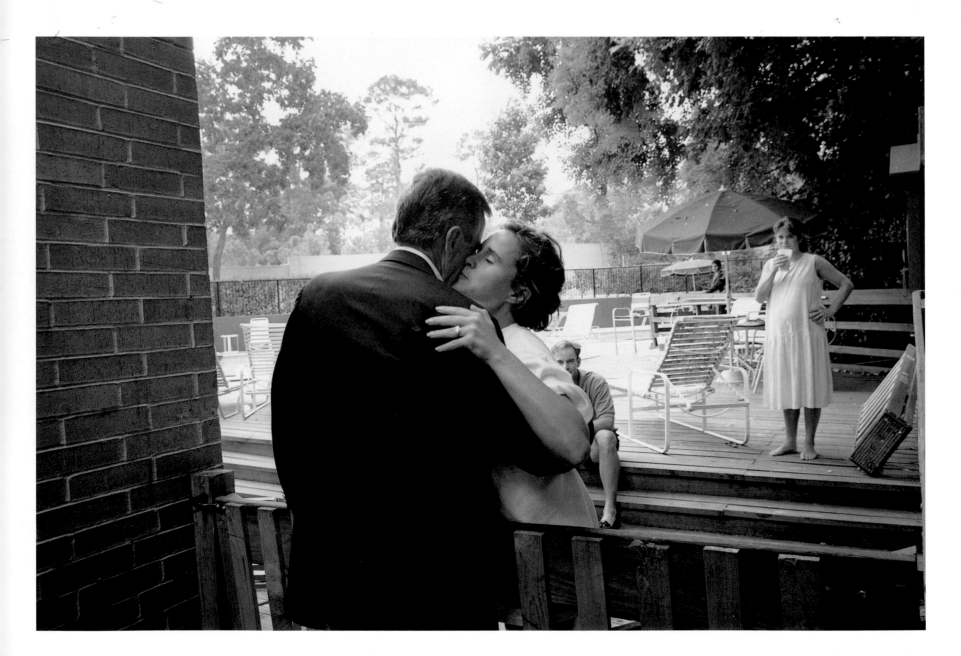

126 • President Bush embraces his daughter, Dorothy, Houstonian Hotel, Houston, Texas, August 19, 1992

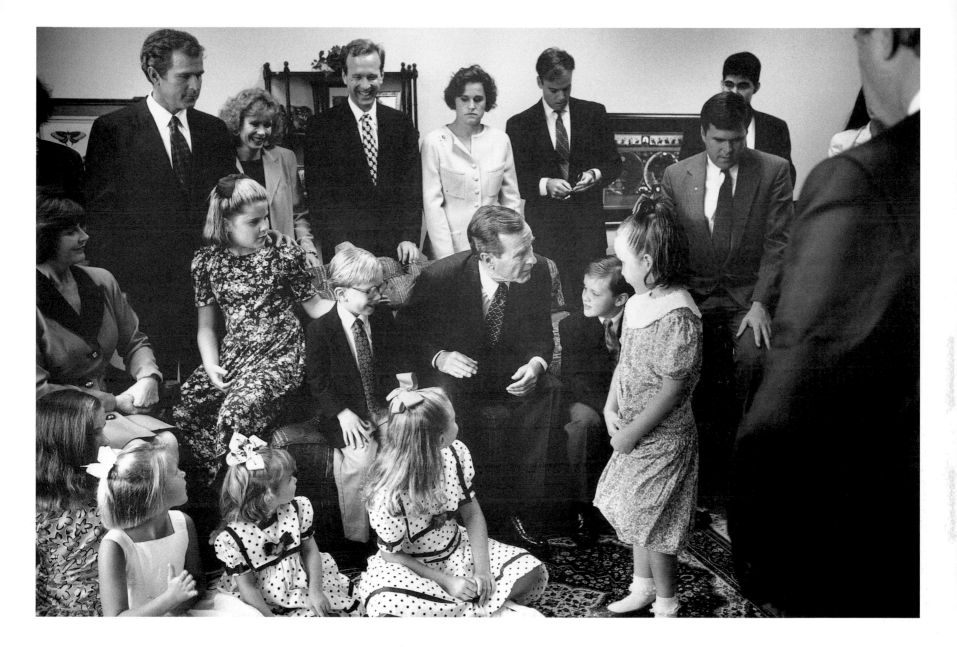

"It's hard to describe what it's like to have a son who is President of the United States. It feels still just like

this, like family. We were all up at Camp David for Christmas in 2001, all 26—every single one of them—and it

was just the same feeling as this, only he's front and center now, as he should be. But it's exactly that way—the

bowling tournaments or the running or whatever. And the dogs and the people. It's great." — *George Bush*

I was allowed some behind-the-scenes opportunities while following President Bush at the Republican National Convention in Houston in 1992. I had been told by the picture editor in New York that I hadn't made a strong lead picture for the story yet, so the pressure was on. I was slipped into the holding room under the stage as Bush waited, with Roger Ailes and Craig Fuller, to make his acceptance speech. Things were pretty quiet as Fuller explained the seating chart for the auditorium. Suddenly Roger Ailes said something that made the President literally stretch out with laughter, and at that moment I knew we had a lead.

— D.W.

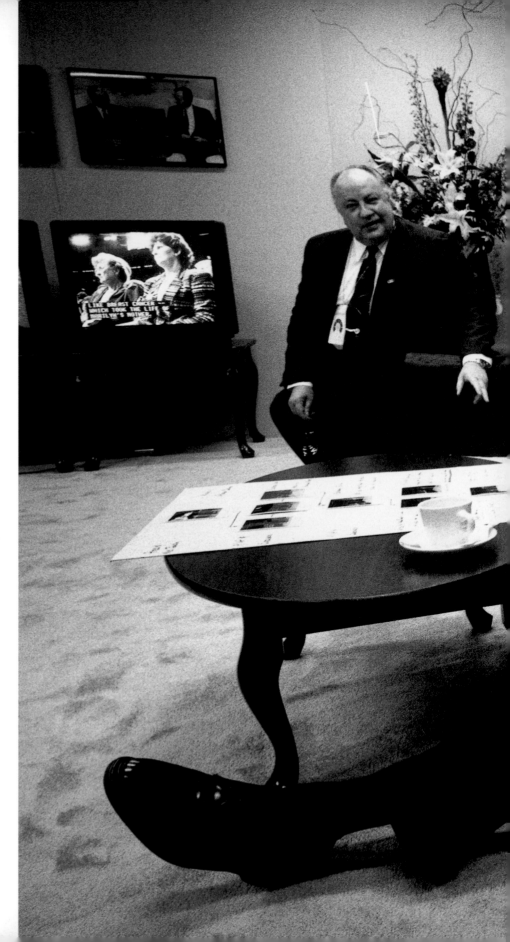

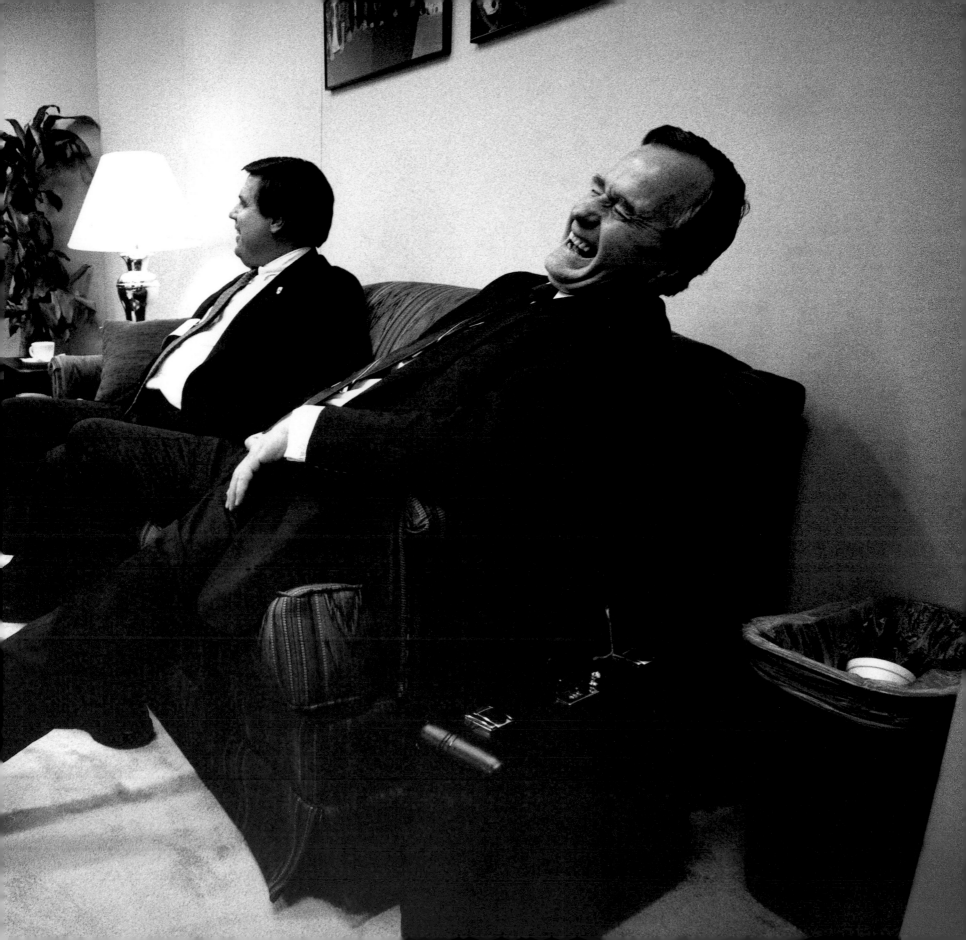

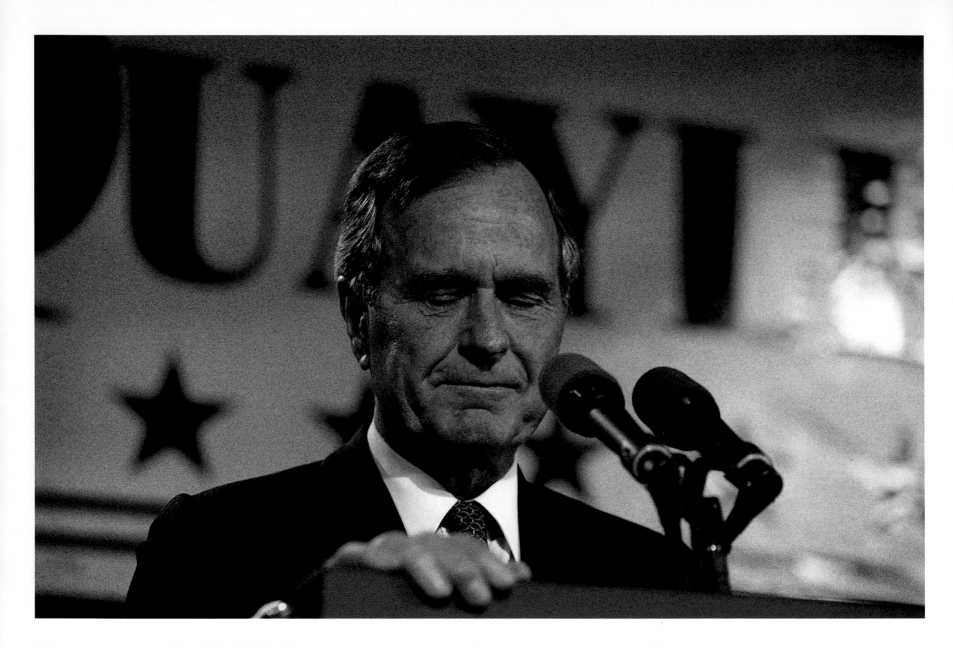

When you are a member of the White House press corps, no matter how you try to stay removed

and apart from the people and the politics, it's hard to see a man you have covered so long, a man

who has become such a familiar person, in a way, lose what he had fought so hard for. — *D.W.*

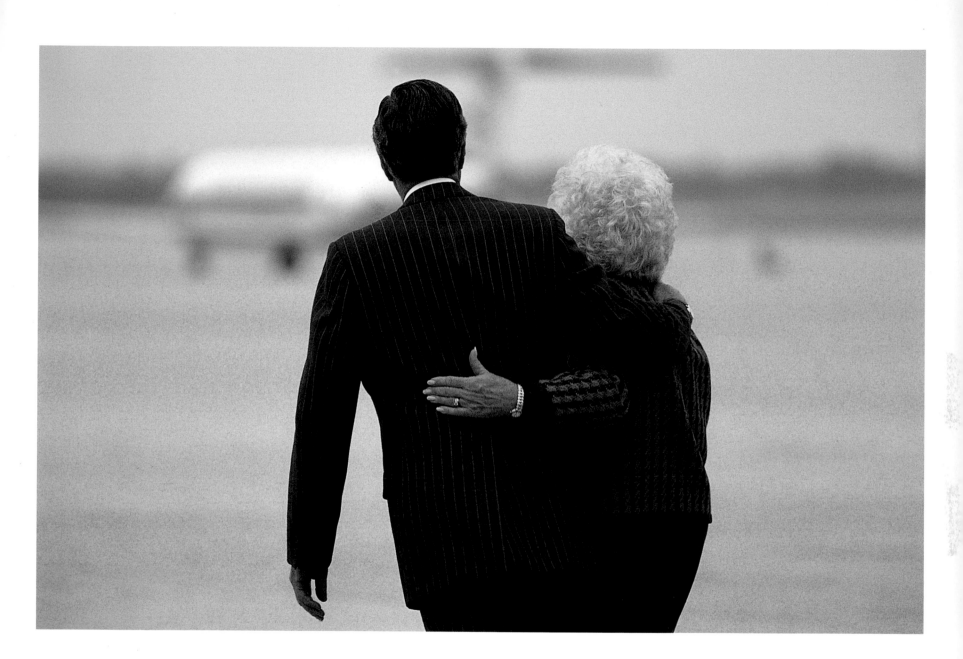

The morning after the election, I felt somehow that the fatigue, the disappointment, and

the ever present grace of the President and First Lady all showed on their backs as they

walked away from Air Force One. — *D.W.*

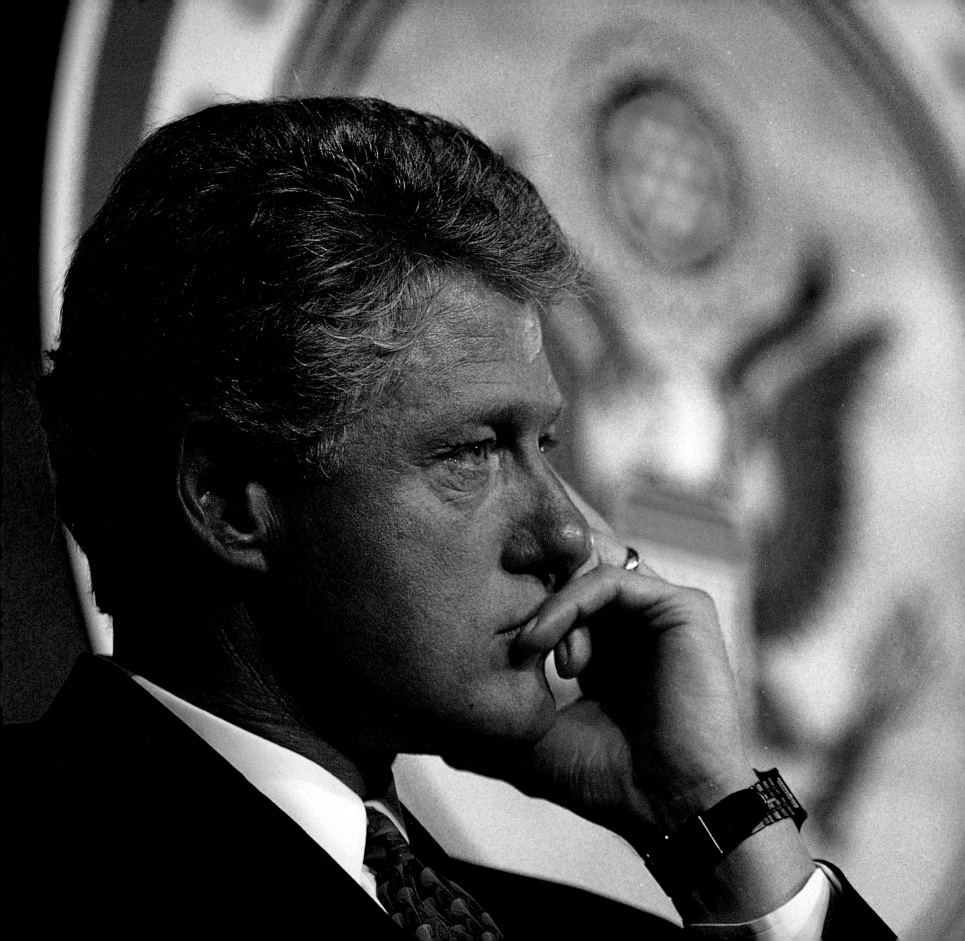

THE BILL CLINTON YEARS

During the Clinton Administration I did extensive behind-the-scenes work, which explains why this section has more black-and-white "private" pictures than color pictures taken from the press area. Whereas in public the President often displayed somewhat predictable expressions, such as his habit of biting his lip, away from the public eye Clinton was the least self-conscious of any person I have photographed. Both the President and Mrs. Clinton, as well as their staffs, clearly understood the value of this kind of photography. They allowed me in often and then seemed simply to forget I was there—just what I was after.

President Clinton appreciated and showed interest in all kinds of photography. About photojournalists he said to me, "You know, photographers try to capture something so that people will see reality. In a way, the intellectual and almost ethical pressures on writers are worse. They always think that they have to say something extra, or spin what they see, or they can't afford to see the whole thing. And great photographers just give it to people. Give them reality. For instance, you did Mandela a lot of favors with the pictures you took of him—not by trying, but just by showing the world who he was and who he is."

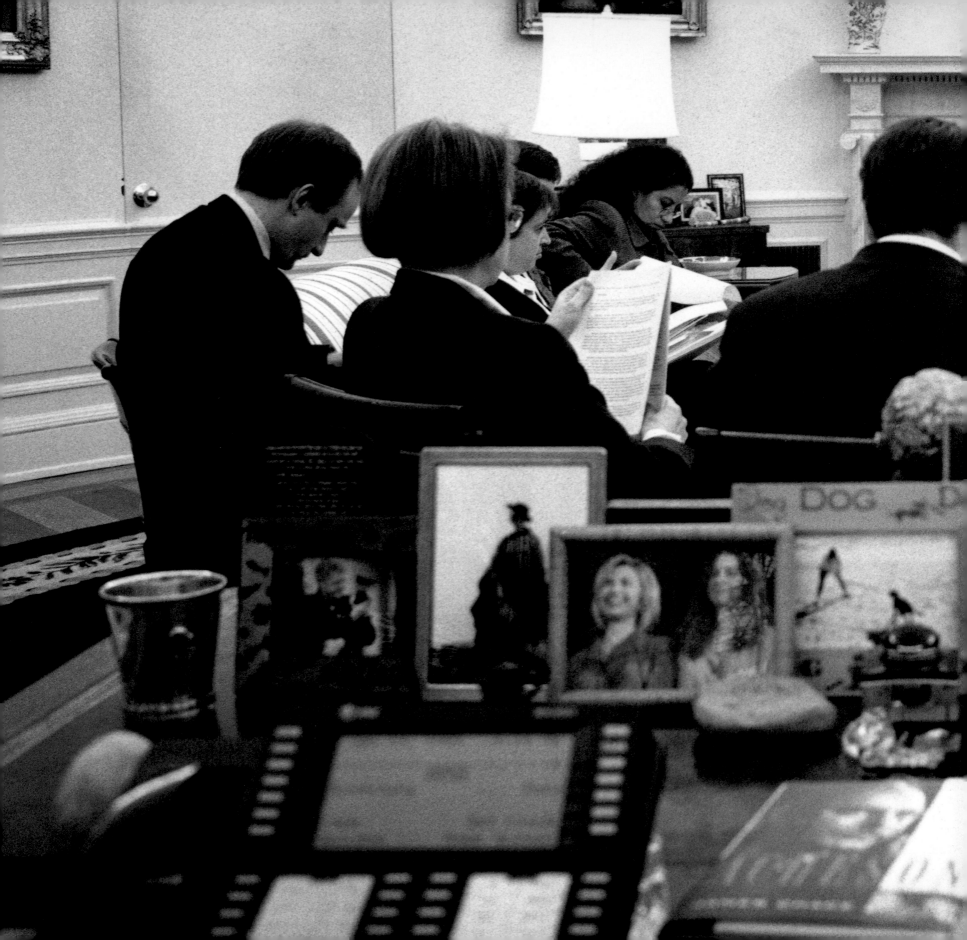

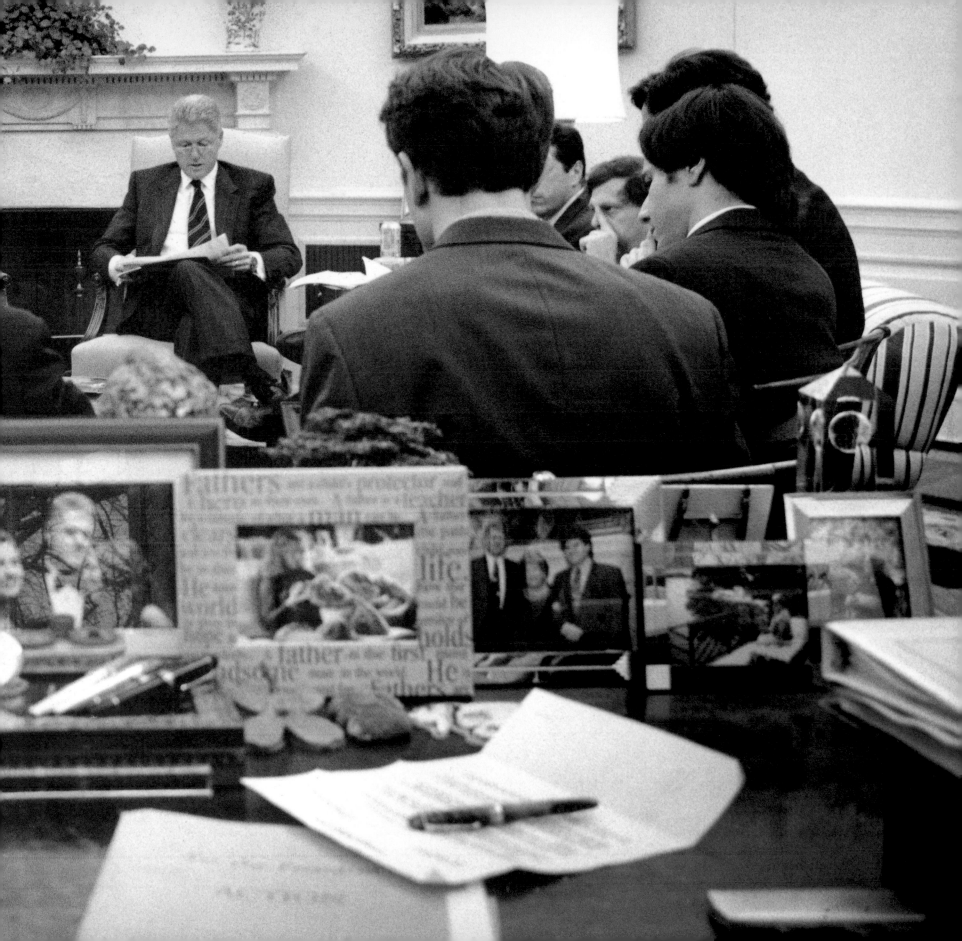

The sound men, whose job is so indispensable to television and radio coverage, are

often yelled at by the still photographers who want the mikes out of the way so

they can make a "clean shot." In this case, the boom mikes seem to enhance the

picture. — *D.W.*

"Doing what comes naturally," as the song goes, at a rally on his whistle-stop trip to the convention in Chicago, Clinton gives a special hug to just-turned-98-year-old Retta Lafaun Plott, who was feeling faint in the sun. Later, he took her up on the stage and had the crowd sing her a happy birthday. — *D.W.*

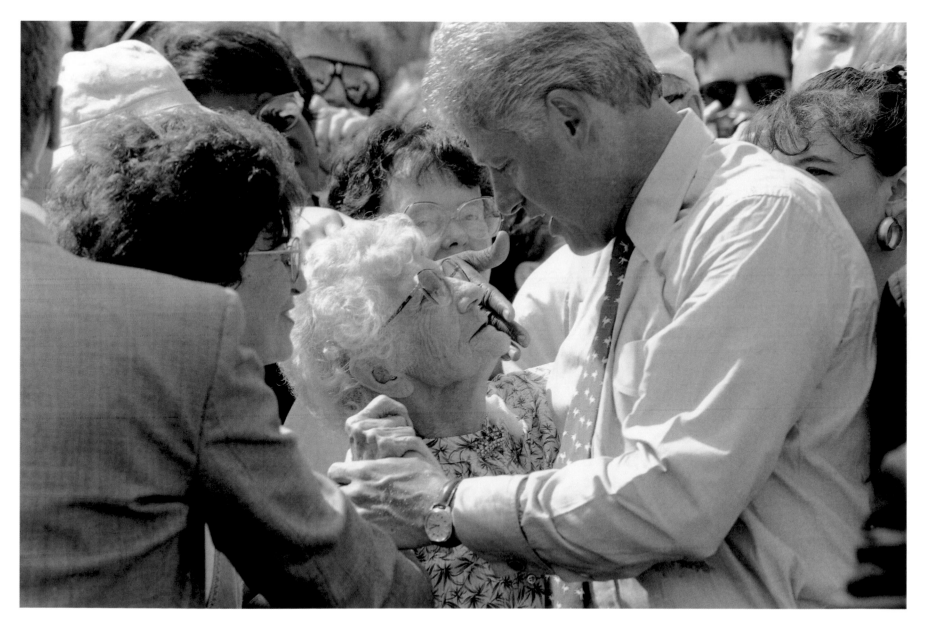

"My first thought about this photo is that my two dear friends and these two great men, King Hussein and Yitzhak Rabin, are no longer with us. I miss them. The world misses them. This is at the signing of the peace agreement between Israel and Jordan. I just thanked these men who worked so hard for peace, and I wanted the world to know the extraordinary courage of these two men who risked everything so that their children and their children's children need fight nor fear no more." — *Bill Clinton*

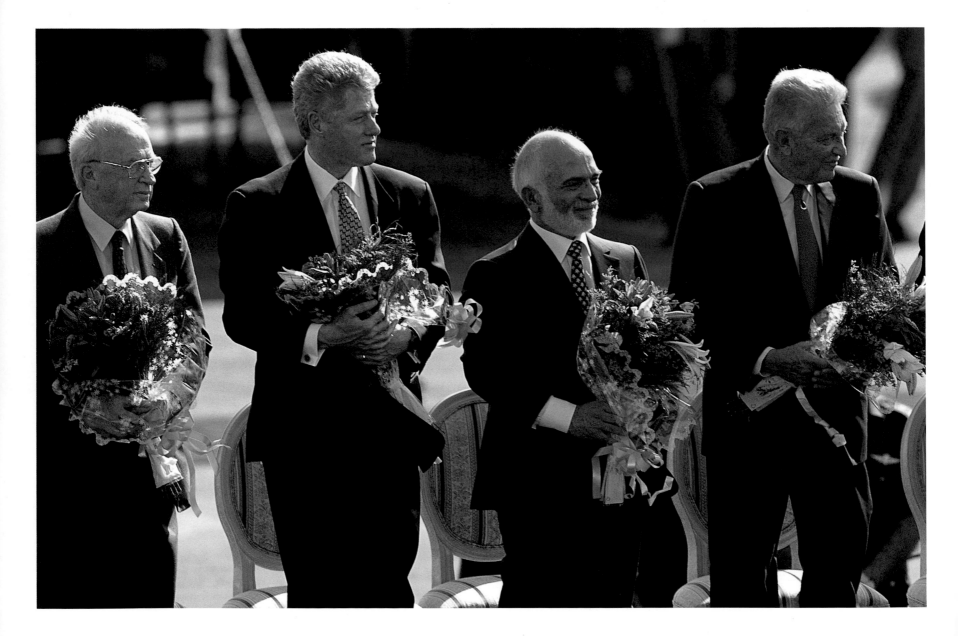

"Hillary and I miss Leah and Yitzhak dearly. Here, I'm telling her that the Middle East lost a friend of peace when Yitzhak was killed, but the work to which she and Yitzhak dedicated their lives must and will continue." — *Bill Clinton*

"You know, I loved Hussein. He was an astonishing human being, a devout Muslim who was committed to world peace and peace in the Middle East and to, you know, actually living—not just a cold peace—but a real, live cooperative future with the Israelis. And he survived many assassination attacks. He had a lot of narrow calls. That sort of life makes some people bitter and harsh, but it made him bigger with each passing year. He was almost saintly by the time he died, Hussein."

— *Bill Clinton*

The press was waiting impatiently in the East Room for a report from the President on the results of the Mideast summit at the White House. I was the only press person on the inside, watching Chairman Arafat and Prime Minister Netanyahu engage in conversation just a few feet away. Like a seasoned actor who still gets butterflies, I tried to stay focused be calm, and make pictures.

— D.W.

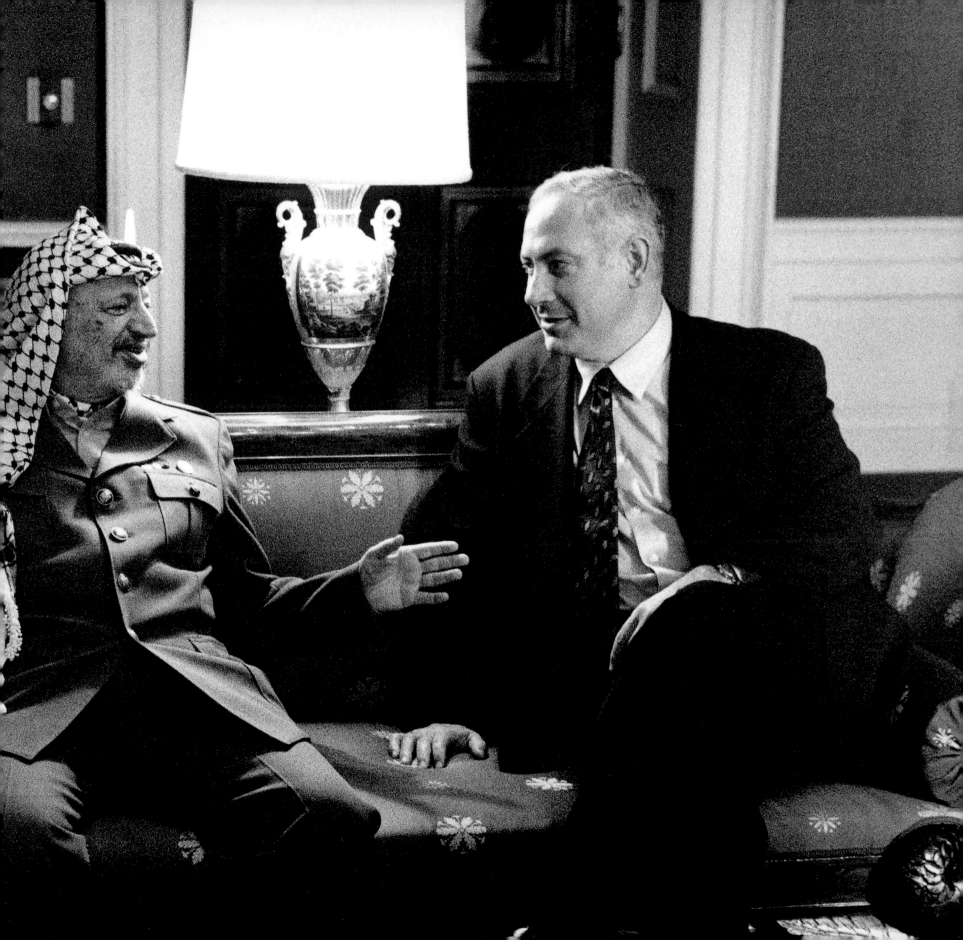

Feeling pressure from *TIME* to be in the President's suite when he received the concession call

from Senator Dole, I waited nervously in the corridor without much hope of getting in. Suddenly

I was rushed into his room. I had time to shoot one or two frames—just enough for history. — *D.W.*

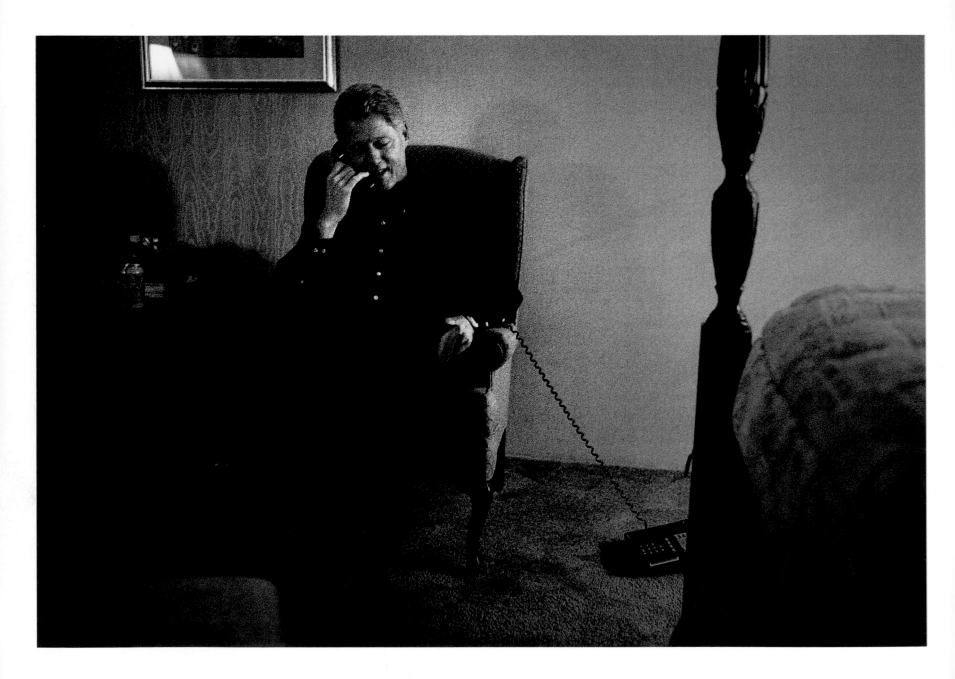

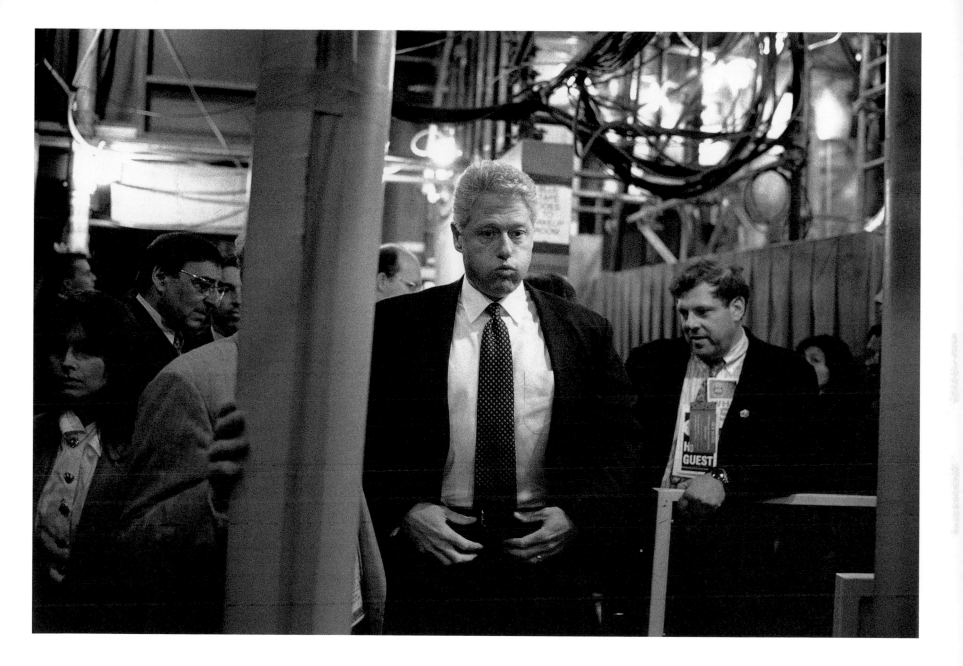

About to accept the Democratic nomination for President for the second time, President

Clinton, waiting backstage, suddenly took an enormous deep breath as his name blared

over the loudspeaker and the crowd began to roar. — *D.W.*

"I love this picture. It's my husband and daughter in one of those moments where she is, I'm sure, explaining some teen pop culture kind of fact to her bemused father." — *Hillary Clinton*

"You know, that's the most important job I ever had—being her father. And I love her so much." — *Bill Clinton*

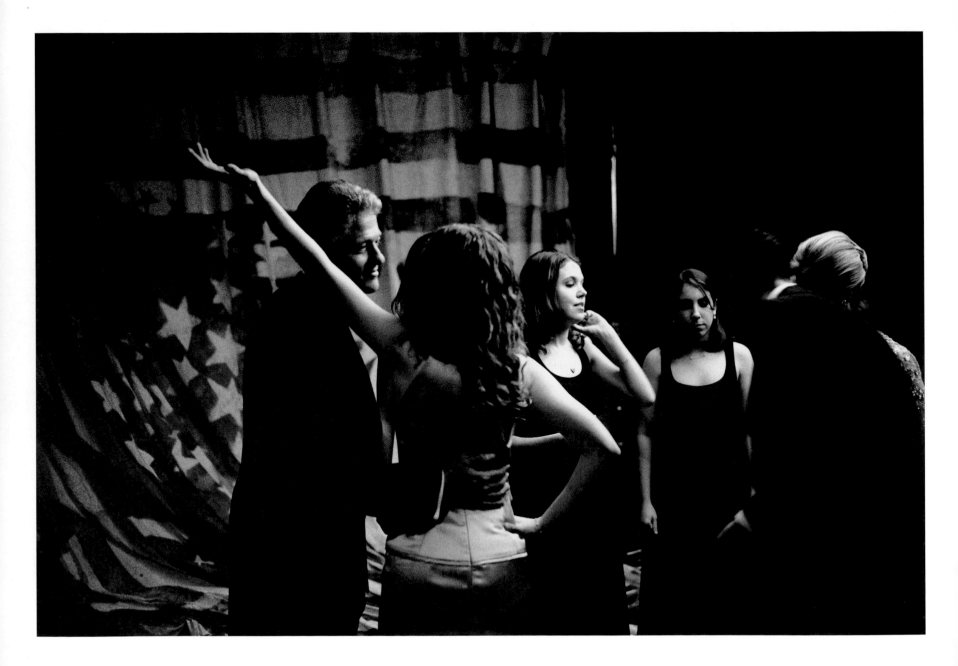

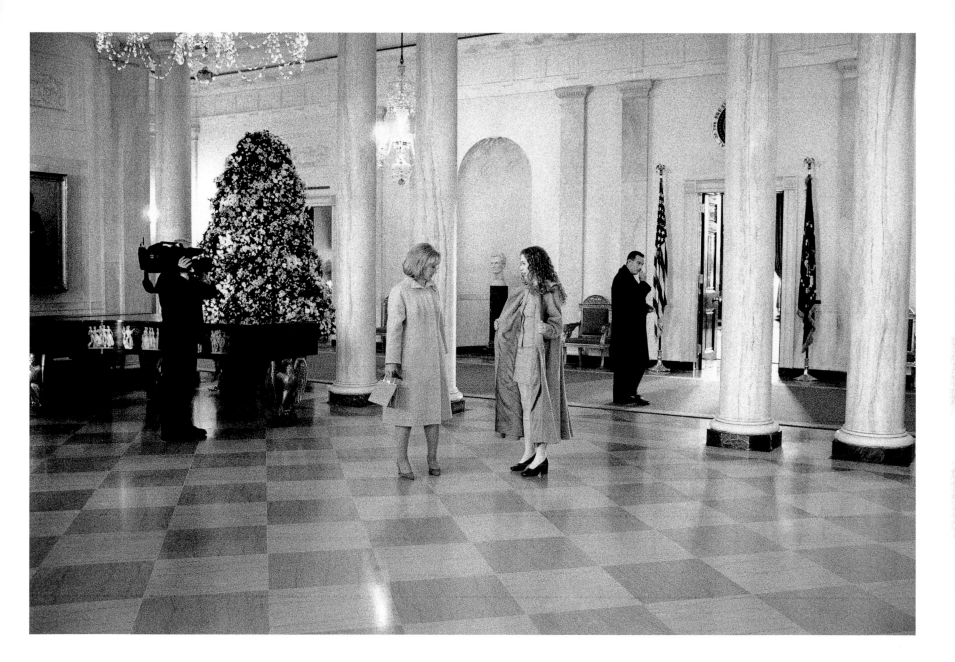

"I had not seen the suit that my daughter had picked out for the Inaugural Parade. And as long as

she kept her coat on I was going to be happy—which, of course, didn't happen." — *Hillary Clinton*

When I see a presidential limo drive by, I often wonder what's going on inside. Vice President Gore would take that time to read downloaded messages on his computer, and the President often read reports prepared for him. Here, riding with Hillary Clinton, I was delighted to discover that, once business and schedules had been discussed, the First Lady and her chief of staff, Melanne Verveer, could just kick back and have fun.

— *D.W.*

"Melanne, my former chief of staff, is a wonderful friend. So is her predecessor, Maggie Williams. They really broke new ground in the White House, and they led a fantastic staff of people who were tremendously dedicated and smart."

— *Hillary Clinton*

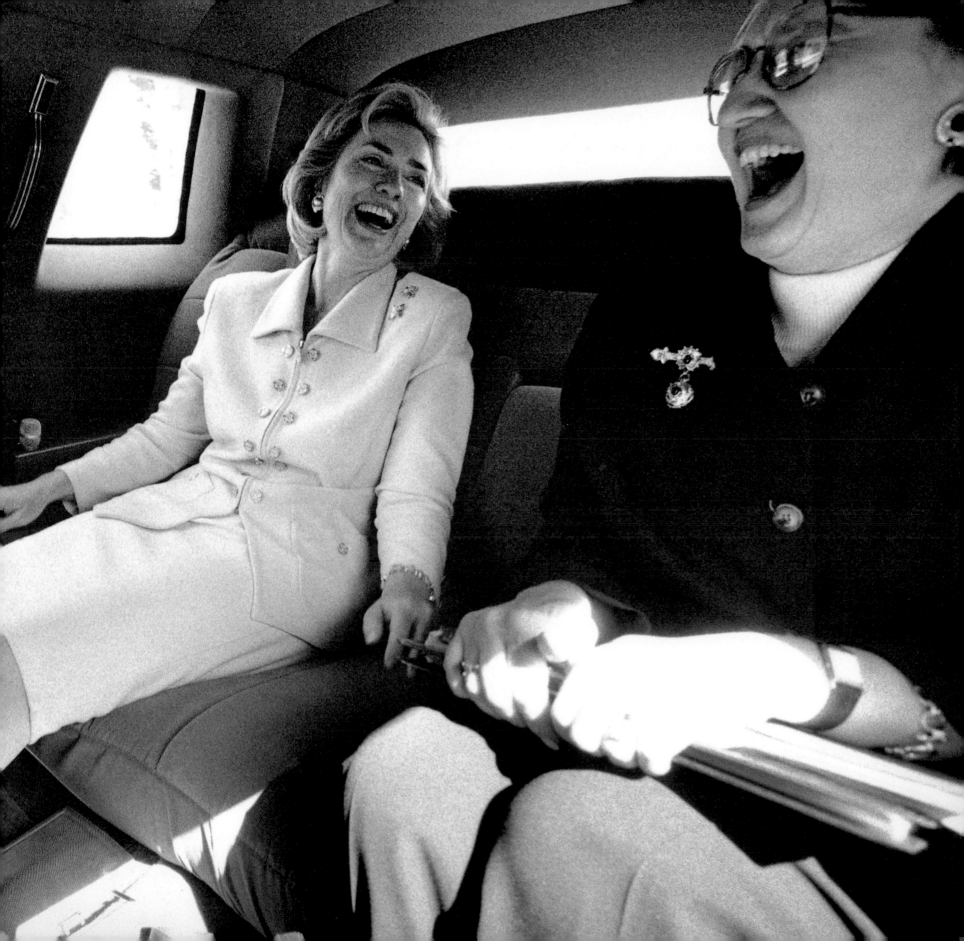

"Every week I had lunch with Al Gore. He'd bring his list; I'd bring mine. We'd go through it, resolve things, talk about it. And then we'd also talk about our families, our kids, what was going on. But we always started by saying grace, and we'd alternate. It was a wonderful experience. It was one of the best things I did as President, my weekly lunch with Al." — *Bill Clinton*

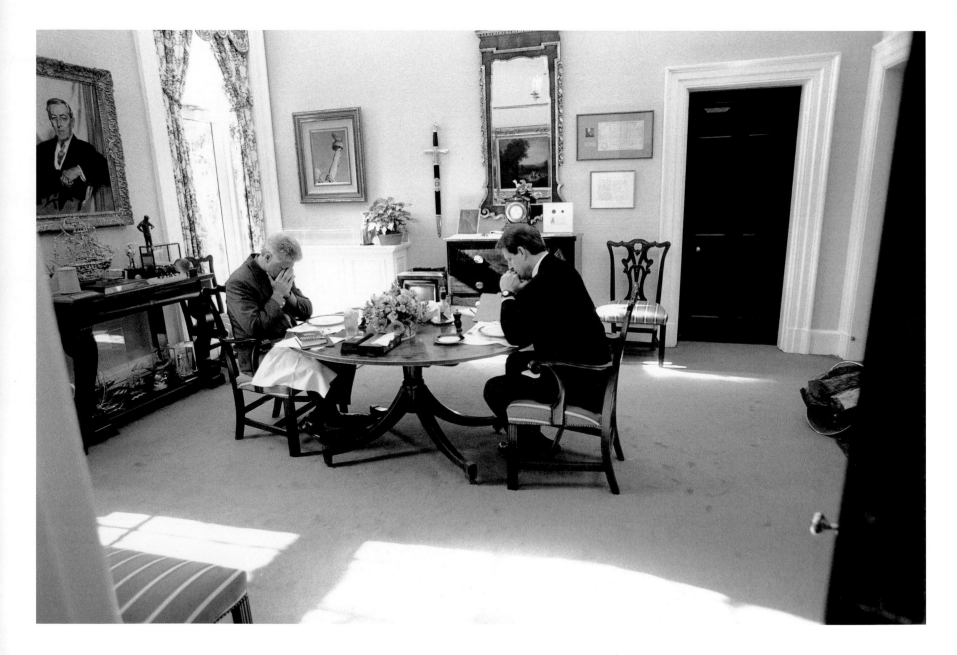

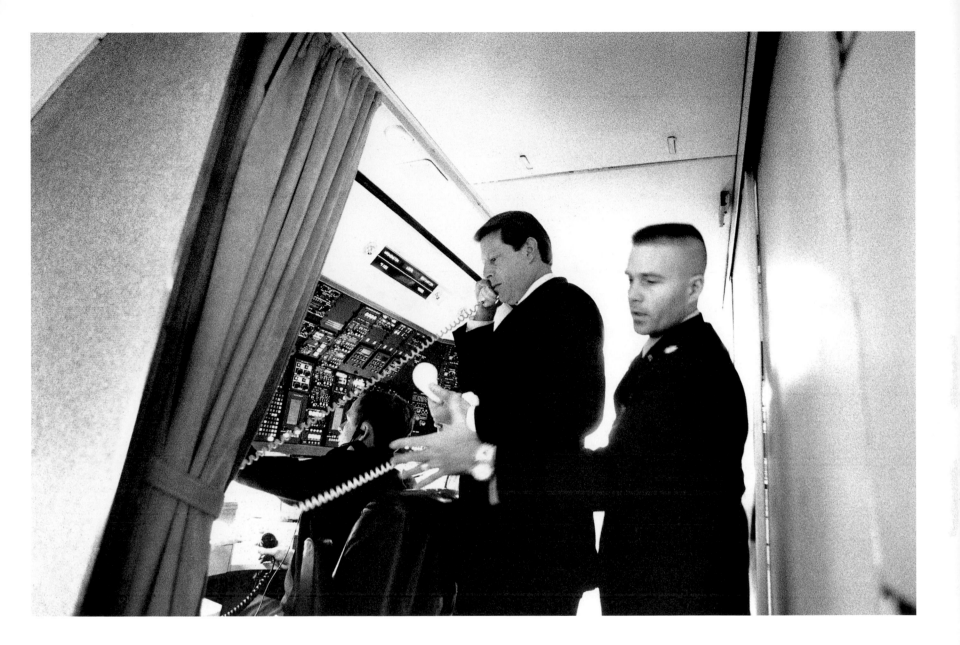

Aboard Air Force Two, Vice President Gore uses a secure phone to take a phone call concerning foreign policy from his national security adviser, Leon Fuerth. On the right is the Vice President's military aide, Air Force Maj. Steve Kwast. — *D.W.*

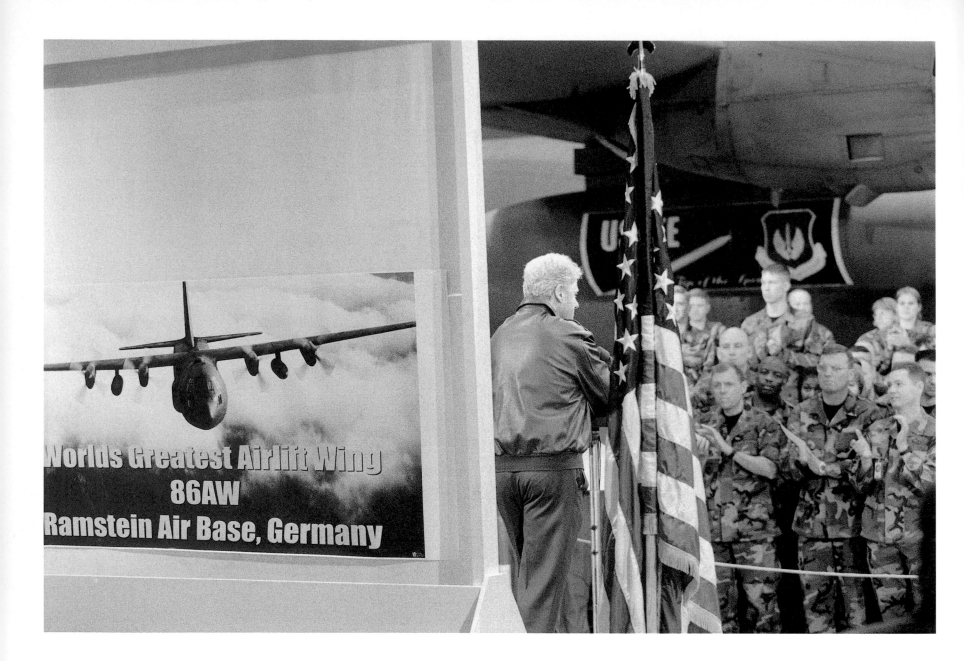

"This was my second trip to Ramstein, for the Kosovo campaign. We did a lot of our work in the Balkans out of Ramstein. I'm very grateful to those people. They saved us from a lot more slaughter of innocents there. These guys did a great job." — *Bill Clinton*

"These are my great passions: working the *New York Times* Sunday crossword puzzle and playing cards—hearts and oh hell. There has to be a loser in every hand of oh hell, which is something that prepared us well for what we did every day. We played thousands of hands of hearts and had a grand time doing it." — *Bill Clinton*

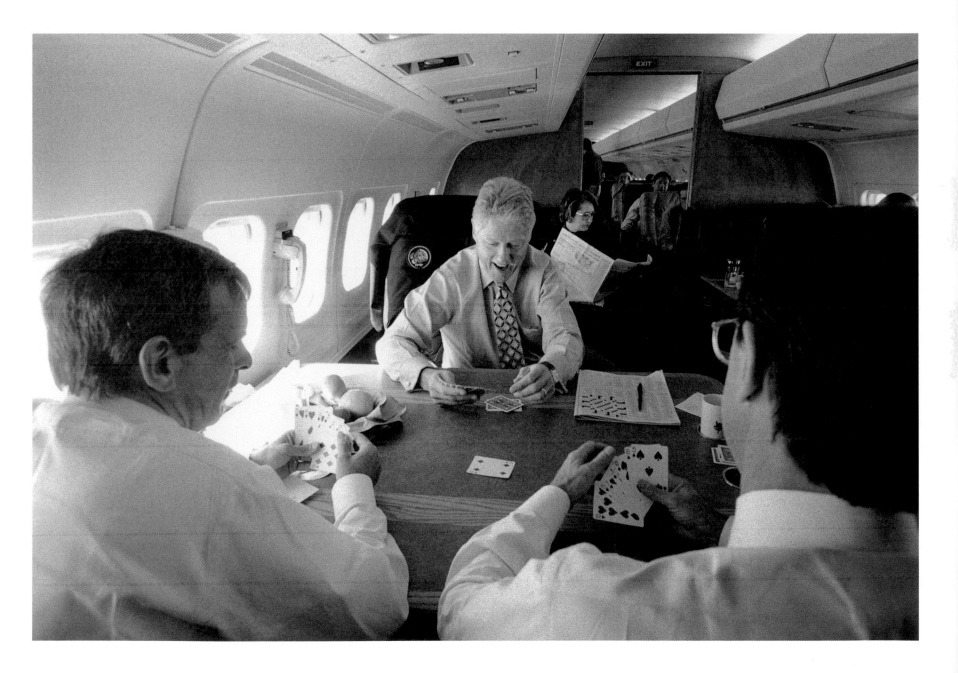

With the House expected to vote on impeachment the next day, the Clintons enjoyed some private time with Eunice Shriver and her family before hosting a dinner for the Special Olympics. Suddenly the President put his arms around the First Lady's neck. Shooting with next to no light, at a negligible shutter speed, I had that thrilling feeling of capturing a moment—if, of course, I'd done all the technical things right. One never knows. — *D.W.*

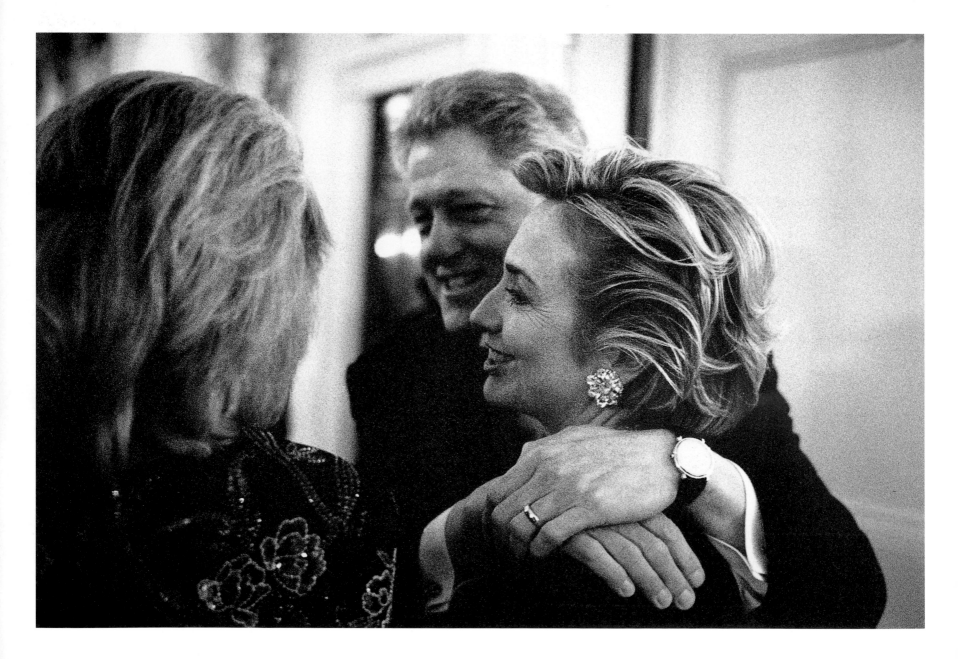

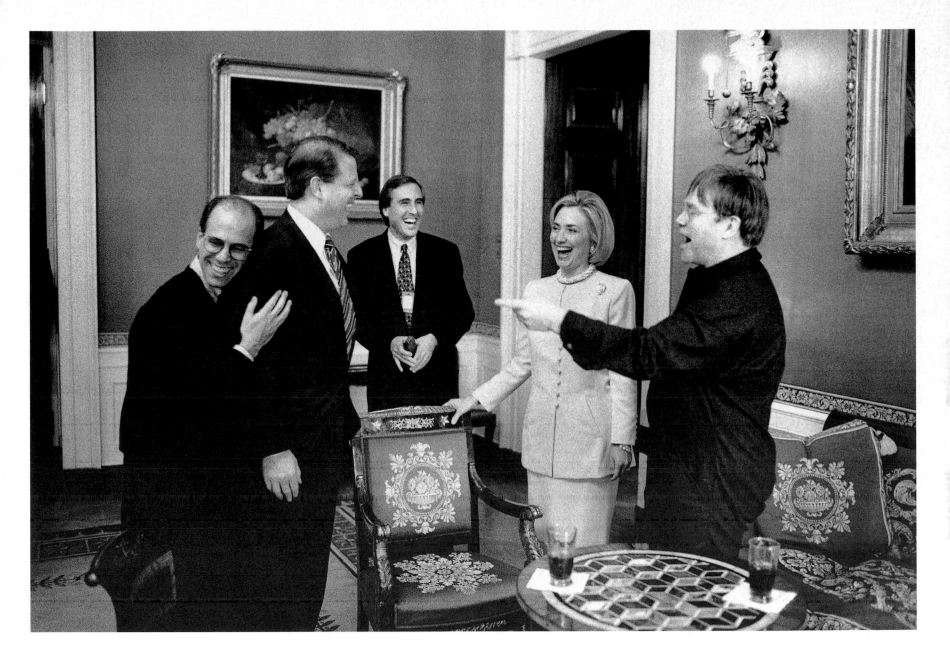

"I loved that day; I am such a fan of Elton John's. Here we are with Jeffrey Katzenberg and Andy

Spann and the Vice President. Elton came all the way to perform for Tony Blair at the state

dinner, and Al came by to see him, and we were just cracking up about something.

A good time was being had. It was one of those light moments." — *Hillary Clinton*

Following pages: Secretary of Defense Cohen, Secretary of State Albright, National Security Adviser Sandy Berger, holding room, Ronald Reagan Building, April 25, 1999

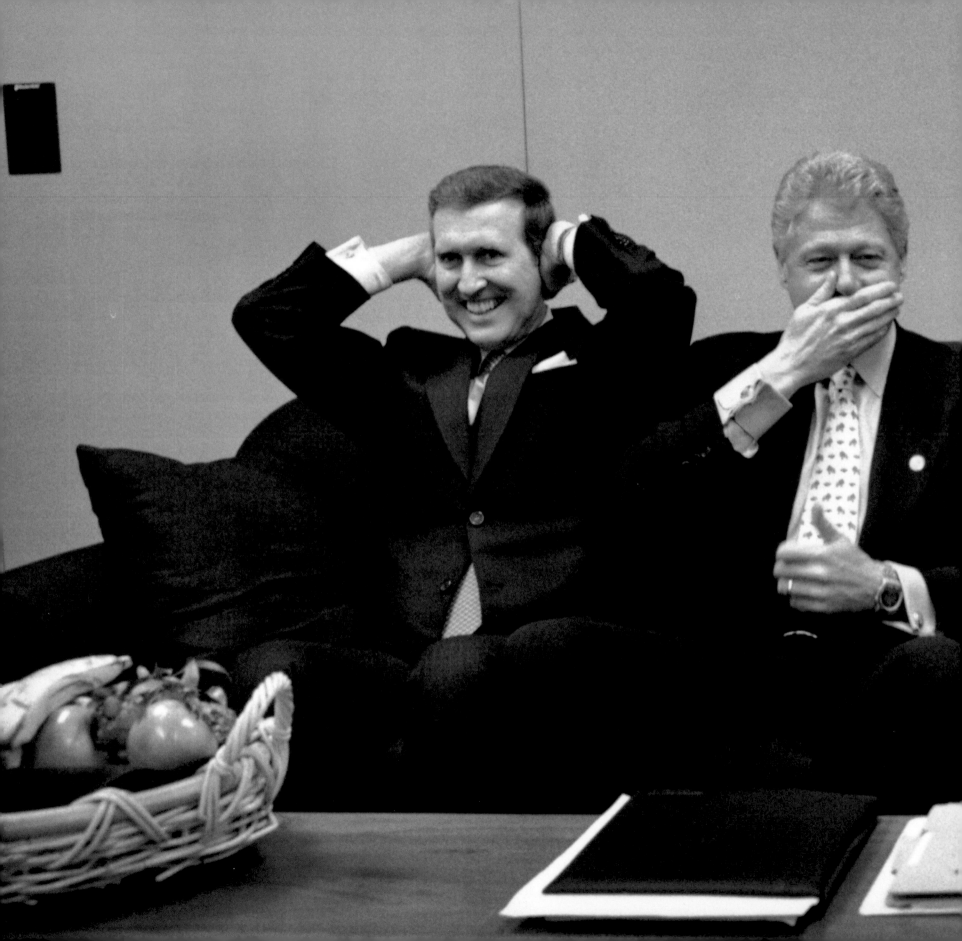

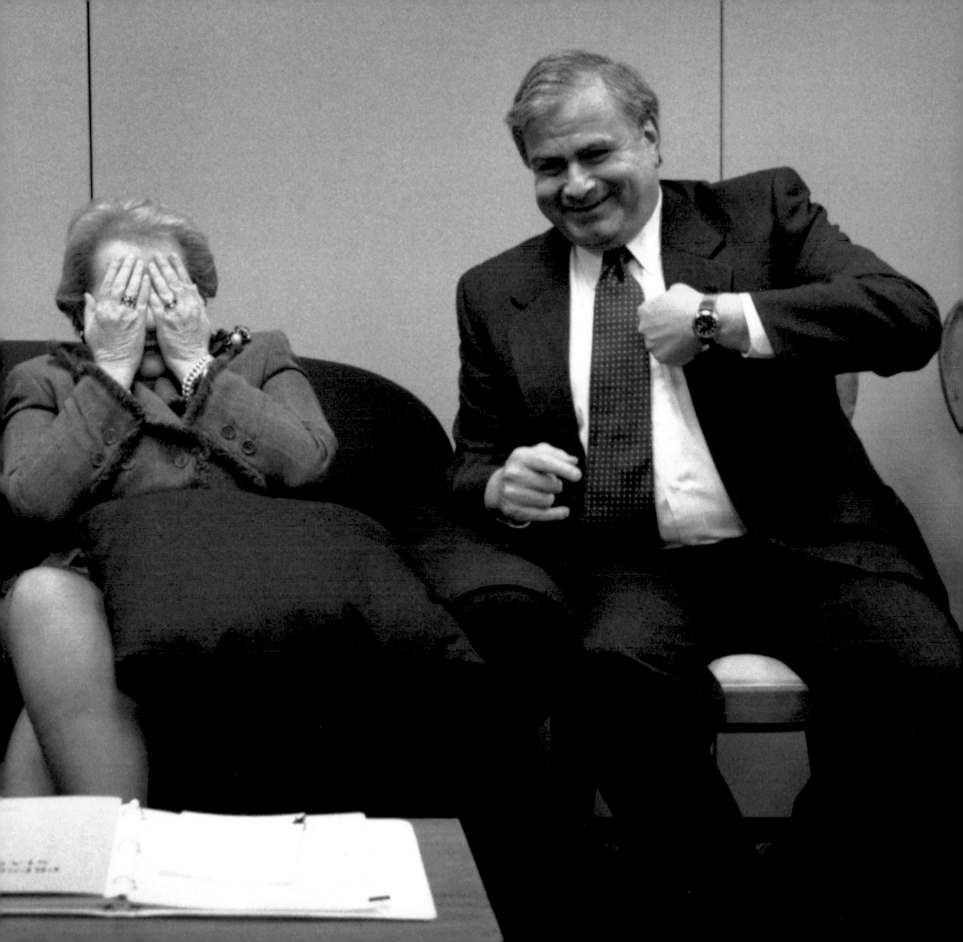

"We were all making comments we shouldn't have about how the meeting was getting very boring. So finally we decided we had to make like the monkey. Cohen started this 'hear no evil,' and then I was next so I spoke no evil, then Madeleine saw no evil, so Sandy Berger said, 'I'm evil.'"

— *Bill Clinton*

"I remember this conversation very well. Chirac was mayor of Paris then. We came out here and looked at the garden, and he was telling me all about how much he loved America. He'd lived here for a while and actually worked as a soda jerk when he was a young man. So even though the United States and France had our policy differences from time to time, I struck up a good personal relation-ship with Chirac and it lasts down to the present day. And there's Pam. Of course, I loved her very much and I only wish she'd made it through the whole administration."

— *Bill Clinton*

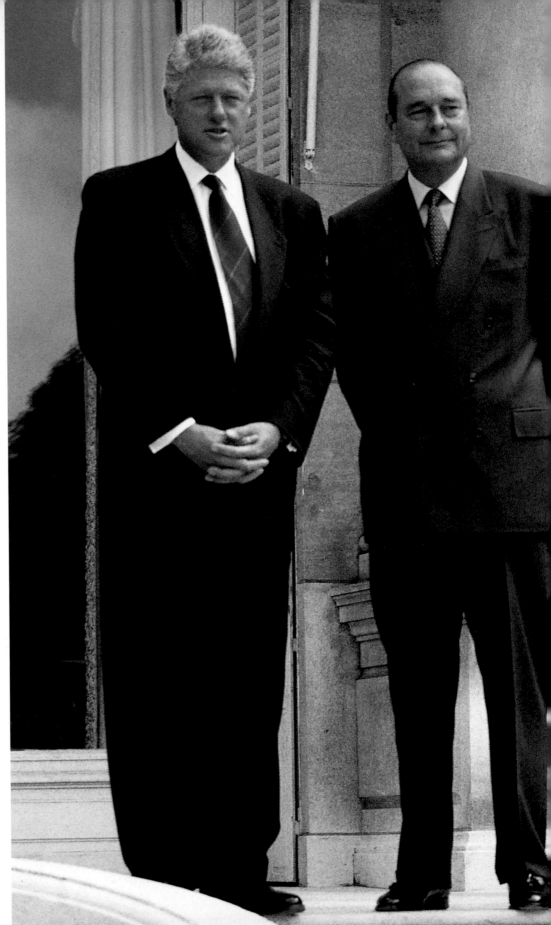

158 • Jacques Chirac, "Mac" McLarty; David Gergen, Amb. Pamela Harriman, Warren Christopher at U.S. ambassador's residence, Paris, June 7, 1994

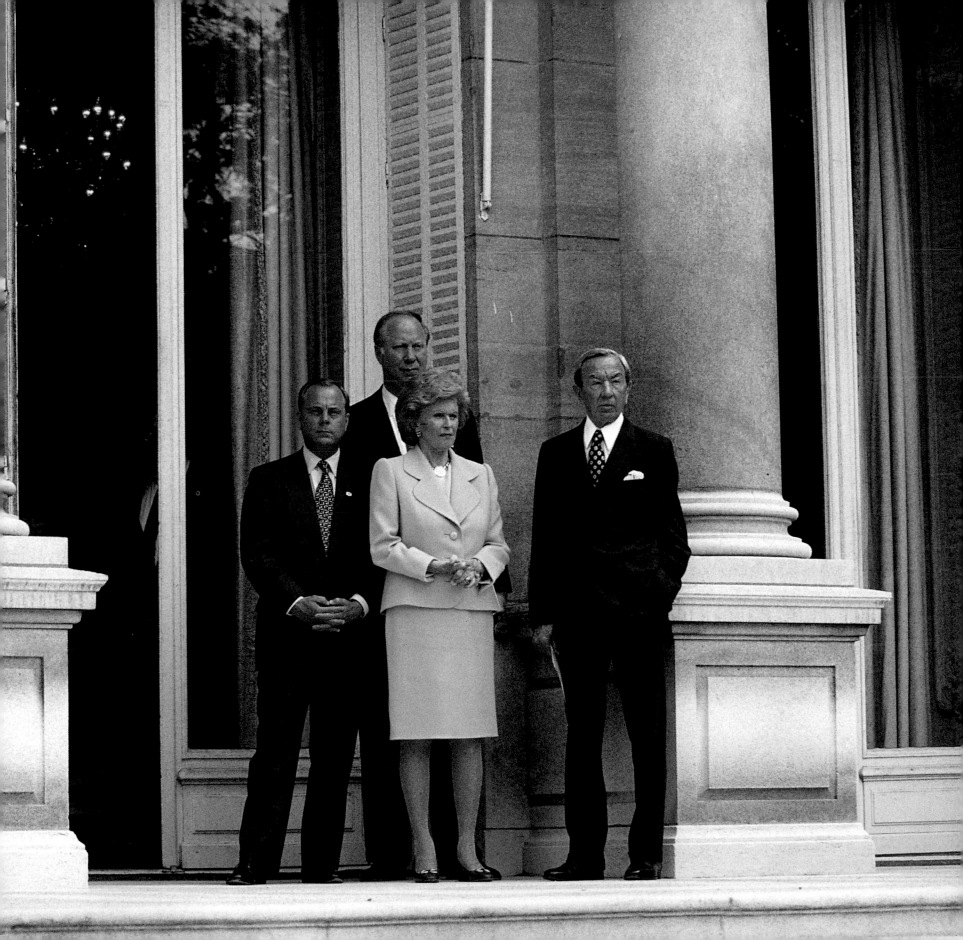

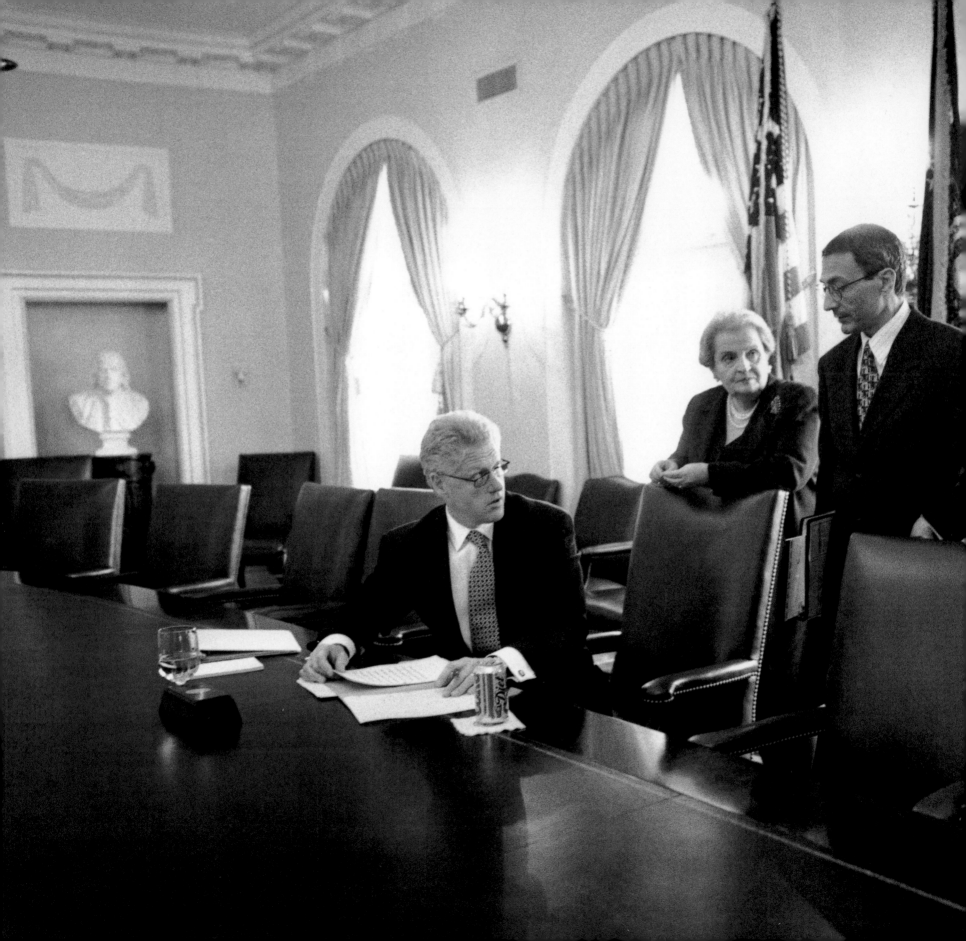

We are used to seeing photographs of the Cabinet Room packed with Cabinet members or congressional leaders and press jammed in every corner. Here, in an off-camera moment, the President discusses an upcoming meeting with the Chinese with Secretary of State Madeleine Albright, Chief of Staff John Podesta, National Security Adviser Sandy Berger, and China specialist Dr. Kenneth Lieberthal.

— *D.W.*

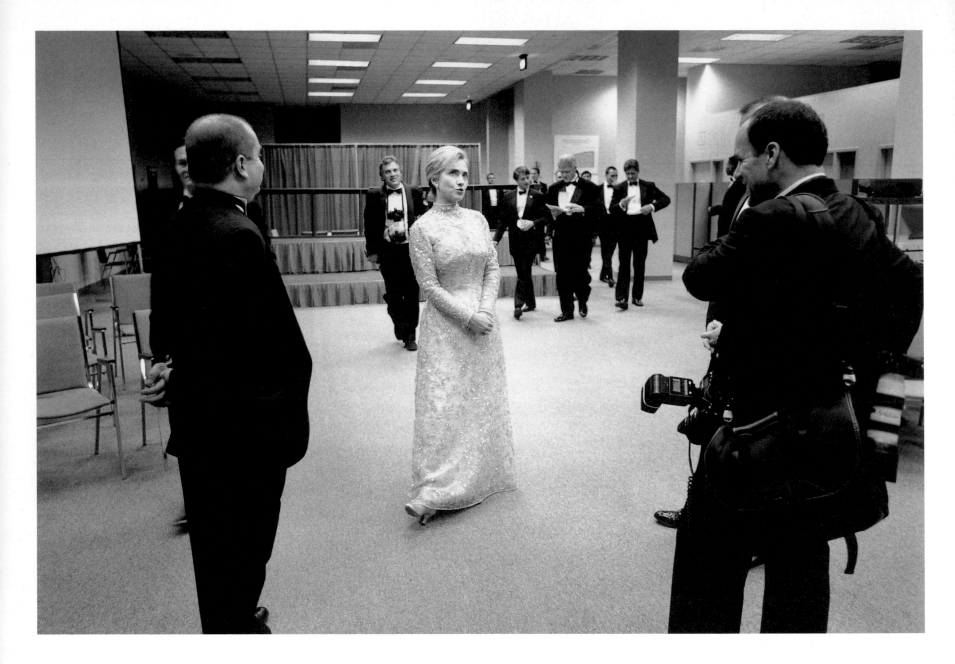

"I think I was singing. I think we were getting very silly because we were on our 11th or 12th

ball. I was probably making up some ditty and singing it." — *Hillary Clinton*

The President usually greeted guests after an appearance, and this is a typical rope-line

photograph. The obvious thrill of meeting a President seems all over this picture. — D.W.

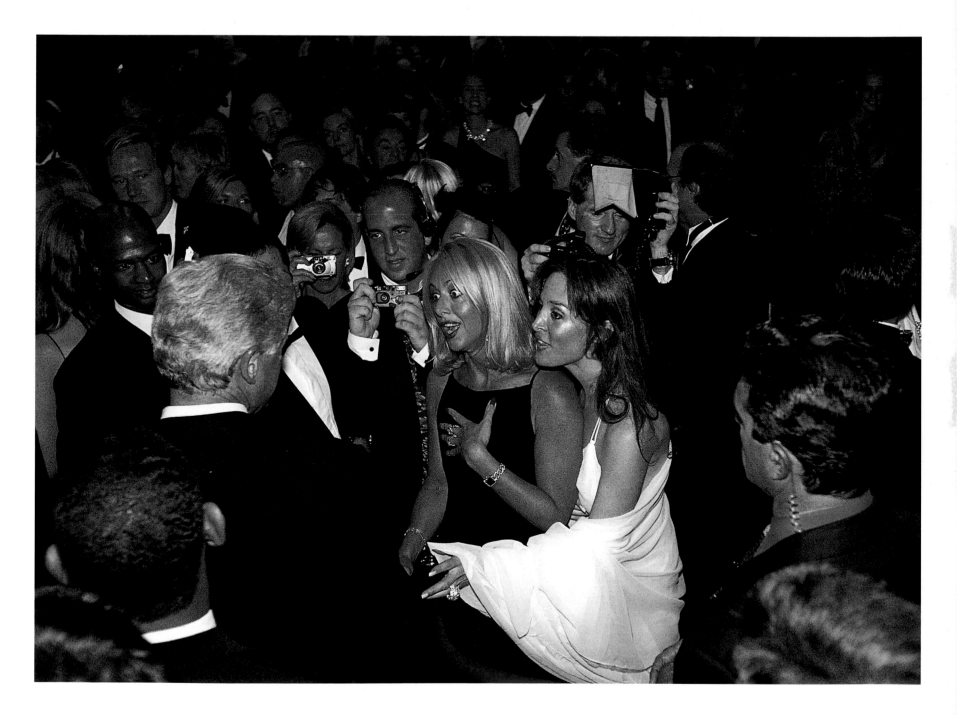

During his last week as President, Clinton went to say good-bye to many employees in the White House. Stopping to say thanks to the cooks in the White House mess, the President couldn't resist a mid-morning snack. He returned to the Oval Office with a plateful of french fries. — *D.W.*

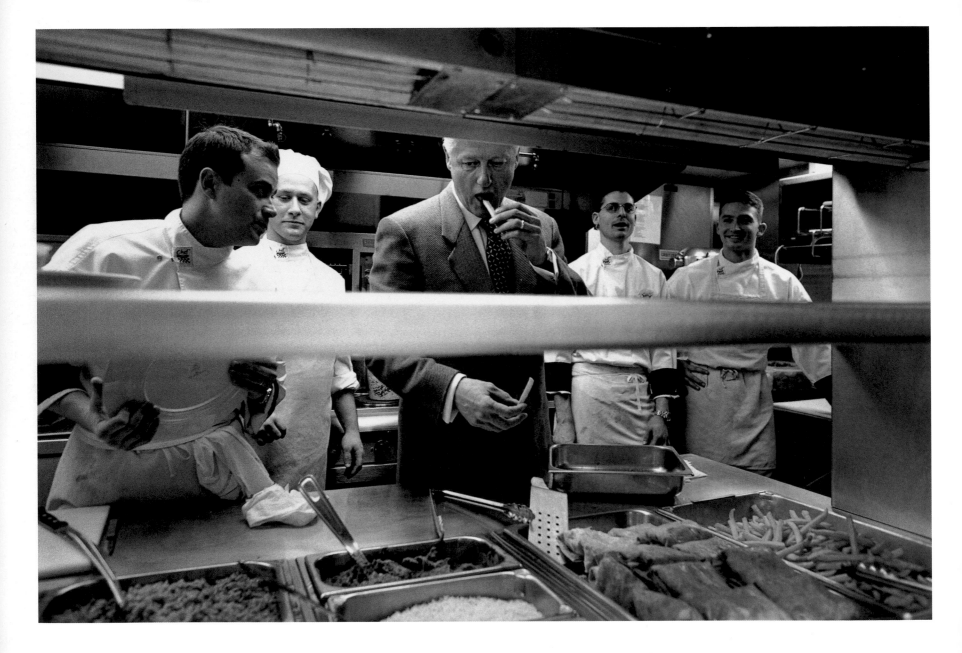

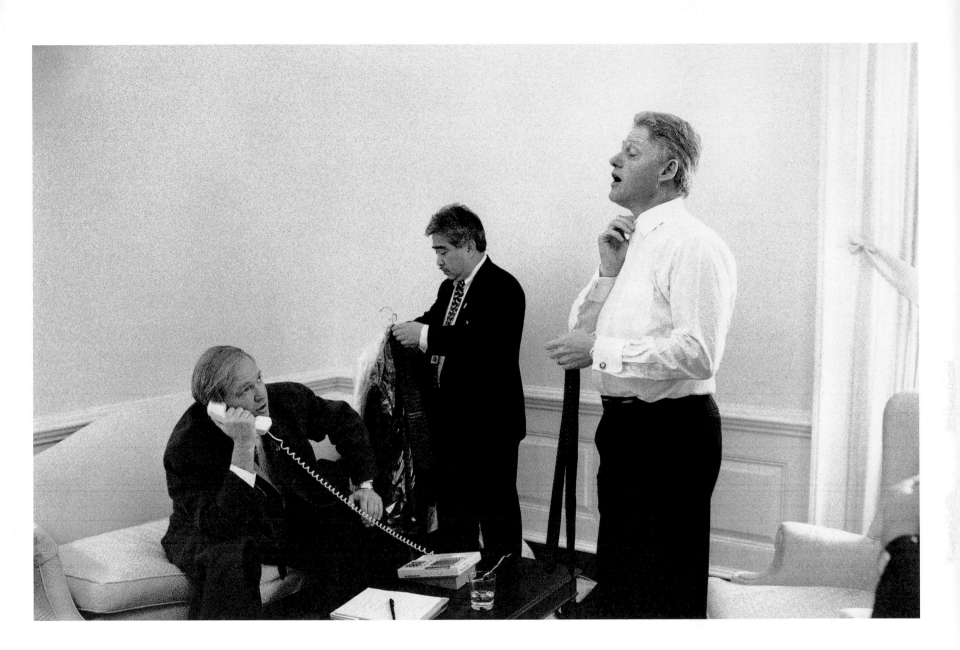

Waiting outside the President's holding room at the Capitol, just moments before he was to be

sworn in for the second time, I never expected the door to open. Suddenly, the staff hurried me in,

and I found Clinton with his valet, Joe Fama, and Press Secretary Mike McCurry. — *D.W.*

While visiting the troops at Ramstein Air Base with President Clinton, Secretary of State Madeleine Albright finds a spot in a temporary building on the base to take a call regarding Kosovo. I loved seeing her sporting the bomber jacket just given to her by the troops in Germany.

— *D.W.*

"I had no idea how much went on behind the scenes. I thought I understood a bit, but I was a novice, a total novice about the preparation that went into any White House event. You come into a scene, and when someone's totally professional like these staff members, you follow the plan without even thinking about it."

— *Hillary Clinton*

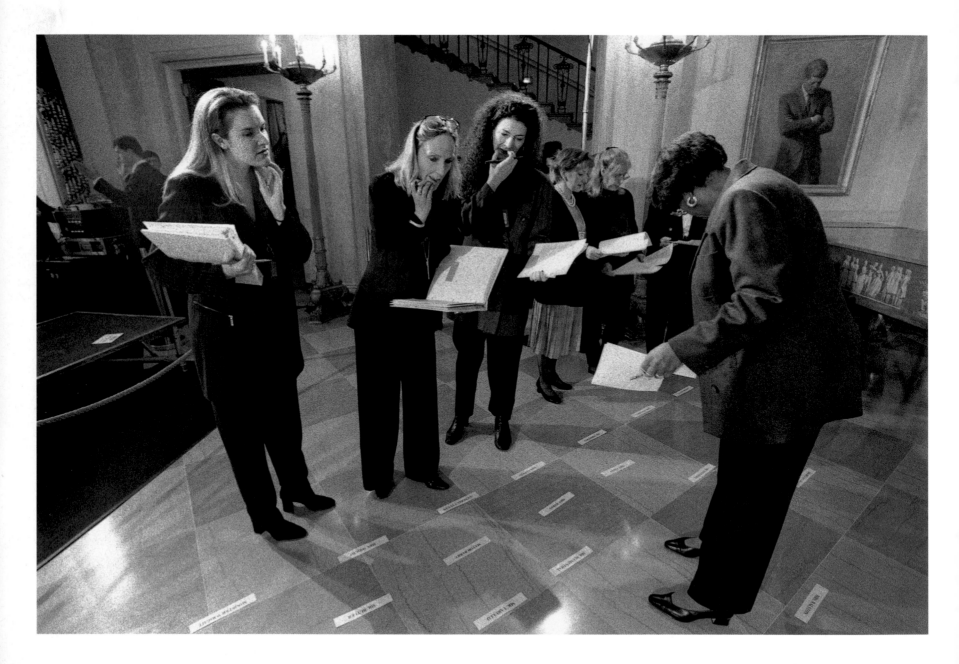

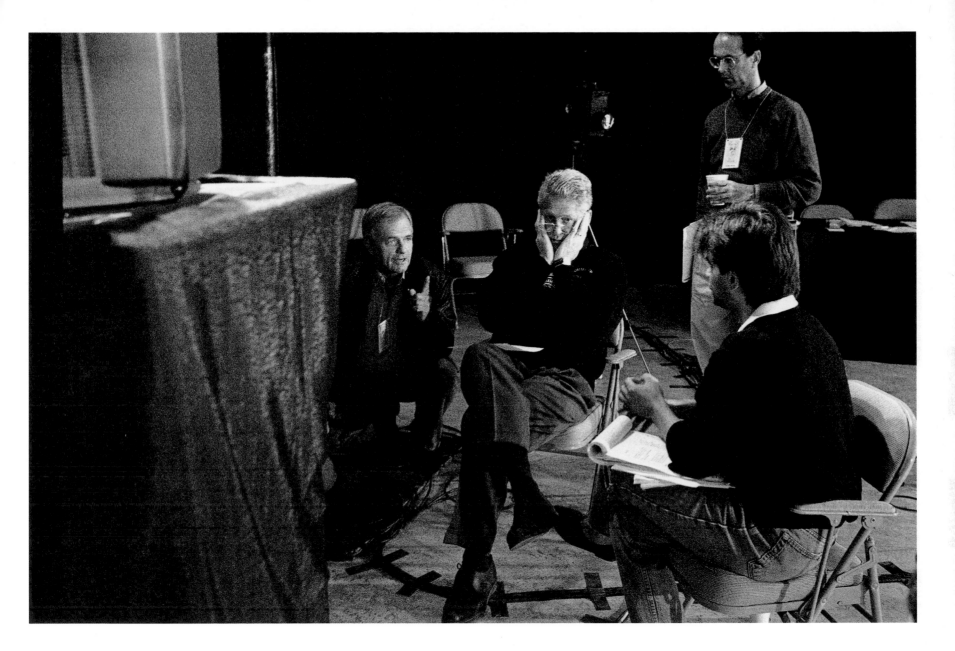

"We were practicing for the debate. I was getting my head straight. George Mitchell was great as Dole;

he mauled me. I said, 'God, if he does as well as you did, I'll be a one-termer.' That's what was happening

here. Mitchell was pounding away, and I was trying to think of what the right answer was."

— *Bill Clinton*

Coaches Bob Squier, George Stephanopoulos, and Erskine Bowles, in an auditorium at the Chautauqua Institution, Chautauqua, New York, October 5, 1996 • **169**

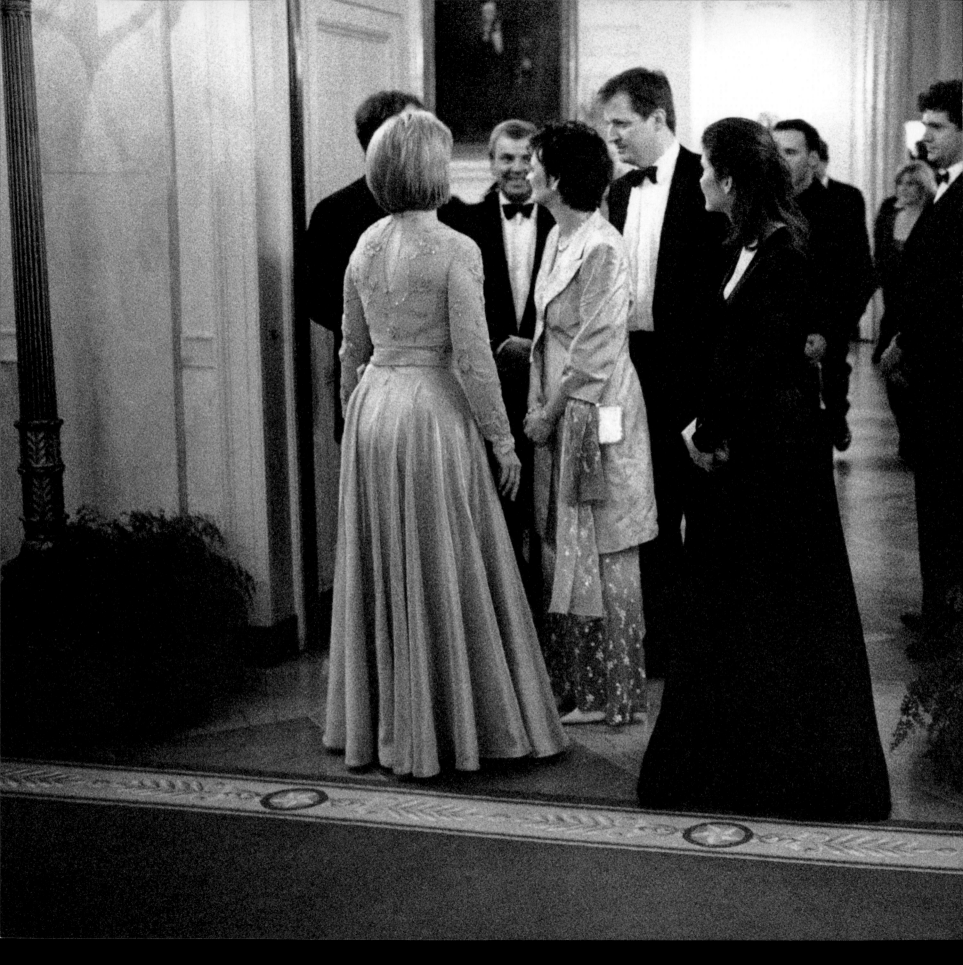

After the evening's entertainment at the state dinner for Britain's Prime Minister and Mrs. Tony Blair at the White House, Harry Thomason, a Hollywood producer and long-time friend of the President, speaks privately with Clinton. Word of a story in the *New York Times* early edition had spread during the entertainment, causing some journalist guests to leave the party abruptly. The story concerned leaked information about what the President's secretary, Betty Currie, had told Independent Counsel Kenneth Starr's investigators regarding the Monica Lewinsky affair.

— *D.W.*

"It was the most gripping personal thing I think that happened to me the whole time I was President. This woman said her next-door neighbors had betrayed her and they attacked her and thought they killed her. She woke up in a pool of blood and her husband and six children were lying dead around her. She concluded she had survived not to hate and be full of vengeance but to live so that she could do whatever was possible to make sure this never happened again." — *Bill Clinton*

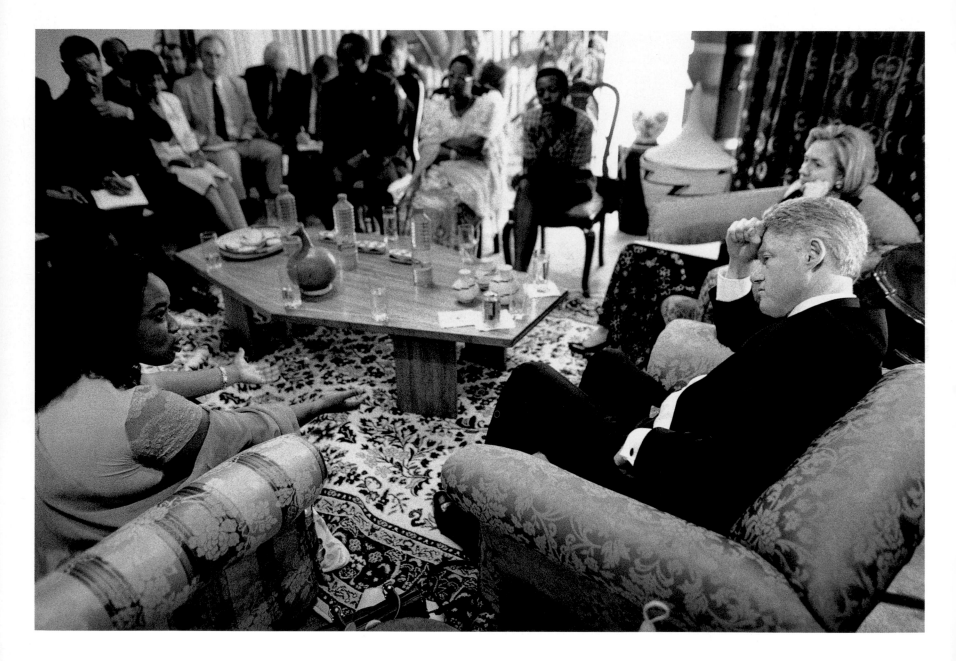

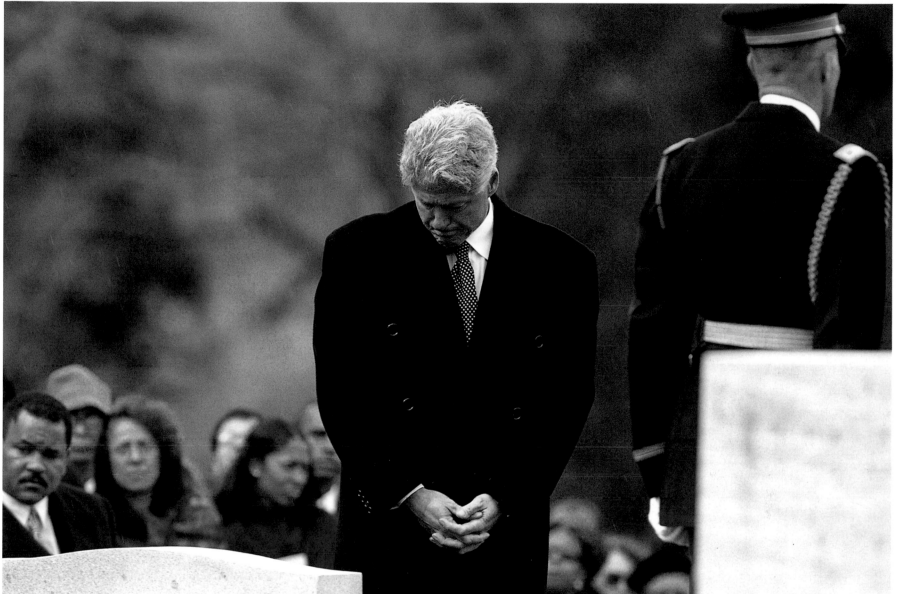

"This was Ron Brown's funeral. It was so sad. What a terrible time. We buried a lot of friends. A lot

of people died during that time, including my father and Bill's mother. It was a tough time."

— *Hillary Clinton*

"I have often told people that Nelson Mandela is my hero, and he's the person who has made the biggest impression on me of anyone that I've met throughout the world. This was my second trip to this prison, because he had brought me there when I came the previous year, on my own. I was so anxious for Bill to come to Robben Island and to be there with President Mandela. I was really watching Bill take all this in, because my first trip to Robben Island with Mandela, to see the cell that he had lived in all those years, was one of the most moving experiences I had in the whole eight years."

— *Hillary Clinton*

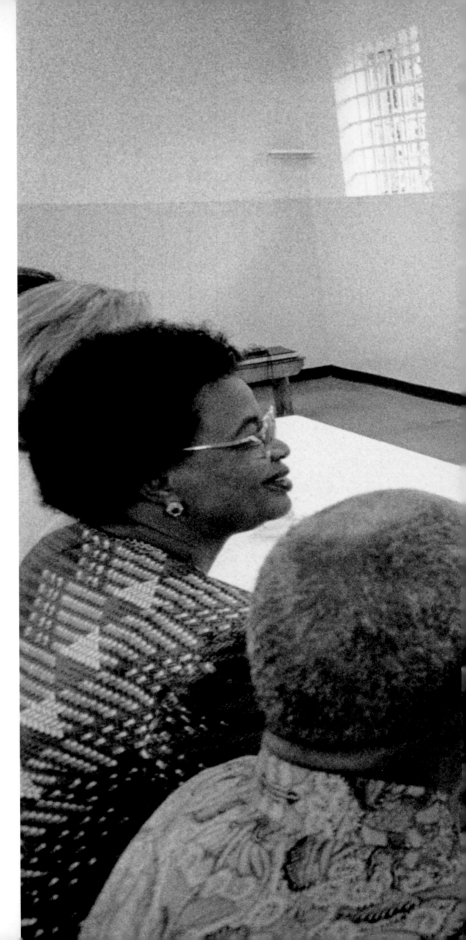

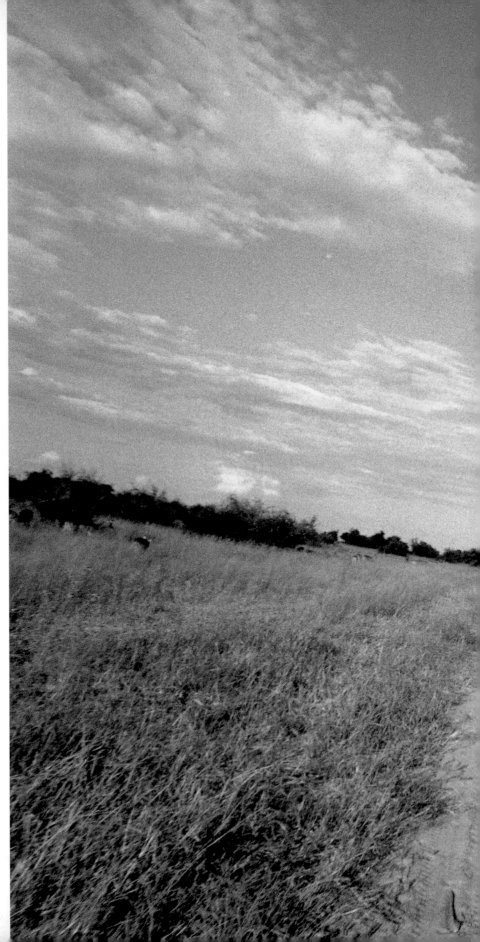

"We saw wonderful elephants and giraffes, and we actually got squirted by an elephant. An elephant squirted water on us! At least I think it was water. But we had a great time. I love Africa. And this was a rare day for me on foreign trips—I actually took a day off. Hillary and I also went on the river that day."

— *Bill Clinton*

Riding in the Land Rover alone with the Clintons and their guides, at one point I jumped out to get a better angle. I remember the guard in the front seat quickly saying something about my getting back in immediately or else I might end up as elephant food.

— *D.W.*

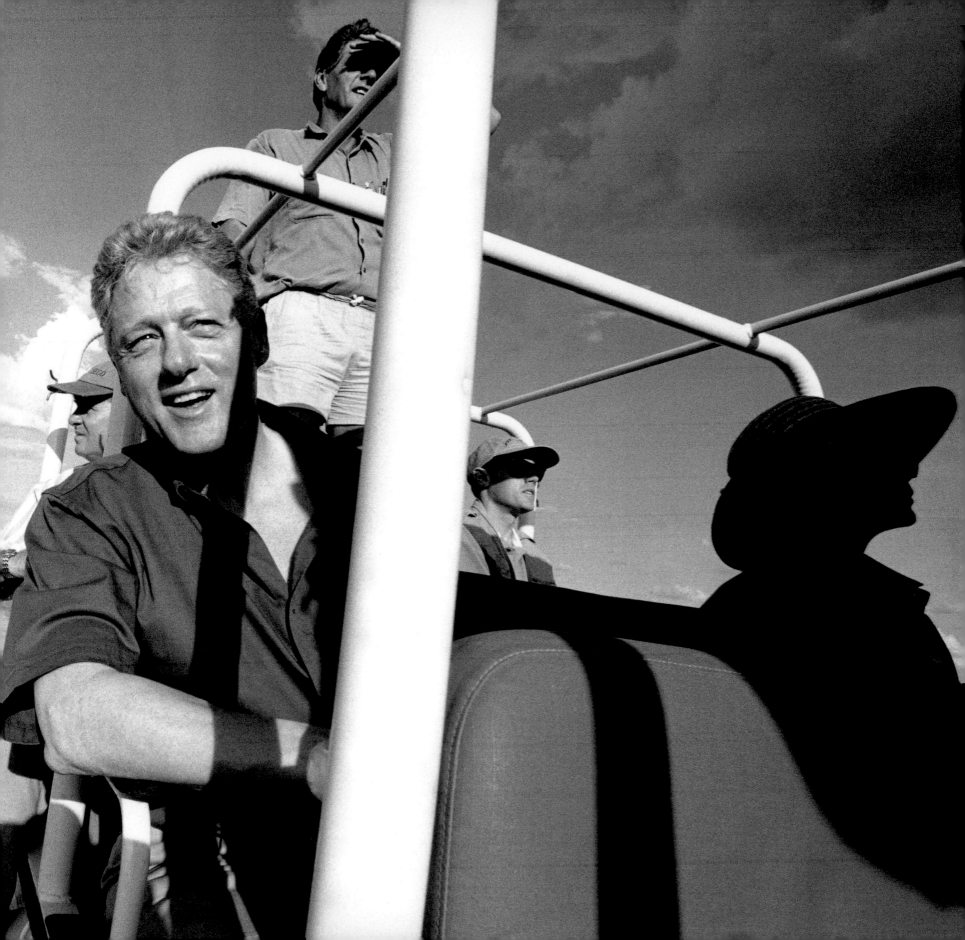

"When Chelsea and I were in Africa the year before, I had announced—to the consternation of the White House—that I was sure the President would be coming shortly. I wanted him to go to Africa and see what we had seen."

— *Hillary Clinton*

Following pages:

The Clintons' boat docks in the evening following an afternoon cruise looking at wildlife on the Chobe River in Botswana. Alone on the boat in the dark, with the press boat somewhere else entirely, I photographed these unusual private moments of the President and First Lady relaxing with friends.

— *D.W.*

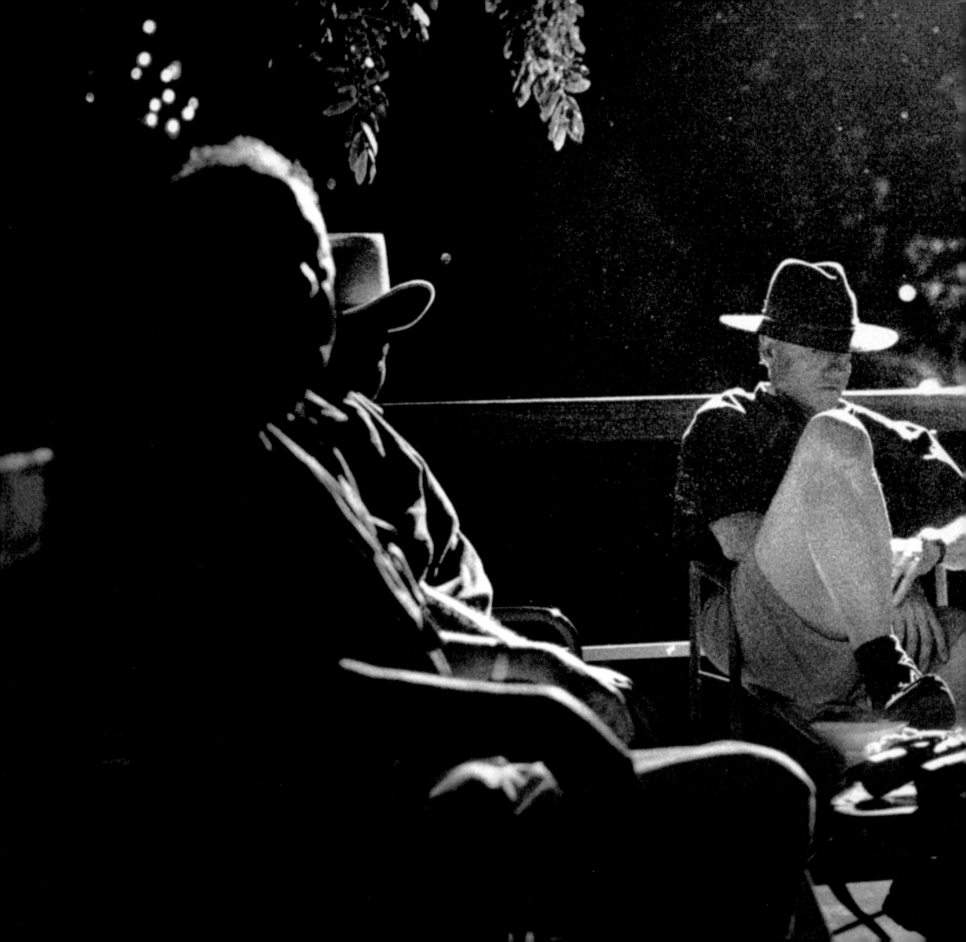

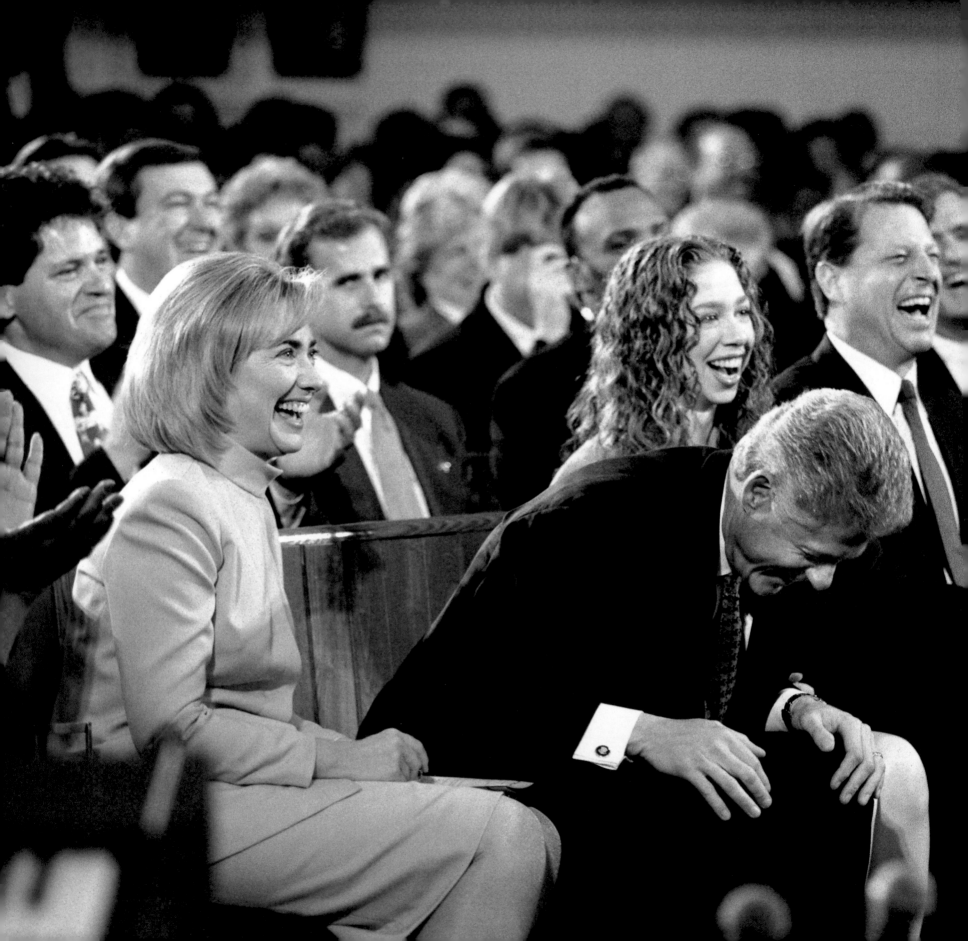

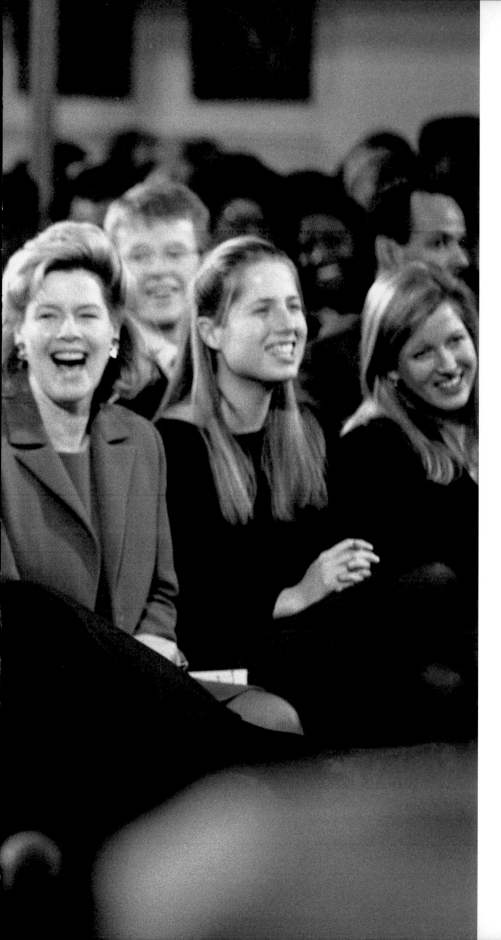

Sitting quietly on the floor behind a church pew during the Inaugural Prayer Service, I was surprised to hear gales of laughter. Whatever it was in the talk by visiting clergyman Rev. Tony Campolo, a longtime Clinton friend, it certainly broke up the First Families and gave me a wonderful picture to start off the day.

— *D.W*

The royal yacht *Britannia*, with Queen Elizabeth, President Clinton, and leaders of World War II allies on board, leaves Portsmouth for Normandy to celebrate the 50th anniversary of D-Day. The ship, trailed by a small armada of well-wishers, was a splendid and moving sight. I thought about the very different pictures of troops crossing the Channel in June of 1944, as depicted in history books and films. I couldn't help but imagine how different the world would be today if they had failed. This was one of those times I was so grateful to have my job, and I was thrilled to be on the deck of a boat on my way to Normandy.

— *D.W.*

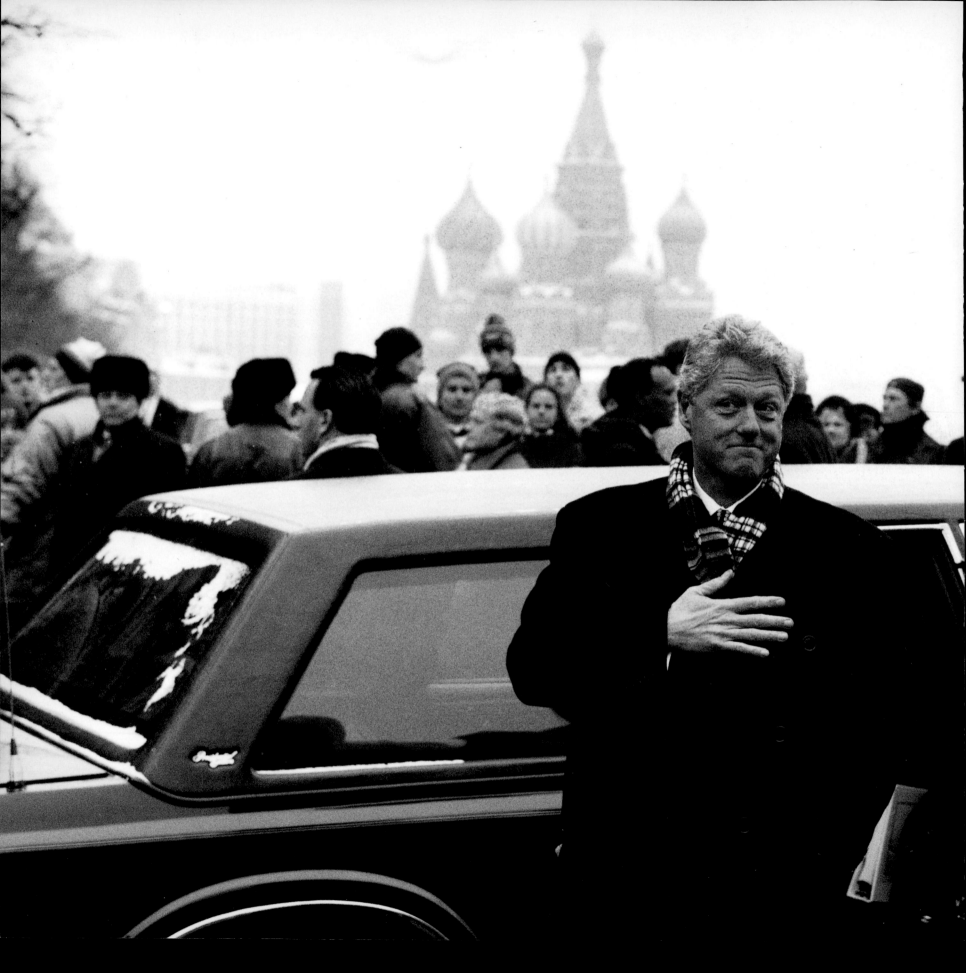

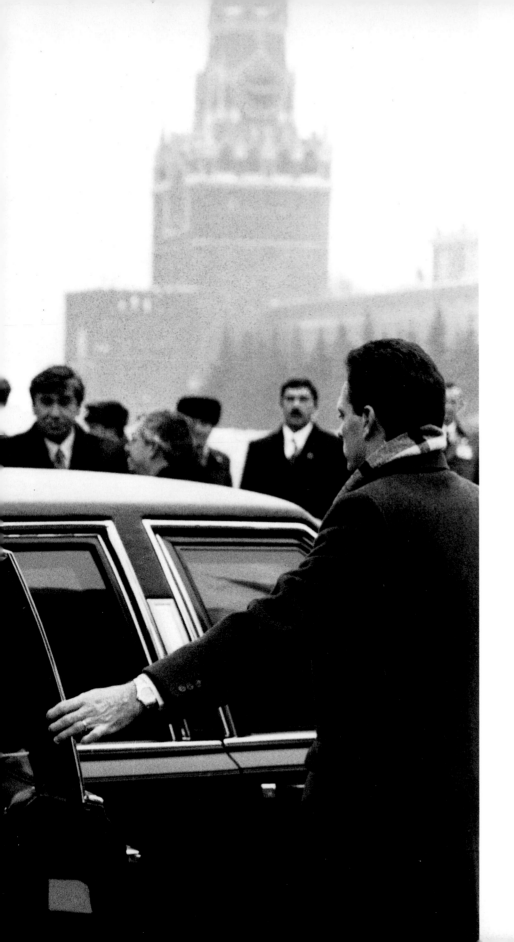

"The church was closed under Stalin. After all those years it is now a church, where one can worship once again. They restored it. It was beautiful. It was right in downtown Moscow, in Red Square. I lit a candle for my mother."

— *Bill Clinton*

"Not a day goes by that he doesn't think about her. She was an extraordinary woman, who had so much true grit. She really lived and died with a lot of courage. And that was a very hard year."

— *Hillary Clinton*

"You know there was nothing planned about that. It's absolutely true. It just happened. People ask me if I had anything I could do over again in the campaign that I would do differently, and I say 'If I had it to do over again, I would have kissed her longer.' But she was struggling." — *Al Gore*

"I was so surprised!" —*Tipper Gore*

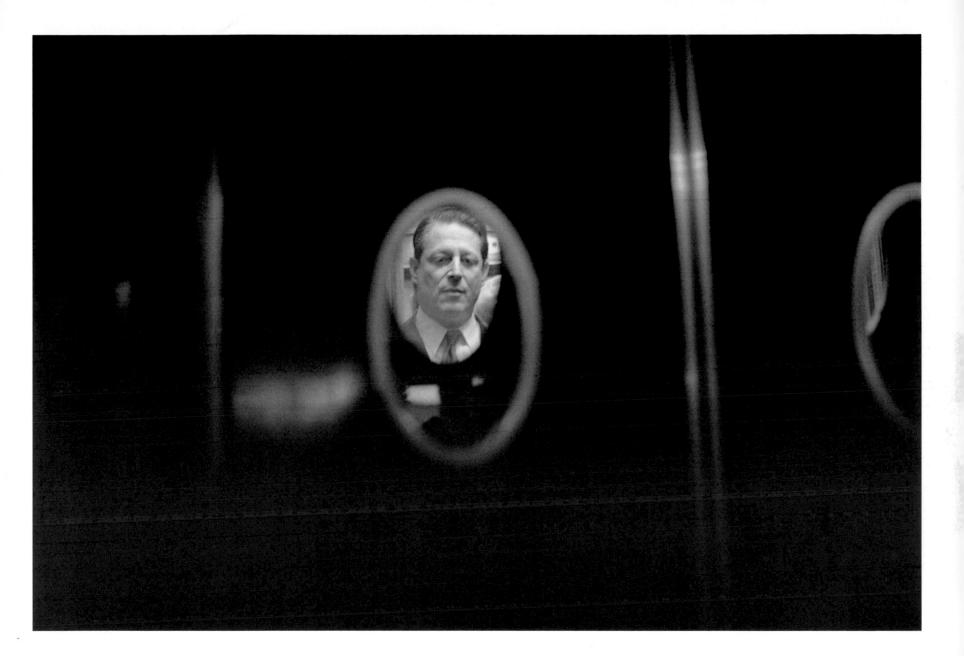

"Well, one of the greatest things about our country is the peaceful transfer of power. And as hard as the experience was for me, it felt good to be sending as clear a signal as I could to the 50 million plus voters who voted for me and not President Bush that there be no question about the legitimacy of our President at any time, because we depend on the supremacy of the Constitution." — *Al Gore*

"One last look around. I remember that. It was hard to say good-bye to the people who were there, who had been such a part of our lives. And I think, you know, that we just wanted one more time to be there by ourselves. I miss the house, which was so beautiful. I miss individual rooms. I miss the people who worked there. But I don't have any regrets. It came and it went. I always knew the experience was unprecedented. I will value that time in my life forever. It's something to look back on with a lot of gratitude."

— *Hillary Clinton*

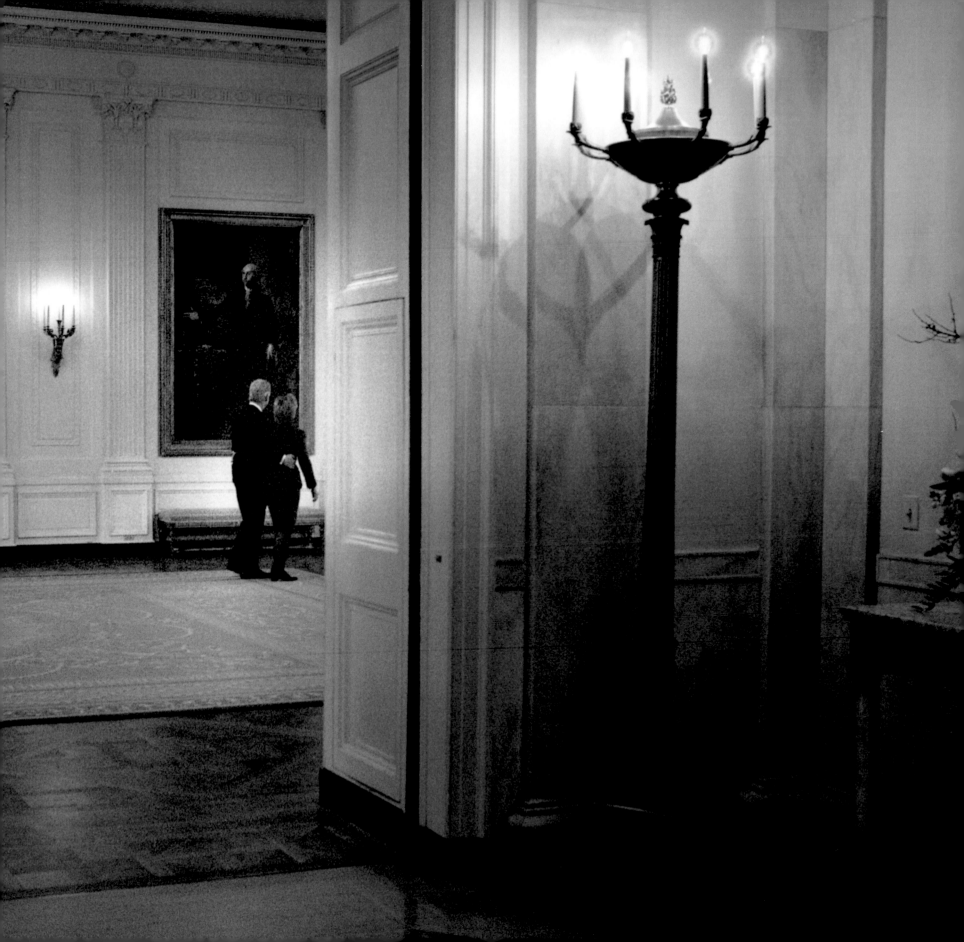

"The day was a happy one for me. I was very happy. It was time to go, and I felt good about our future. So, it was a day filled with good-byes, which were sad, but also anticipation, which made me very excited."

— *Hillary Clinton*

Following pages:

"On my desk is the letter I left for George Bush, and I'm just looking out at that view I love so much one last time. I loved the Oval Office. It's always light. Even on the darkest days the Oval Office was always light because you had these windows here, and then this whole part of the room is lighted indirectly. It's the best place in the world to work because it's quiet and airy and light. It always lifted my spirits to go in there. It really is the most wonderful office."

— *Bill Clinton*

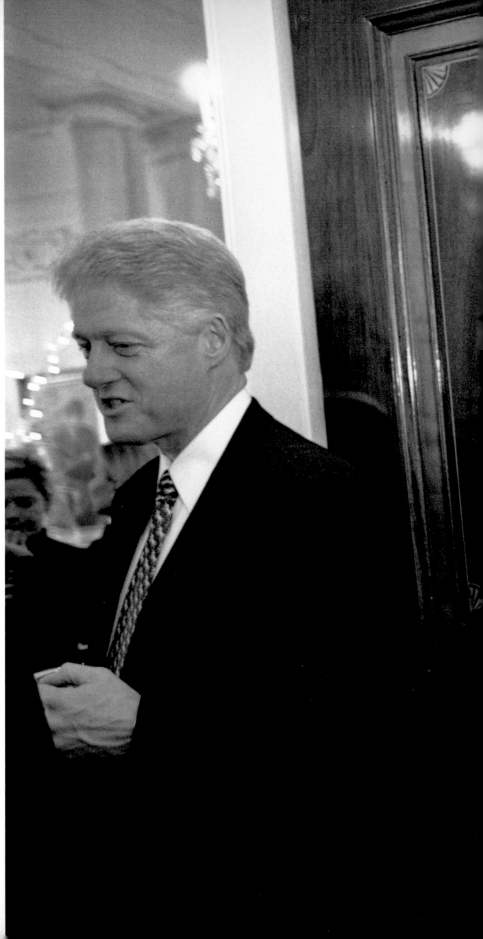

194 • President and Mrs. Clinton with President-elect George W. Bush, the White House, January 20, 2001. *Following pages:* The Oval Office, January 20, 2001

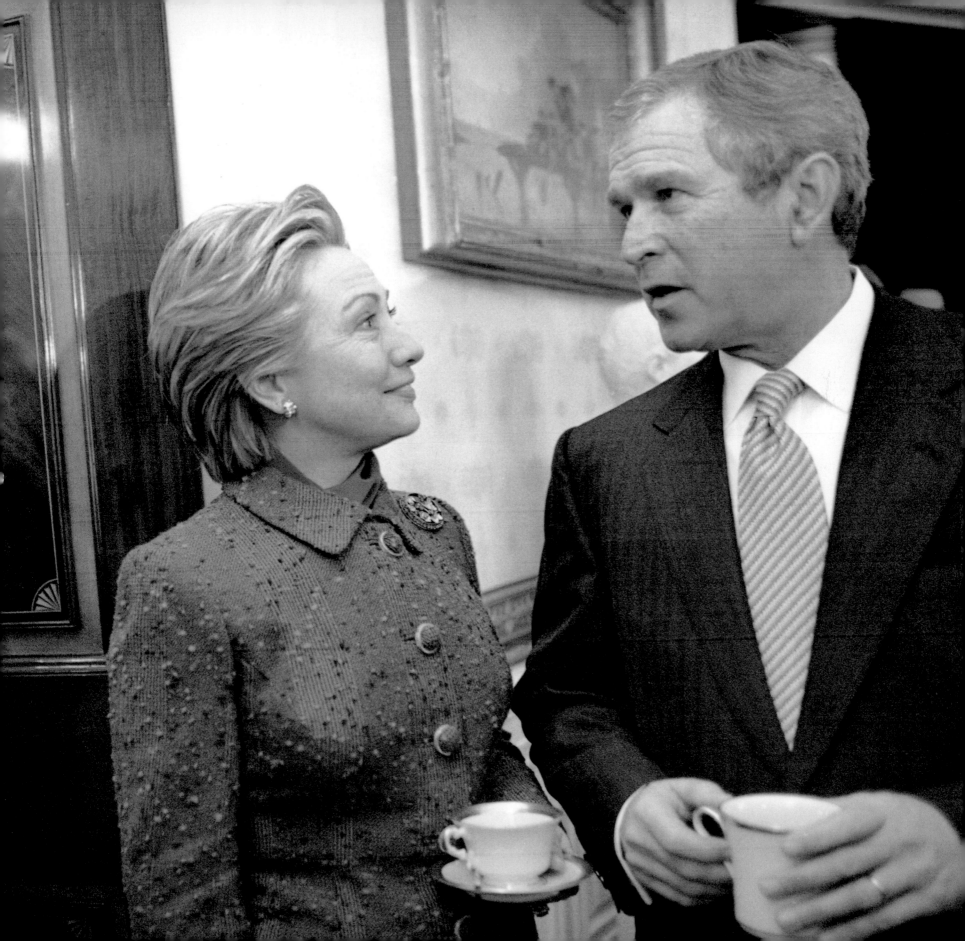

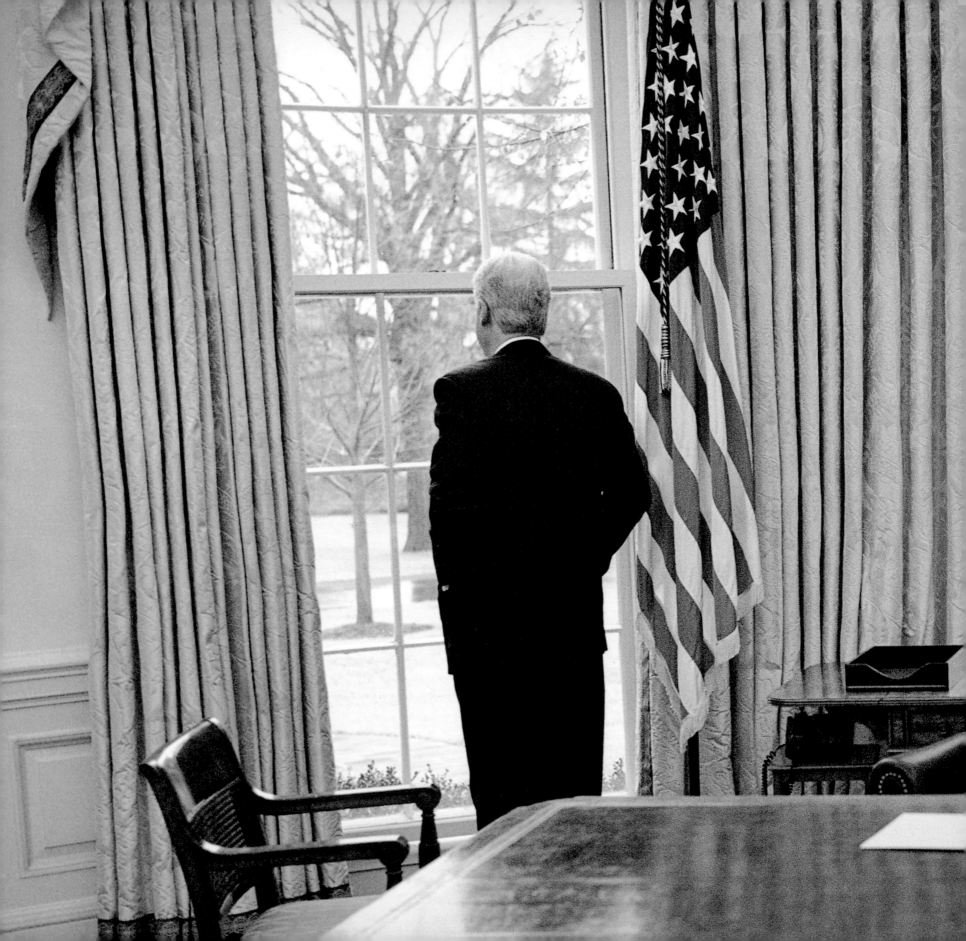

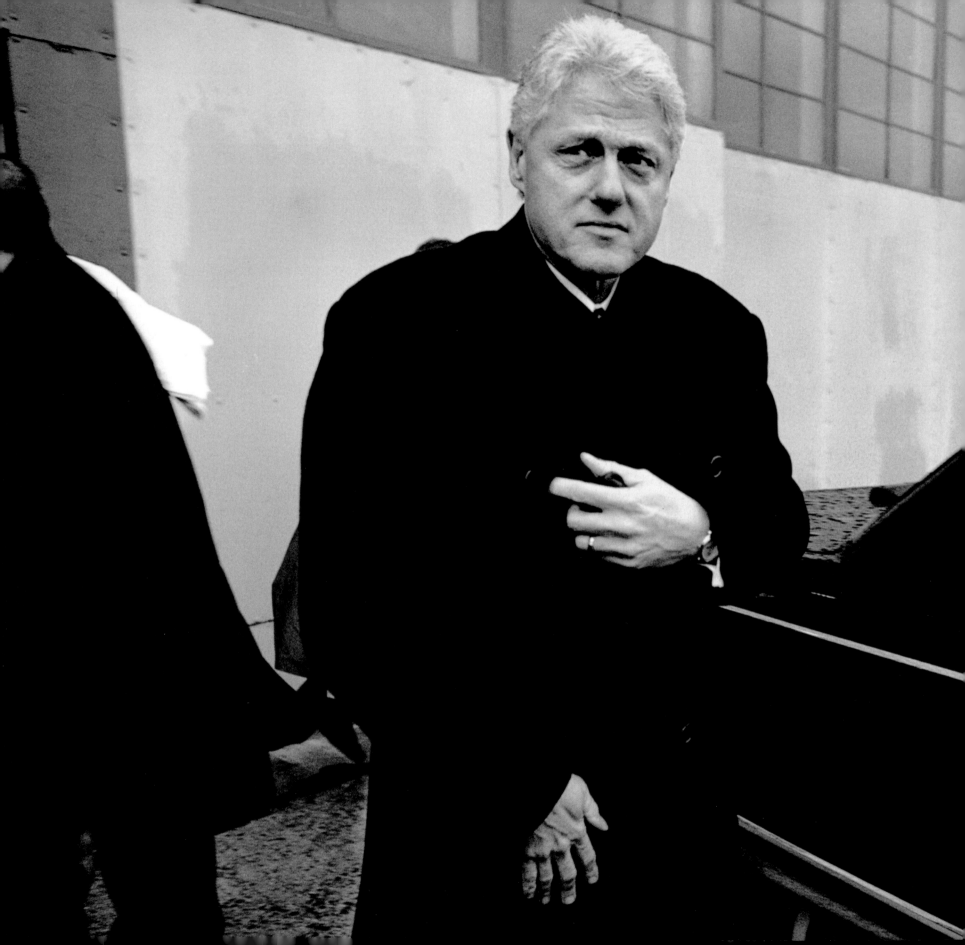

After a farewell rally at Andrews Air Force Base, former President Clinton heads for the plane. I can't imagine his feelings that day—perhaps his face tells us a little.

This was my last day on the White House beat. I'd been where I wanted to be, watching the last moments of the President being the President and welcoming a new President. I had very mixed feelings. I'd been to wonderful places, been witness to exciting events and some truly remarkable moments. I'd seen our political system at very close range and had some images to show for it. I had been very lucky and now felt it was time for me to go. As I watched the President and First Lady drive off toward their new life, I had mine, too. Suddenly I remembered that January 20 was my birthday, and once again I'd spent it with a President.

— *D.W.*

Acknowledgments

For this book I wish first to thank Leah Bendavid-Val, whose enthusiasm, encouragement, direction, and ability produced *Public & Private*. My thanks go to my longtime friend Elizabeth Newhouse, who introduced me to National Geographic Books; to editor Becky Lescaze for her infinite help with the words; to picture editor Mary Dunn, who found these images, to Bill Pierce who printed them, and to Alex Castro who designed this book with his special "music." It was a great team. My thanks also go to Anne Moffett, Miriam Winocur, Amy Carmichael, and Cornelis Verwaal for fact and picture research.

I thank the former Presidents and First Ladies Gerald and Betty Ford, Jimmy and Rosalynn Carter, Ronald and Nancy Reagan, George and Barbara Bush, Bill and Hillary Clinton, Vice Presidents Walter Mondale and Al Gore, and Tipper Gore for their extraordinary generosity in participating in such a significant way in the making of this book, and also those who assist them. All of the press secretaries and their assistants from these administrations, as well as the White House staff photographers, extended enormous help to me in my work over the years, and I wish to thank them very, very much.

All but a few of the photographs in this book were shot on assignment for *TIME* magazine. Thanks first must go to the director of photography and my friend of many years, Michele Stephenson, whose eye, support, and heart have meant everything to me throughout my career. To the late great John Durniak and Anne Callahan, to my "chief" Arnold Drap-

kin, and to John Dominis, all of whom gave me my start; to editors Rick Boeth and MaryAnne Golon, and to my longtime colleague Dirck Halstead, I owe my thanks. I thank the entire *TIME* picture department: editors, researchers, the traffic desk, the lab, the art directors, production, syndication, bureau picture desks, and especially my fellow *TIME* photographers and correspondents, the best people in the world to work with. Special thanks go to editors Henry Grunwald, Walter Isaacson, Jim Kelly, and Priscilla Painton, who put the pictures on the page.

I am indebted to my friend Gail Tirana for encouraging me to become a photographer. Equally important in my career have been the following: Tom Arndt; Dick Baghdassarian; Sandra Berler; Marsha Berry; Susan Biddle; Art Buchwald; David Burnett; Joseph Califano; Jamie Lee Curtis; Kris Engskov; Betsy Frampton; Andrew Friendly; Nancy Gibbs; Arthur Grace; Susan LaSalla; Jack Limpert; Elise Lufkin; Bill Moraveck; Russell Munson; Charlie Peters; Ann and Walter Pincus; Linda K. Smith; George Stevens, Jr.; Anne Tyler; Robin West; and, most especially, my husband, Mallory Walker.

I wish very much the following were still here on Earth to thank. I'd like them to know we made this book: Stanley Tretick; Yoichi Okamoto; Annie Callahan; Elaine Crispen; Carol Trueblood; Katharine Graham; Emily Friedrich; Pamela Harriman; Neang Seng; and my father, B. Lauriston Hardin, Jr.

Published by the National Geographic Society
John M. Fahey, Jr., *President and Chief Executive Officer*
Gilbert M. Grosvenor, *Chairman of the Board*
Nina D. Hoffman, *Executive Vice President*

Prepared by the Book Division
Kevin Mulroy, *Vice President and Editor-in-Chief*
Marianne R. Koszorus, *Design Director*
Leah Bendavid-Val, *Editorial Director, Insight Books*

Staff for This Book
Leah Bendavid-Val, *Editor*
Rebecca Lescaze, *Text Editor*
Alex Castro, *Art Director*
Anne Moffett, *Researcher*
Lewis Bassford, *Production Project Manager*
Janet A. Dustin, *Illustrations Assistant*
Kelly Parisi, *Design Assistant*

Manufacturing and Quality Control
Christopher A. Liedel, *Chief Financial Officer*
Phillip L. Schlosser, *Managing Director*
John T. Dunn, *Technical Director*
Vincent P. Ryan, *Manager*
Clifton M. Brown, *Manager*

One of the world's largest nonprofit scientific and educational organizations, the National Geographic Society was founded in 1888 "for the increase and diffusion of geographic knowledge." Fulfilling this mission, the Society educates and inspires millions every day through its magazines, books, television programs, videos, maps and atlases, research grants, the National Geographic Bee, teacher workshops, and innovative classroom materials. The Society is supported through membership dues, charitable gifts, and income from the sale of its educational products. This support is vital to National Geographic's mission to increase global understanding and promote conservation of our planet through exploration, research, and education.

For more information, please call 1-800-NGS LINE (647-5463) or write to the following address:

NATIONAL GEOGRAPHIC SOCIETY
1145 17th Street N.W.
Washington, D.C. 20036-4688 U.S.A.

Visit the Society's Web site at www.nationalgeographic.com.

LIBRARY OF CONGRESS CATALOGING-IN-PUBLICATION DATA

Walker, Diana (Diana H.).
 Public & Private : twenty years photographing the Presidency / Diana Walker : foreword by Michael Beschloss.
 p. cm.
 ISBN 0-7922-6907-1
 1. Presidents—United States—Pictorial works. 2. United States—Politics and government—1945–1989—Pictorial works. 3. United States—Politics and government—1989—Pictorial works. I. Title: Public and private. II. Title

E176.1.W266 2002
973'.09'9—dc21 2002070282

Printed and bound in Italy